Dubuffet
as architect

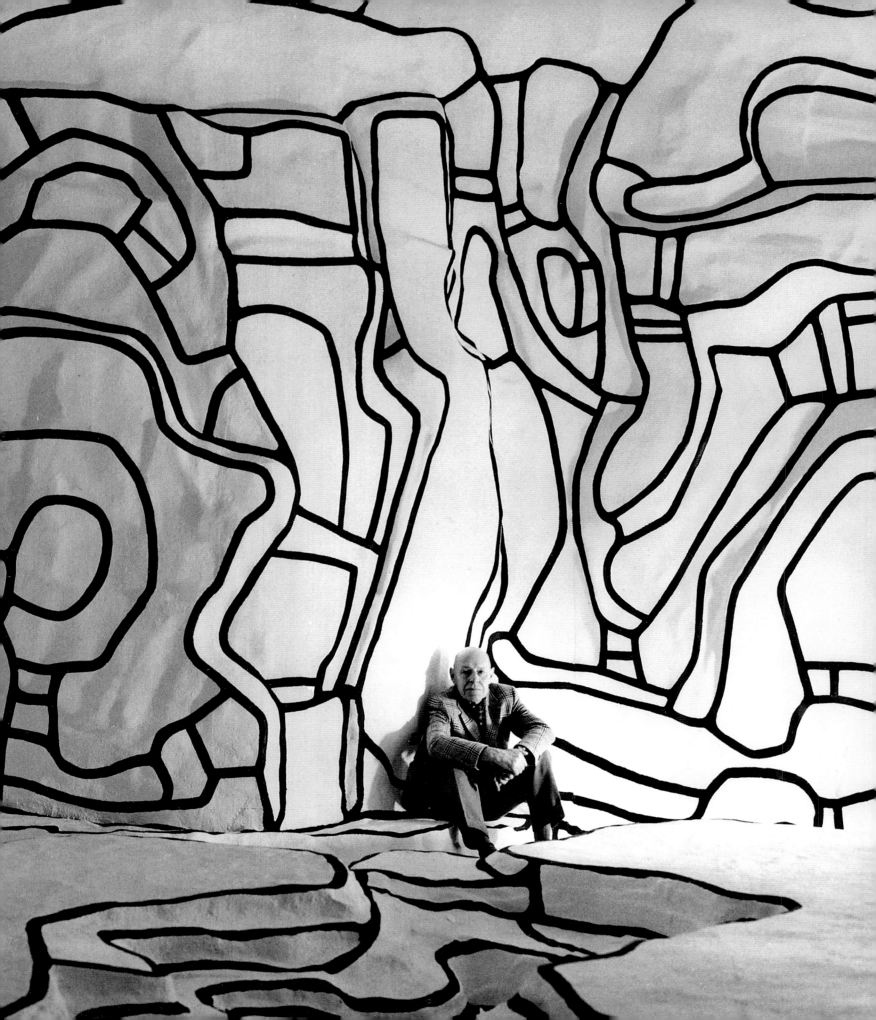

Dubuffet
as architect

Daniel Abadie

HAZAN

Published by Éditions Hazan, Paris
Distributed by Yale University Press, New Haven and London

acknowledgments

As the *Dubuffet as architect* exhibition deals with a hitherto unexplored side of Jean Dubuffet's work (only the exhibition in the Consuls' Hall in the Archbishops' Palace in Narbonne partly investigated this aspect), assistance has been called upon from many quarters both in setting up the exhibition and for the catalogue.

My first thanks go to François Gibault, President of the Fondation Dubuffet, who from the outset not only endorsed the project but also made it possible through the loan of many works belonging to the foundation.

From the first, the idea behind the exhibition was to involve the countries and cities that in their different ways had been part of the great venture that gradually enabled Jean Dubuffet's painting to come into being physically, in the real world. For this reason, the Fondation Dubuffet and I have been particularly appreciative of the enthusiasm shown by the Henie Onstad Art Centre and director Karin Hellandsjø, the Skissernas Museum directed by Elisabet Haglund, and Claire Leblanc and the Musée d'Ixelles when we asked them to become active partners in this project.

In each of the countries concerned, the idea for the exhibition received the support of the French Embassies, so our thanks go naturally to Their Excellencies Madame Brigitte Collet, Ambassador for France in Norway, Monsieur Joël de Zorzi, Ambassador for France in Sweden, Madame Michèle Boccoz, Ambassador for France in Belgium, as well as their staff who provided valuable assistance. Special mention must be made of the help we consistently received from Emmanuel Michaud, cooperation and cultural action advisor, and Dominique Lebrun, cultural attachée to the French Embassy in Norway for her valued assistance.

Two loans – both exceptional because of their importance as well as their dimensions – gave this exhibition its full meaning, and for this reason we are both pleased and grateful to thank Richard Armstrong and the Solomon R. Guggenheim Museum in New York, as well as Ann Hindry, Curator of the Renault Collection, for allowing us to present, in these three exhibitions, two works that are essential: *Nunc Stans* and the *Mur bleu*. We also wish to express our appreciation to Nils Ohlsen, Director of the National Museum of Art, Architecture and Design, for the loan of *Demeure VI*, a most important painting conserved in Oslo, and further our indebtedness for loans from Arnold and Milly Glimcher whose names have always been linked to any significant event concerning Dubuffet, as well as to the Pace Gallery they founded.

Such an event involves teamwork: I first wish to thank Sophie Webel, Director of the Fondation Dubuffet, and her team – Claire Baulon, Michèle Chakhoff and Florence Quénu – without whose continued help, responsiveness and patience this exhibition would never have been possible. Similarly, Jean-François Barrielle and Éditions Hazan made it possible for us to publish, in a very short time, two catalogues, one in French, one in English, whose number of pages was significantly augmented by an influx of hitherto unpublished documents. In this case also, assistance from Chloé de Lustrac and Bernard Lagacé was indispensable.

I have also benefited, on more than one account, from the assistance of Jean Levaux, treasurer to the Fondation Dubuffet, Pierre-André Maus, President of the Société des Amis of the Fondation Dubuffet, and Jon Mason, who retrieved precious information from the Pace Gallery archives.

To all the people mentioned above, I extend my very warmest thanks.

Daniel Abadie

contents

PAGE 2
Jean Dubuffet on the *Closerie Falbala*
Périgny-sur-Yerres, January 1978

foreword

Although Jean Dubuffet is acknowledged as one of the most significant artists from the 20th century, it is not widely known that he was also one of the most prolific. His creative activity, which only really got underway in 1942 and which he deliberately put an end to in December 1984, produced nonetheless nearly 10,000 works of art: paintings, drawings, prints, sculptures, architectural maquettes, theatre, not forgetting his literary and musical work. Many of his works have been presented to the public through exhibitions devoted to him throughout the world. Yet designing an all-inclusive exhibition showing all the aspects of a man so creatively inventive as Jean Dubuffet is a perilous venture. No matter how enlightened the choice of the works exhibited, there will always be some areas of this unique artist's work that are only briefly evoked.

The scope of this exhibition is quite different.

One particular aspect of Jean Dubuffet's work will be explored in depth: an aspect that is seldom shown in its entirety, but one which occupied a long period in his working life: the architectural dimension.

If we exclude a first exhibition in 1968, *Édifices, projets et maquettes d'architecture* in the Musée des Arts Décoratifs in Paris, where Jean Dubuffet presented his projects for monuments to the public for the first time, and a second which took place two years later at the Art Institute of Chicago, there have been few exhibitions to date that have brought together so many of the artist's monumental projects. The Fondation Dubuffet, which conserves all the artist's architectural maquettes and projects, has made its archives and collections available in order to provide just such an opportunity.

When Dubuffet set up his Foundation in 1973, it was with a view to conserving one of his major projects, completed that year, the *Closerie* and the *Villa Falbala*, built close to his studios in Périgny-sur-Yerres in the suburbs of Paris. Dubuffet built this monumental work for his own purposes, fully aware that he could not hope to see his projects come to fruition if he relied only on the patronage of potential commissions. While a first commission awarded him in 1969 – the *Groupe de quatre arbres* monumental sculpture in New York – went duly forward, as did a subsequent commission for the *Jardin d'émail* at the Kröller-Müller in Otterlo in the Netherlands, many others never got beyond the project stage due to administrative delays, technical hitches, funding problems or, on occasion, political issues. As Daniel Abadie notes, the building of the *Closerie Falbala* was in this sense a response to the failure of certain major projects to follow through. When Dubuffet set up his Foundation, the first thing he did was to endow it with all his architectural maquettes and projects, even before the paintings. His main concern, apart from conserving the *Closerie Falbala*, was to ensure a future for these projects, that they might after his death, under the Foundation's control, become reality. And it is indeed thanks to this donation that it is now possible to present such an exhibition.

When Daniel Abadie imagined this *Dubuffet as architect* exhibition and the accompanying book, he pointed out that the title might seem surprising, even provocative: "for although everyone is in agreement that he is one of the most important painters from the second half of the 20th century, and although some feel that

he is a remarkable writer, equally adept as a theoretician and as a letter-writer, only a few know of his "musical experiences" or this architectural dimension, which he developed during the *Hourloupe* period (1962–1974) and for which he was awarded in 1982 a medal of honour from the American Institute of Architects – the only honour in his life that he did not refuse. Daniel Abadie not only has expert knowledge of Dubuffet's work – his writings and the many exhibitions he has already curated are proof of this – but he also observed the making, and even initiated some of the monumental pieces. The frequent exchanges he had with Jean Dubuffet give him a privileged status that is the envy of many.

Dubuffet is strongly represented in Scandinavian collections (notably the National Gallery in Oslo and especially the Henie Onstad Art Centre at Høvikodden, Oslo, which acquired many of the artist's works; the Moderna Museet in Stockholm; the Museum Jorn in Silkeborg and the Louisiana Museum in Humlebaek, Denmark), reflecting the strong ties that Dubuffet enjoyed with such northern European institutions and the people who ran them. Only a few months before he died in May 1985, Jean Dubuffet was exhibiting in the Konsthall in Malmö, Sweden, and corresponding with the Henie Onstad Art Centre and with the Konstmuseet-Arkiv för Dekorativ Konst, today the Skissernas Museum / Museum of Public Art in Lund. The specificity of the collections in this last-named museum, which is devoted to the study of monumental art, was one of the conceptual driving forces behind this exhibition. But a further important factor in planning the exhibition was the fact that the Henie Onstad Art Centre and Skissernas Museum each had in their possession one of the two preparatory works on paper for the commission that was awarded Dubuffet by the University of Paris School of Humanities in Nanterre in 1965 – a commission which played a determining role in the future development of his monumental work. The exhibition could not have happened without the determination shown by both museums. The two major loans – *Nunc Stans* provided by the Solomon R. Guggenheim Museum in New York, and the *Mur bleu* from the Renault Collection – are all the more appreciated as they are both equally representative of the stages that are essential in comprehending the metamorphosis of 'Dubuffet the painter' to 'Dubuffet the architect'. Lastly, the Musée d'Ixelles, the final partner in this coproduction, confirmed early on their immense interest in this particular subject, given that the tower Jean Dubuffet planned for Brussels in 1973–1974 was one of his last architectural projects.

This exhibition *Dubuffet as architect* thus attests to the intense activity in which the artist was engaged between 1965 and 1974, in the midst of his stunning *L'Hourloupe* cycle. May those who visit it discover *an edifying aspect of Jean Dubuffet's work* and may it rouse in them the desire to encounter his extraordinary *edifices*.

Elisabet Haglund
*Skissernas Museum/
Museum of Public Art, Lund*

Karin Hellandsjø
*Henie Onstad Kunstsenter,
Høvikodden*

Claire Leblanc
*Musée d'Ixelles,
Brussels*

Sophie Webel
*Fondation Dubuffet,
Paris*

Postscript: *Contrary to normal usage, we have respected the typography that Jean Dubuffet chose for the titles of his work. Works marked with an asterisk (*) in the captions are not presented in the exhibition.*

On an Edifying Aspect of Jean Dubuffet's Work

*In memory of Sylvie et Éric Boissonnas, who invented
Flaine and invited Picasso and Dubuffet there.*

Pascal may well have been right to note that the current state of the world is due to Cleopatra's nose, but it is to Edison that we owe Jean Dubuffet's architectures. His habit of letting his ballpoint pen wander over any paper to hand whilst on the telephone gave rise to the *L'Hourloupe* cycle of architectural projects and constructions. When, in July 1962, he realized that there might be some point to the automatic writing with its blue and red hatching, Dubuffet took the scissors to it and cut it up into fragments: isolated on a background, the fragments seemed to take on a certain elusive significance. What for other people might be an everyday idle gesture, the mind drifting, was to lead Dubuffet – ever constant in his celebration of the ordinary and the unnoticed, the main thrust of his work – to develop this discovery over a period of twelve years, and to build a universe that was both complex and unpredictable.

Anyone considering Jean Dubuffet's work as a whole cannot fail to notice the mixture of changing moods, like shifting winds, and fierce determination. This explains the apparently contradictory series of periods that alternate between a tendency for concrete experimentation using anything rejected by official culture – whether atypical materials, banal images or residues that retain the density of life itself – and the most gratuitous of mental vaticinations, the inspired exhilaration which ignored codification and launched straightaway into the most random yet exact of associations. These two poles, apparently mutually exclusive, gave Dubuffet a dynamic for his work, a tension whose continual alternatives gave the spirit no rest and left to others, like so many sloughed snakeskins, what had just been discovered. Yet no matter how spontaneous his inventions, they are always an intricate part of his previous work. The reasons why Jean Dubuffet's work suddenly moved towards greater volume with *Édifices* must be sought in the beginnings of *L'Hourloupe*.

From the first, *L'Hourloupe* was about cities. When his first homunculi found themselves in the presence of others, no longer isolated against a black background, they needed a site. They soon discovered the streets of *Paris Circus*, where a few globular cells quickly provided them with temporary housing. In Dubuffet's work, the end of one cycle and the beginning of another often ambiguously coincide, as if he could not quite manage to give up the one despite his eagerness for the new lines of enquiry that were opening up. Yet so little was he concerned about repeating himself that this state of affairs seldom lasted. *L'Hourloupe* was a solution for continuity in his work, more than he initially imagined no doubt. With *Les riches*

fruits de l'erreur (The Rich Fruits of Error), *L'Hourloupe* invented its own system: no landmark, no milestone to help out when faced with a surface loaded with historiated narrative. As had already been the case with the *Texturologies* and the *Matériologies*, the work seemed to be a fragment in a greater whole, a continuous sort of frieze, arbitrarily cut out, that fluctuated like the rhythm of thought itself. In *L'Hourloupe*'s allusive figuration, readings are provisional and images virtual. There is no point in seeking out distinct figures, except dot by dot, as a kind of ironic incitement to find others. The game is a much more ambitious one, a combinatorial game in which the spectator, seeing nothing, can no longer remain on the outside. It is a game whose cards are masterfully dealt by Dubuffet.

Like successive cards in an incomprehensible tarot pack, the figures are emblematic: there are the characters who at first remain undifferentiated but for whom Dubuffet soon finds names – *Fiston la Filoche*, *Béniquet Trompette*, *Canotin Mache Œil*; and the everyday furniture, his theory of utensils, from the screwdriver to the car; the bestiary common to other parts of his work (dogs, birds, cows); then finally the abodes, the *Demeures*, which were discreetly ushered into his work on 12 December 1963 with a ballpoint pen drawing. Once the theme itself had been announced, this architectural dimension remained constant in *L'Hourloupe* – self-evidently via the subjects treated, yet less perceptibly in the way the works themselves were made or regarding their ultimate purpose. Summer 1964 saw a brief series of paintings and works on paper take shape (*Le village fantasque*, *La grande place d'Étaples*), still very descriptive compared with the *Demeures*, which from March 1966 to May 1967 gave rise to six important paintings, as well as a host of marker drawings. In the last one, *Demeure VI*, Dubuffet disconnected the contrary concepts of outside and inside in order to recompose them into an organic whole, with rooms, stairs and entrance steps distributed over the façade. As Georges Limbour aptly remarked, unlike objects that preserve their outward appearance, "The abodes are ideograms."

Still, the "household saga" had not spilled outside the frame. A fortuitous event provided the opportunity to do so in the form of a commission for two vast wall panels for the new Paris University buildings in Nanterre. The project, which was never executed due to administrative delays, did yield other benefits, however. Apart from his drafts and the intermediate enlargements of the two panels as planned, *Nunc Stans* and *Epokhê*, Dubuffet also carried out trials transcribing his ideas into ceramic, the material that had originally been chosen for the wall decorations, in collaboration with ceramicist Roland Brice. Amongst them were the shallow reliefs *Le lampeur* and *L'horloger* (May–June 1965), which prefigured the sculptures to be made a year later as a prologue to *Édifices*.

Yet even the way *L'Hourloupe* was painted carried within it the germ of relief. The optical relationship between red and blue, exacerbated by the white background, slightly distorts space, with the hot tones receding and the blues that form the armature being foregrounded. Dubuffet's first painted sculptures only in fact use the hollowed out historiated surfaces, bringing the hatching into relief, as if timidly apprehending *L'Hourloupe*'s entry into a three-dimensional world. Dubuffet's

instinctive mistrust of perspective, a cultural system guaranteeing the established order, always made him prefer less conventional modes of representation in his painting, and so in *L'Hourloupe* he piles up subjects that accentuate the painting's frontality, leaving no space to see through. The first sculptures bore the mark of this original mistrust. As panels or cubic masses, they seldom freed themselves from the plane of the painting, but the intention of giving substance to the *virtual virtues* of painting, to its *inconsistencies*, was there. Expanded polystyrene foam was far from being a traditional material used by sculptors; it was rather the preserve of packaging manufacturers and shippers. Dubuffet chose it for its lightness, which meant that he could move huge blocks around by himself without difficulty, and its ease of carving, but its whiteness also made it an ideal surface for colour. According to Max Loreau: "The part consistently played by white in the painter's recent chimeras is obvious, and in this particular case the substance itself is a sparkling white right through, nothing but white, scooped out by millions of alveoli, white on white, insubstantial and fragile as a cloud – as if, deep down, being is no more than an incandescent fading into infinity, a sort of slight floating tremulousness with no depth."

Yet Dubuffet's ever-watchful spirit was quick to spot the potential for cavities in the first sculptures' protruding masses, whether they were milestones or busts. His *Château d'errances*, December 1966, a simply designed solid block, nonetheless opened the way for the architectural projects that, along with other work, were to occupy Jean Dubuffet until 1974. Now fully involved in volume, his research became twofold: forms in space such as chairs, syringes and telephones on the one hand, and on the other, low reliefs, avatars of paintings that transform into walls, into environments. The low reliefs quite obviously follow the codes of *L'Hourloupe*, but the forms in space are problematic inasmuch as the object suddenly superimposes itself on its representation. The mental game of chance identification, of hallucinatory evocation highlighted by the paintings is in opposition to the sculptures' physical presence. As Dubuffet wrote: "The idea of sitting on a chair figuratively placed by a painter on a canvas would never occur to anyone, yet there is the temptation to do so when a sculptor figuratively makes one in three dimensions, a chair that is therefore physically embodied. . . . What happens, or is quite liable to happen, is that the sculptor's work disappears, it fades away when the sculptor, expecting to contemplate a mental figure (maybe a wildly extravagant one) of a chair, is frustrated in his efforts in the presence of a work that ceases to belong to a mental world, the world of seeing, and becomes part of a world where things are offered in order to be seen, to be used even, the world of chairs we are prepared to sit on."

Dubuffet the architect was in no way a socially committed builder, even though some of his projects did fully engage the public, but everything shows his inordinate preference for ranging far and wide unencumbered by maps, for lucid delirium. Dubuffet's experience of sculpture taught him that if the spirit were to be aroused then form should have no useful value. The *Tour aux figures*, the first project for which he designed an interior, was initially conceived with a lift and different floors just like any other abode, but it finally achieved its own norms based on the "gastrovolve", the hermit-crab mode that the houses are modelled

on – and for which, Dubuffet stated, one was "forced to a life without belongings". All architectural conventions are overturned. Compared to any ordinary idea of a house, Dubuffet's edifices are the Ryoan-ji relative to a suburban garden. They are places in which the self is forgotten in order to investigate through the sole power of the spirit whither goes the unpredictable echo of the Tao Te Ching: "Without going out the door, know the world/Without peering out the window, see the Heavenly Tao/The further one goes/The less one knows/Therefore the sage/Knows without going/Names without seeing/Achieves without striving".

L'Hourloupe's inherent capacity for aberrancy attains its highest expression in the *Édifices*. Occasionally the floors and ceilings are decorated, as in some primitive cave, with marks familiar to spectators of *L'Hourloupe*. But they do not follow the changes in level, or the protuberances and the surface planes, they contradict them, only highlighting them here and there as if to underline the fact that they diverge. Two distinct readings are thus created: that of the eye, immediate yet slow, and that of the body, without memory, called into question each time a step is taken or a hand grazes the surface. For the physical dimension of *L'Hourloupe*, discovered by Dubuffet through his architectural work, maquettes were not enough: edifices had to be on a human scale.

The *Cabinet logologique* was Jean Dubuffet's first monumental work. It really is the summa of *L'Hourloupe*, with four panels forming a room, complete with subjects for the two doors – a vast frieze in low relief, all the motifs from *L'Hourloupe* continually and apparently uniformly flowing from one wall to another according to a mode of representation that proliferates in differing degrees. Anyone going into the *Cabinet logologique*, on seeing the doors close, cannot but feel immersed in a ritual bath of initiation. The spirit is completely disconcerted as it attempts to cling to an image fleetingly recognized, then suddenly perceives it to be the constituent part of another element, which in turn . . . Only feet that are firmly rooted on the ground enable such a *Houle du virtuel* (Tempest of the Virtual) to be weathered without loss of life or limb. To avoid such final recourse, the ground of the *Jardin d'hiver*, like the *Jardin d'émail*, was also treated in volume, historiated, made an integral part of the work. In this manner, the world of *L'Hourloupe* closed in on itself, an undecipherable, fascinating logogryph where reality has no place.

The *Cabinet logologique* required permanent housing, so Dubuffet began the *Villa Falbala* edifice at Périgny-sur-Yerres where his studios were located. This was then completed with the *Closerie Falbala*, his largest architectural creation and one of his greatest achievements. Everything that Dubuffet had learned from his different experiments with volume can be found here. The *Closerie* and the outside of the *Villa* seem austere at the outset, with the coldly uniform white paint and the black lines picked out. In this Paris commuter land of manicured lawns and patio barbecues, its effect takes one aback. The *Closerie* sucks visitors in, entraps and isolates them from a world already reduced to a few sprigs of vegetation; it requires them to pay attention when walking over the uneven ground; then again, it might suddenly extend an invitation to sit in an alcove in a wall that has been more deeply excavated; finally, at the centre, it surprises as the *Villa* suddenly rises up. An anti-chamber

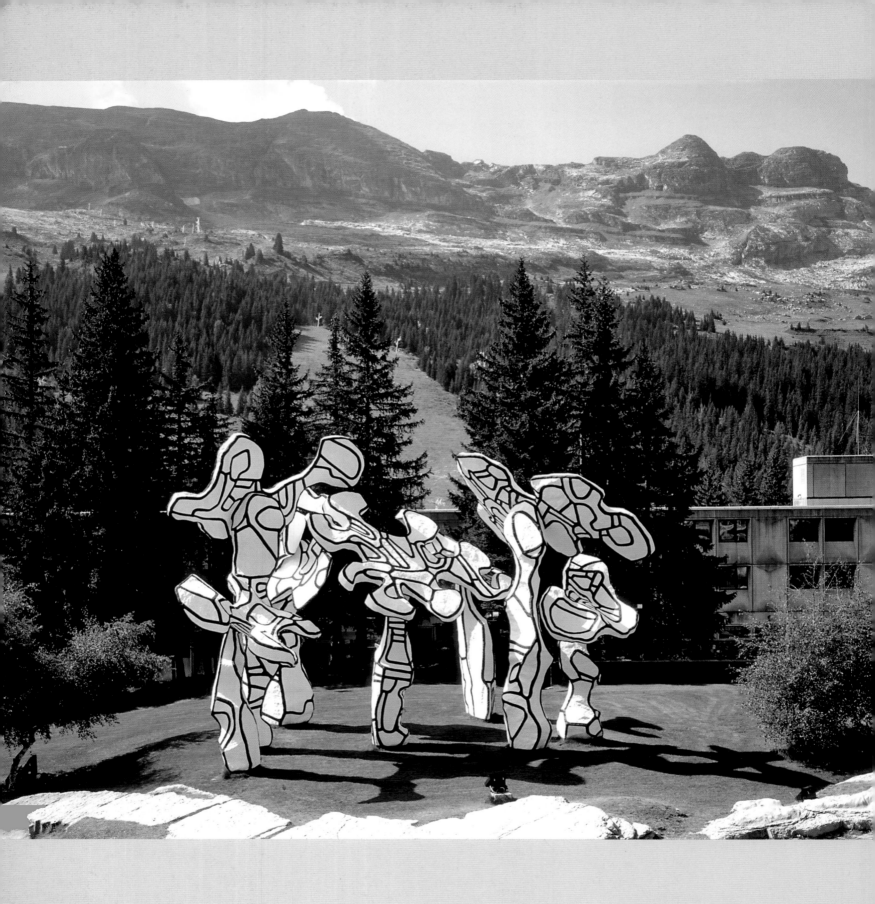

historiated in blue and red leads to the *Cabinet logologique*. Everything heightens the feeling that this is the heart of the matter; the marks gradually get smaller, from large and abstract outside, denser in the anti-chamber, and finally compact and evocative in the *Cabinet*, where colour surges. Colour is absent in the *Closerie* and muted along the pathway leading to the *Cabinet logologique*, before exploding, once the door is pushed open, in intense blues and reds, like blood suddenly filled with oxygen.

Dubuffet's architectural works are few in number, yet this was not due to a lack of projects on his part. In France, two essential pieces of his were never executed: the *Site scripturaire* for the La Défense district in Paris never came to fruition, while work on the *Salon d'été*, commissioned by the Renault car company, got underway, before being interrupted and finally buried by an unsympathetic new director. The long court battle between Dubuffet and the Régie Renault stifled Jean Dubuffet's architectural ambitions for several years. Only at the end of his life, after the two monumental sculptures in Houston and Chicago had been built, did Dubuffet agree to *Le Boqueteau* being built in the Alps, in Flaine, and the *Tour aux figures* just outside Paris. He died before seeing these works finished, one in an urban space and the other in a natural mountain setting, both completely integrated into their site, yet achieving a fittingly powerful counterpoint. The strength of these monuments is that they belong, as strangely natural as an ancient temple on the Mediterranean.

In the end, what is odd about Dubuffet's peregrinations through the world of architecture and its edifices, their "edifying" quality as it were, is that they reveal the artist's true social status. Belatedly revered by museums, grudgingly accepted by the press, who did more than any other group to insult him, Dubuffet ultimately remained unacceptable to society at large. For unconsciously, there was the private realization that his work could not be measured by any usual artistic yardstick – even though today yardsticks lend themselves to every conceivable manner of conversion – but, over and above the acknowledgments from institutions and collectors, it was that his adventure was a visceral refusal of convention, a hatred for official thinking, the ferment of rebellion. ■

The Story of a University Faculty in a Place Called *La Folie*

(or how Dubuffet met with architecture)

2 April 1963

The Conseil Général des Bâtiments de France (French national body for building works), presided over by M. de Lestang, director of architecture, approves the project for a university complex in Nanterre presented by architects Jean-Paul Chauliat and Jacques Chauliat, the latter being chief architect for public building works, in charge of construction. Given the law stipulating that 1% of the total building costs should be used for works of art to decorate such a building, he suggests several decorative panels scattered throughout the building, and especially "mosaic panels with relief effects" in the entrance hall leading to the main lecture theatres.

9 December 1964

The national committee for creative arts meet to endorse the architects' proposals for the 1% attribution, presided over by Bernard Anthonioz, director of the creative arts department at the Ministry of Cultural Affairs. Representatives for the departments concerned (Direction de l'Architecture, Ministère de l'Éducation Nationale, Service des Beaux-Arts, etc.) attend the committee, which also comprises Jean Cassou, head curator of the Musée national d'Art moderne, art critic Frank Elgar, architect Guillaume Gillet, poet Jean Lescure and François Mathey, curator at the Musée des Arts Décoratifs.

The architects Jean-Paul and Jacques Chauliat, whose design for this *grand projet* includes 270,000 francs for purposes of decoration, suggest that the bulk of the money be awarded to sculptor and mosaicist Charles Gianferrari. The committee argues that the building of the Arts Faculty in Nanterre comes within the remit of the *grands projets*, and that as such "a more thorough study of sites" for the artwork should be carried out in situ. It appoints to this effect Messrs. Cassou, Elgar, Mathey and Gillet.

9 March 1965

With architect Bernard Anthonioz and Jean Barbot, assistant director of the creative arts department, the members appointed to the 1% committee report that "such a vast architectural project of such high quality . . . requires a decorative programme of great standing, to be awarded to proven artists", and suggest that the decoration of the great hall be entrusted to Vasarely, "who might be assisted by younger artists . . . or to Dubuffet, whose recent *Hourloupe* exhibition shows the artist's great feeling for mural work".

13 March 1965

The committee members meet at the Galerie Jeanne Bucher, where they are shown different paintings from *L'Hourloupe*. They decide unanimously that the commission for mural works at the Faculty in Nanterre be awarded to Jean Dubuffet, and request that Charles Gianferrari's work be placed in other buildings.

22 March 1965

Dubuffet, then living in Vence, notes in his *Journal des Travaux* a call from Bernard Anthonioz, who informs him verbally of the commission for the decoration of the Arts Faculty in Nanterre. The same day, he gets in touch with ceramicist Roland Brice, a former student of Fernand Léger who had executed the polychrome ceramic pediment for the Léger museum in Biot. Dubuffet undoubtedly takes this decision firstly because Roland Brice's reputation as a skilled technician is firmly established through this work, and also because Vence and Biot are only a short distance apart. But no doubt the deciding factor in the decision is the mutual esteem and friendship between Brice and Léger. Dubuffet, seldom admiring of other artists, feels a great esteem for the man who painted *The Constructors* and who befriended him in the 1920s. "I had a room in their house in Fontenay-aux-Roses which was filled with paintings that I loved greatly. I still love them. The complete opposition that Léger professed to aesthetic simperings and puffed up academism strengthened my views in that direction," he wrote in his *Biographie au pas de course*.

Over the next two days – 23 and 24 March – Dubuffet notes in his *Journal* that he has done a blue and red gouache, the first section (the left-hand one) of a three-section panel, registered in the journal as number *EG 142A*. He also notes prudently that it could later be cut out for future assemblages. From the outset, the title of this vinyl painting on paper measuring 0.67×1 metres is *Nunc Stans*.

Between 25 and 29 March, Dubuffet begins work on the second section of *Nunc Stans*. Then, having introduced two collage elements into

Plans by the architectural firm Chauliat showing
(highlighted in blue) the sites earmarked for Dubuffet's
two walls, opposite the building's main entrance
and flanking the entrance to the auditorium,
with its 1,000 seats.

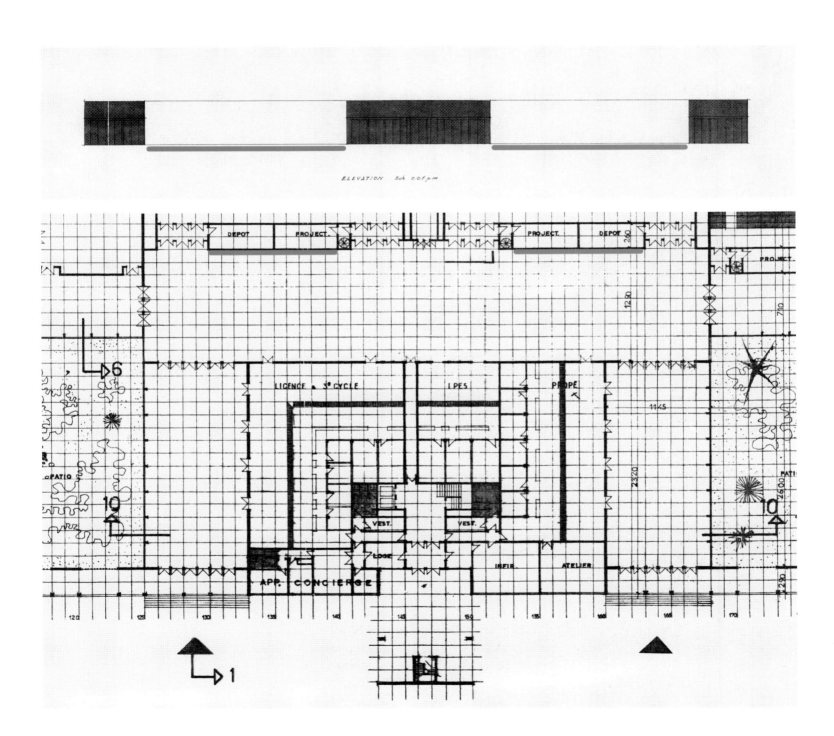

it, in blue and red only, he leaves it off, and goes back to the first gouache in order to rework it with other colours (30, 31 March and 1 April).

The third section completing the draft, measuring 0.67 × 3.38 metres in its final state, is finished on 9 April. The general reference number in the journal is now *EG 142*.

Just as he finishes the draft for the first of the two monumental pieces, Dubuffet receives a letter from Bernard Anthonioz informing him that: "In a recent meeting, the creative arts committee, as you know, formulated the wish that you should execute the decoration for the Arts Faculty in Nanterre as part of the 1% endowment.

I am happy to say that M. Malraux fully supports this proposal and is delighted that your name should be linked to an architectural project of such importance as the Paris university campus."

The constant discrepancy between creative urgency and administrative delays, which increases to the point that the commission aborts, is all the more flagrant as Dubuffet begins work on ἐποχή (*Épokhê*) on 10 April, finishing it on the 17th, having already completed *Nunc Stans* on 9 April. *Épokhê* is the second, identically dimensioned (0.67 × 3.38 metres) draft for the Arts Faculty in Nanterre. In a letter to Troels Andersen, curator with the Silkeborg Museum, Dubuffet relates on 27 September 1981: "Do you know the meaning (little known) of the Greek word *épokhè*? It means 'suspension of judgment'. It was Asger Jorn who told me of this word and what it means. When I drafted the two large ceramic pieces that were intended for the University in Nanterre, I thought it was appropriate to name one in Latin, '*Nunc Stans*', and the other in Greek, '*Épokhê*', to give the panels a philosophical perspective."

30 March 1965

So that Roland Brice can carry out the first trials in ceramic, Dubuffet makes a variation on one of the elements from the central panel of *Nunc Stans*. The fragment in vinyl on paper measuring 67 × 50 centimetres later becomes the *Composition avec cinq personnages*. The ceramicist scales it up to three times its height. Made with ready-prepared clay squares measuring 40 × 40 centimetres, the trial when finished is 2 metres high but with part of the cartoon missing on the right. This first trial respects the flatness of the draft, a constant at the time in all the work that Roland Brice had been able to see in Dubuffet's studio.

So that Brice can go on with the trials, Dubuffet gives him two recently finished paintings that reproduce figures from *Nunc Stans*, but isolated on a black background. These two paintings – *Le lampeur*, initially called *Le lampiste*, painted on 2 April 1965, and *L'horloger*, painted on 3 April 1965 – both measure 130 × 97 centimetres. They are scaled up to the same degree. However, Brice – on Dubuffet's initiative or his own initiative? – brings the globular lines from *L'Hourloupe* into relief, using a technique he devised for the monumental pediment on the Musée Fernand Léger in Biot.

A third painting, *Le porteur d'horloge* (painted on 4 April 1965, measuring 160 × 80 centimetres), is enlarged to the same scale, but without relief, as are the two last ones to be transposed in this way: one from the *Personnage de l'Hourloupe* painted on 12 May, transferred onto paper 100 × 40 centimetres, representing the final figure, in context, of the third section of *Nunc Stans*, and the other of the *Illustration du robinet* painted on 29 and 30 April, the only work in these trials not to have been generated by *Nunc Stans*.

The bill made out by Roland Brice on 3 June, which recapitulates the works he has transposed into ceramic, shows that by this date all the trials have been completed.

18 April 1965

Now the first trials in ceramic have been done (for which Dubuffet has made two payments), architect Jacques Chauliat visits Jean Dubuffet in Vence on the instigation of Bernard Anthonioz. Dubuffet notes the visit, on Easter Sunday, in his *Journal*. He shows Chauliat both the original drafts for the wall pieces and the first ceramic transfers, adding that the exact dimensions for the panels have still not been made clear nor have the sums of money available for the commission or method of payment.

A month later, in a letter to Bernard Anthonioz on 10 May, Jacques Chauliat reports on his visit, insisting not so much on the project's progress as the fact that Dubuffet will cause Charles Gianferrari to lose the other possible commissions: "I am pleased to inform you that I have been in touch with M. Jean Dubuffet and M. Brice as you requested in order to coordinate the execution and installation of the ceramic panels in Nanterre. The execution can be completed by the end of October. M. Jean Dubuffet tells me that the finished tiles, delivered to Nanterre, will cost 200,000 francs.

To this should be added 40,000 francs for the installation. The entrance hall decoration will therefore cost a total of 240,000 francs. May I remind you that the total budget for the decoration of the Arts Faculty is 270,000 francs. The remaining amount will not therefore be sufficient to cover the rest of the decoration programme, in particular the decorations for the base of the administrative building and the wall of the peristyle, which I feel are indispensable.

It will therefore be necessary to find extra funding. I wish to know what your intentions are on this matter. I also inform you that Mr Jean Dubuffet wishes to receive payment in instalments as his work proceeds."

16 May 1965

Following the trials carried out by Roland Brice to scale up the preparatory elements for *Nunc Stans* and *Épokhê*, Dubuffet realizes that the drawing will lose its tension in the 1:6 enlargement. He therefore decides to scale up the models himself, making an intermediary model on canvas that is almost two and a half times as large. From 16 May to 5 June, he begins "assiduous work" (as he notes in his *Journal des Travaux*) on "enlarging the *Nunc Stans* panel in Flashe vinyl paint over three canvases each measuring 1.62 metres high, together forming a group 8.19 metres".

19 May 1965

At work in Vence on his master copy of *Nunc Stans*, Jean Dubuffet writes to Bernard Anthonioz:
"I can no longer continue work on the ceramics for the School of Humanities in Nanterre without receiving any money. So far, I have advanced two and a half million francs [in order to make his expenditure sound more serious, Dubuffet speaks in old French francs; the sum would have been 25,000 new francs]. Yesterday the ceramicist came to see me, asking me to pay him a million francs [10,000 francs]

by the end of the month. I will do this, but any advances from my own pocket will have to stop there.

I would remind you that to date I have received no official contract apart from verbally, and neither has the price I have requested of 20 million francs [200,000 francs] figured in any clearly formulated agreement – a price, as you know, that covers only my expenditure with no profit to myself.

The ceramicist wishes to order the glazes from his supplier (it takes three weeks to have them made and delivered). I have asked him to postpone this order. I have also asked him to cease from today making and firing the clay tiles. My special order of tiles (ready for the paintings) has been going ahead for the last two months. Out of the 1,200 tiles needed, 400 are currently fired and ready; a further 300 have been moulded and are drying before being fired. All this takes time. The execution – without any untimely break – will take at least two and a half months for each of the large panels, therefore five months for both. In order to deliver the panels as M. Chauliat requested, it is urgent that we begin straight away. Even now it is late. But as we are forced to call a halt to our work, and since we cannot even order the glazes (delivery is three weeks) or make and fire the tiles, we will not be able to deliver on the due date."

5 June 1965

Jean Dubuffet leaves Vence for Paris, staying for a fortnight. He is concerned as to how the official contract for the commission is progressing, and on 14 June 1965 writes to Roland Brice:
"From Anthonioz, still the same quite categorical and firmest of reassurances reiterated as to the commission. But still no letter with written confirmation of what I have demanded, or any payment. Still the same promise that I will receive the letter – and the money – in a few days.

As for you and me, we will have to put all work on hold until we receive this long promised letter."

2 July 1965

Dubuffet is back in Paris and, on 15 July, before leaving for Le Touquet on 22 July, receives the official contract for "two ceramic panels, each approximately 80 m²" signed in the minister's name by Bernard Anthonioz.

15 July 1965

Thinking that Jean Dubuffet is already in Le Touquet for the end of the summer, Roland Brice sends him an account of the work in progress: "Your tiles are ready, holes pierced, washed, calibrated . . . waiting for the go-ahead. I've received a bill for 9,480 francs for our glazes that I need to settle by the end of the month. . . . I've received the slides from your photographer, which seem fine to me. I'll phone him or his assistant this week so that we can preview the scaled up work 4.13 metres high."

Dubuffet replies on 24 July: "I only arrived in Le Touquet the day before yesterday, so only just received your mail. I cannot understand why the cost of the glazes should be so high. . . . As you know, I've already advanced considerable sums of money on this undertaking, although I haven't as yet got anything back from the state coffers, or even any precise details as to when I will."

This letter crosses paths with another from Roland Brice dated 23 July 1965, in which the latter announces that "the ministerial confirmation has arrived at last! . . . In the meantime [until payment is made] I will clear some of the ground between the two workshops and level it, so that when the time comes the boards can be set up to view the tiles."

27 July 1965

In a reply to the remarks made by Jean Dubuffet in the letter dated 24 July, Brice clarifies the series of orders and cancellations due to the administrative delays for a commission due to be completed two and a half months later: "All the glazes were delivered in June and billed late July. I ordered them in May. I cancelled the order as you requested, and then ordered them once more following your phone call from Paris. I ordered all the glazes we will require, almost 1,000 kilos. I could do no other as they are made specially for me based on the clay I use. They are high-temperature glazes not earthenware glazes."

31 July 1965

In return, Dubuffet details the administrative situation for Brice:
"The ministerial order for the execution of the two panels is not a full contract as no mention is made either of the price or of payment, all

**Composition avec
cinq personnages***
Vinyl on paper
67 × 50 cm
30 March 1965
Private collection

**Composition avec
cinq personnages***
Ceramic
200 × 120 cm
April 1965
Private collection

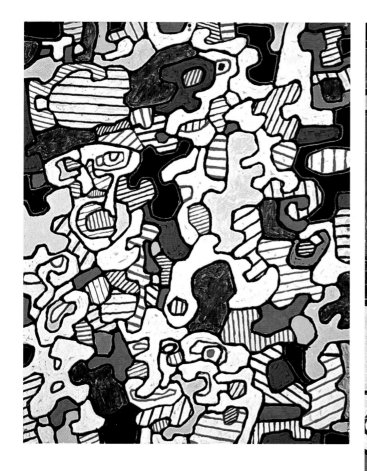

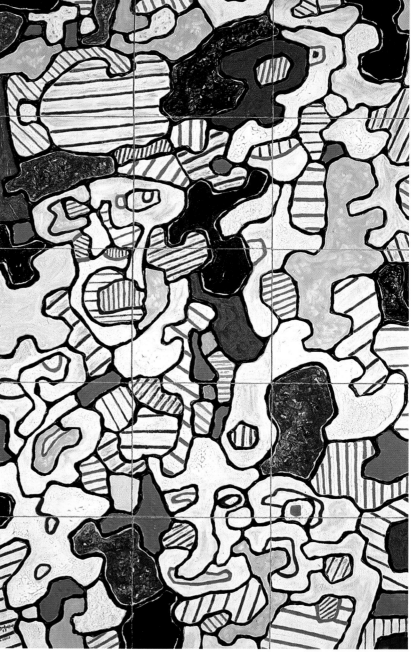

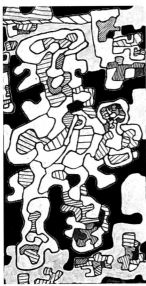

LEFT
Le porteur d'horloge*
Vinyl on canvas
160 × 80 cm
4 April 1965
Private collection

BELOW
Le porteur d'horloge*
Ceramic
160 × 80 cm
April 1965
Private collection

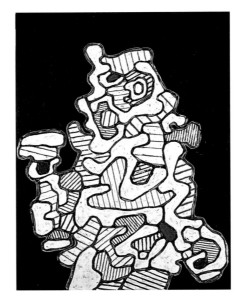

LEFT
Le lampeur*
Vinyl on canvas
130 × 97 cm
2 April 1965
Private collection

BELOW
Le lampeur*
Sculpture in relief (ceramic)
130 × 97 cm
Private collection

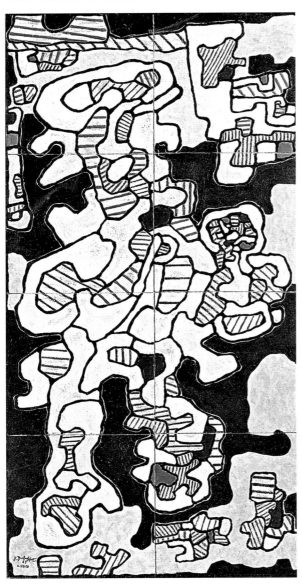

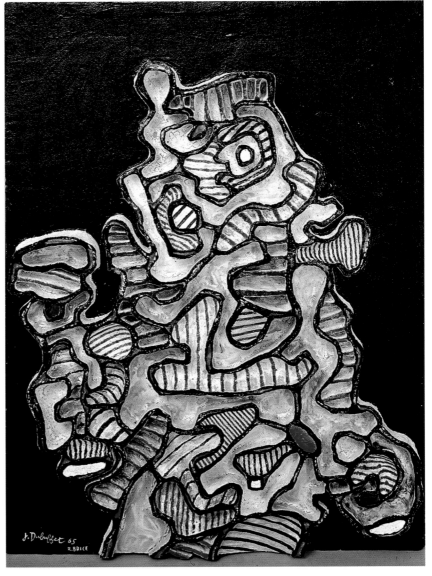

the concrete clauses about the commission are left to the decision of some or other committee or body that will get in touch with me at a later date. It is not at all sure that the conditions I stipulated will be accepted, or that I will accept those that are offered to me.

In these circumstances we must proceed with caution, as it is not at all sure that this business will reach a happy conclusion. Whatever the case, I no longer wish to lay out any more money. I do not wish to advance any money on such an uncertain business."

4 September 1965

Worried about the possibility of Dubuffet giving up the project, Brice writes to him after meeting Bernard Anthonioz: "He told me everything was settled now and that the first payment had been transferred to your bank."

7 September 1965

Another letter from Jean Dubuffet in Le Touquet to Roland Brice confirms the painter's reluctance:

"I would be very surprised to learn that things were going forward at the rate M. Anthonioz has led you to believe. From what he said to me before the holidays, there are all sorts of procedures, each entailing another, involving several ministerial departments that have to study estimates, establish contracts and what have you . . . giving me the impression, from what he said, that it will all take at least a hundred years. . . .

As there is so little haste at the ministry, there is no reason why we should fall over ourselves to get the work done, and I for my part have decided to take my time to suit myself."

Back in Paris on 26 September 1965, Jean Dubuffet informs Brice of another development in a letter dated 13 October 1965:

"One small step has been taken: two weeks ago, a ministerial order was communicated to me [dated 25 August] commissioning two panels at the price stipulated. . . . M. Chauliat however, whom I unofficially consulted, made no secret of the fact that he thought this year's funding was already used up, and that I would have to wait several months for the first instalment to be paid to me.

This is the first time ever that I have been involved in a commission from the state. Until now, I had always been wary.

I am losing patience with the way in which this matter is being treated. I have not yet taken a final decision, but I must say that withdrawing from this project readily crosses my mind. However, let's take a little more time, I will see what decision should be taken at a later date."

Dubuffet's final decision is no doubt influenced by the fact that on 30 November 1965, one and half months after the date the commission is supposed to have been completed, Bernard Anthonioz is once again obliged to write to M. Richard, head of the Paris education authority's building department:

"In our recent telephone communications, you informed me that you were not yet in possession of all the necessary details in order to establish with M. Dubuffet, the artist and painter, a contract as stated in the ministerial order dated 25 August 1965, to execute two ceramic panels, each 80 m², for the entrance hall to the lecture theatre in the School of Humanities in Nanterre.

I am in a position to inform you that these panels will be executed using 40×40 centimetre tiles in high-temperature stoneware clay. The painted decoration will be transferred on to them using high-temperature glazes, with both matt and brilliant finishes, variously textured.

The price of 200,000 francs includes the preparatory study for the finished work and its execution, excluding installation, which, as you have confirmed, will be carried out by specialists.

In fact, this sum of money, based on 1,250 francs per square metre, will almost entirely be used for the execution of the ceramic itself, an operation of high quality. In addition to the characteristics I have outlined above, the work has been entrusted to an experienced ceramicist, M. Brice, who has executed well-known ceramics for the great painter Fernand Léger.

The price is moreover extremely moderate given that 1,000 francs per square metre is usual for decorative ceramic panels in ordinary clay.

M. Dubuffet agreed to the conditions as soon as he was contacted for his collaboration on the great architectural project in Nanterre. But he has always considered that his own creative work was not remunerated.

As a large amount of work has already been carried out for this work so that it might be installed on time, I would be obliged if you could do the necessary for M. Dubuffet to rapidly receive as large an advance as possible."

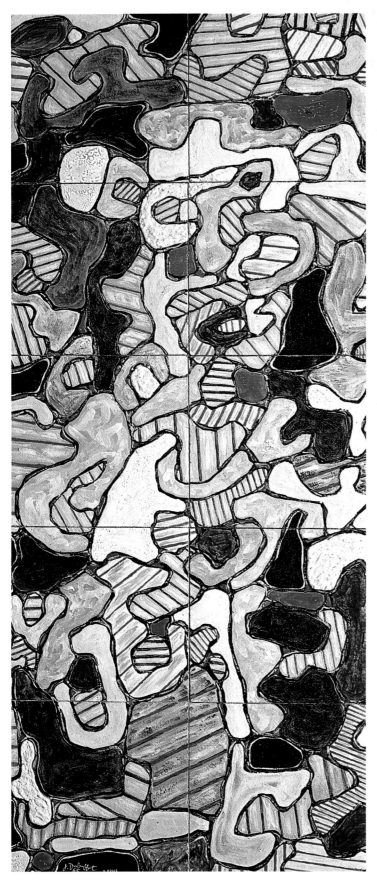

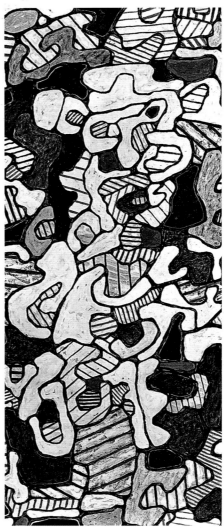

22

16 December 1965

Dubuffet writes to M. Richard, putting an end to this his first foray into official commissions: "Last March I did indeed agree to execute two ceramic panels to be installed in the School of Humanities entrance hall in Nanterre. Your letter gives me to understand that you now intend to establish a contract in due form, and I wish to thank you for this. But too much time has elapsed. All the systems set up last spring in the Alpes Maritimes for the work to commence have been dismantled; I am myself involved in other projects and am no longer in the proper frame of mind to return to this project."

Although the Faculty in Nanterre never saw the monumental panels that Dubuffet created for the university, what he accomplished was not without consequence for his later work.

Having undoubtedly realized that murals would have trouble surviving in an area that was the hub of a university (a university that was the centre of student unrest in 1968), and that he had to find a texture that would stand up to being banged and covered with graffiti, Dubuffet experimented with new materials, from ceramics, to foam and plastic resins, gradually learning about relief and volume, and eventually moving away from sculpture and into architecture.

FACING PAGE, LEFT
Personnage*
Ceramic
100 ×40 cm
May–June 1965
Private collection

FACING PAGE, RIGHT
Personnage de L'Hourloupe*
Vinyl on paper
100 × 40 cm
12 May 1965
Private collection

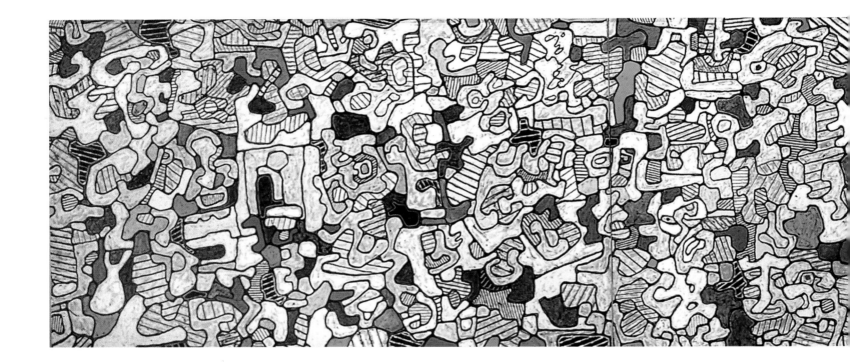

"Antonin Artaud once said to me: 'Charles Estienne, don't trust the Egyptian priest who comes back at night to pull your feet.' This dangerously mythological character quite obviously did not hail from the United Arab Republic, but from pharaonic Egypt with its secrets of the great pyramid for sale and for hire . . . I have therefore always given his warning its full due, and even more so today as I relate the peculiarity, the strangeness that I scent in Jean Dubuffet's current work. In fact, he is the one who provides us with a lead when he suggests that the representation he has summoned up concerning the theatre of his mind and his painting is to show 'things that do not exist', 'shifting errors and lures', and that he performs this task like an 'inebriated dancer' or a 'Chinese juggler'. Naturally. Juggler . . . of course, but a rather special breed. Let's take a good look at our juggler at work, as he pulls out of his highly imaginative hat all those joyful, ferocious, extravagant falsehoods. I can see him in his juggler's stage costume, hysterical and

carefully shaved, rouged but wearing a mask like an initiate who has decided to show himself like this in public, just on the off chance . . . But, in truth, nothing of what he shows exists . . . in truth. Is it just a sort of Russian ballet, mere aesthetic entertainment? No, and there's the rub. It's more a Chinese ballet, or a Tibetan ballet, with of course the show taking place not at the Champs-Elysées theatre, but in an ideal magical theatre of universal illusion. And that makes me think of something else that Antonin Artaud said. On being asked about Tibet, he is supposed to have replied: 'I can only answer such a question by screaming and stamping my feet.'

And this is precisely what happens here. From the seething movement in this immense painting, a series of fairly disquieting figures gradually appears, intent on chasing, threatening and fighting each other. There are about eighteen of them, I was told, but I was unable to check the number completely given that these

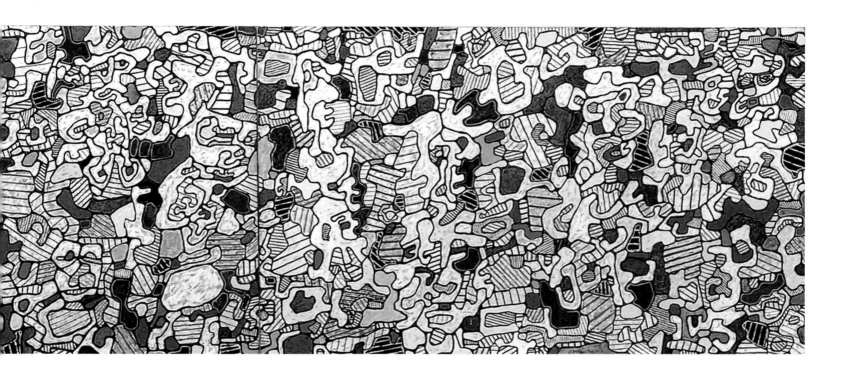

stage characters mischievously disappear into the background as soon as you have got hold of them, only to burst out once more when you look at the painting from the side, when your view of it is physically on the edge. These ghost-characters have no depth, they are not in the round, they are flat as playing cards, dry, stripped clean, pared back–despite their truculent grotesquery–and they fight silently and convulsively, yet they are awesomely present in the seething mosaic from which they come.

I am therefore unable to defend myself against not having 'seen it somewhere before', 'seen' so to speak as it took place in Tibet, a country I have never been to except in my dreams, so let's say that the exact location for this 'seen' is an area that is peculiar to what people 'believe they have seen'. One of the fundamental rites of Tibetan tantrism termed *chöd* involves giving a representation of 'shifting errors and lures', in short the 'things that do not exist', which is so powerful that the shaman believes in it and does

in fact see himself being beaten, lashed and dismembered by demons, by all that is Arbitrary and Fanciful coming out of his mind. Then, once he has recovered, he observes that it was nothing, no, really nothing, pure nothingness, the ghosts of a universal and constant illusion. And the only visible plastic trace remaining is what we decipher, now plain to view, on the painted Tibetan banners. No one will object to my thinking that Adolf Wölfli's masked demons and the figures in Jean Dubuffet's *Nunc Stans* relate to the same mental standard as the demons dancing *chöd* on Tibetan banners. Not at all the same, really, as the carnival in Nice or even the one in Basel."

Charles Estienne
(part of the presentation of *Nunc Stans* in the Galerie Jeanne Bucher, 1966)

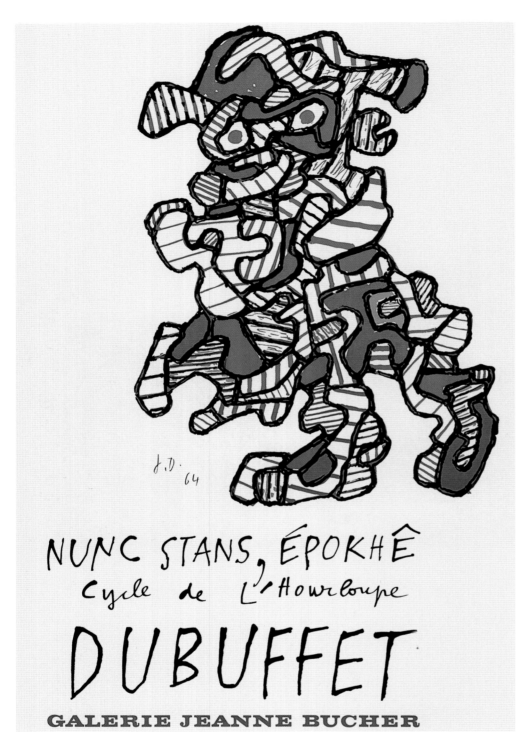

LEFT
Exhibition poster for
Dubuffet – Nunc Stans, Épokhê,
cycle de L'Hourloupe
Galerie Jeanne Bucher, Paris
7 April–May 1966

PAGES 27–35
Jean Dubuffet's working photograph
album documenting the different
stages in the making of
the two panels *Nunc Stans*
and *Épokhê*. Pages concerning
Épokhê, 10-16 April 1965.
Archives Fondation Dubuffet, Paris

$$\boxed{2^{\underline{e}} \ panneau}$$

Photo 1
10/4/65 – 10H30
1er volet
(à partir d'un fond
noir tracés gris)
(blanc + rouge + noir)

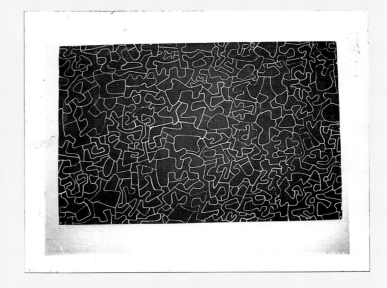

Photo 2
11/4/65 16H
remplissage blanc

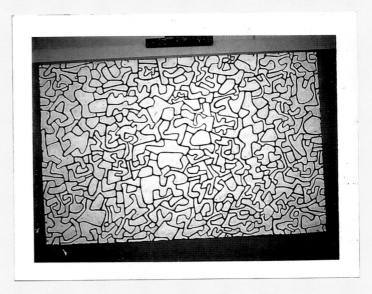

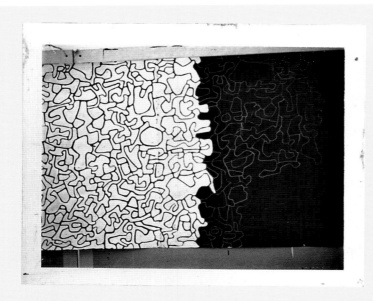

Photo 3

commencement du 2ᵉ volet
(liaison avec le volet 1)

Lundi 12/4/65 - 10ᴴ

les tracés gris sur le fond
noir sont commencés (et
à gauche un commencement de
remplissage en blanc pour
liaison avec le volet 1

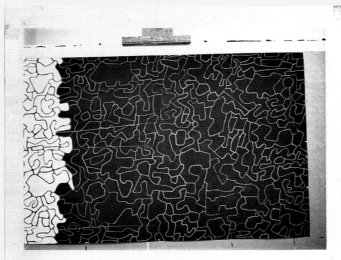

Photo 4

12/4/65 - 10ᴴ30

Volet 2

les tracés gris sur le fond
noir sont terminés

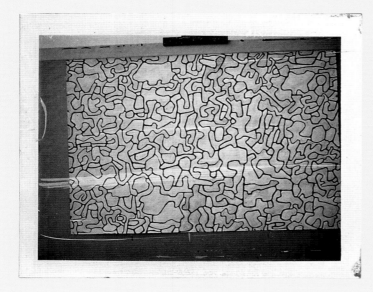

Photo 5

12/4/65 - 14ᴴ

Volet 2

opération de remplissage
en blanc

Photo 6

12/4/65 - 18H

3e volet

Tracés gris sur fond noir
(à gauche commencement
remplissage de blanc pour
liaison avec le Volet 2

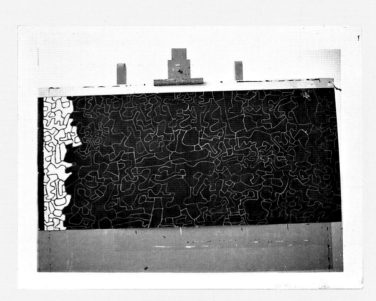

Photo 7

13/4/65 - 16H

3e volet

fin du travail de
remplissage de blanc

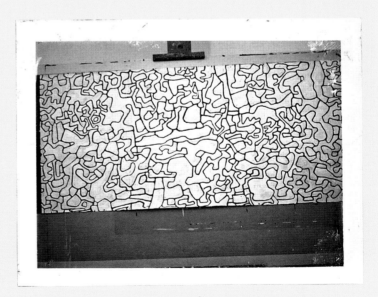

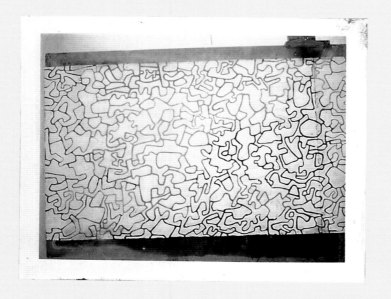

Photo N° 8
13/4/65 - 17ᴴ
Volet 1
travail avec blanc
pour simplification des
tracés

Photo N°9
14/4/65 - 10ʰ
3ᵉ volet
commencement du travail
de constitution des figures

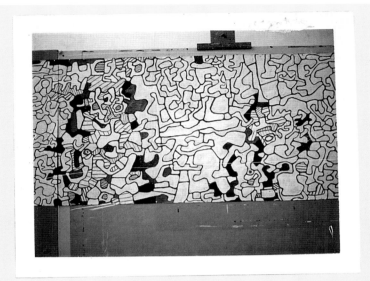

Photo N°10
14/4/65 - 12ʰ
3ᵉ volet

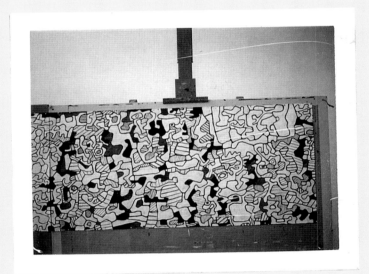

Photo N°11
14/4/65 - 15ʰ
3ᵉ volet

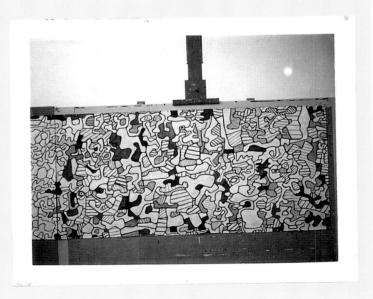

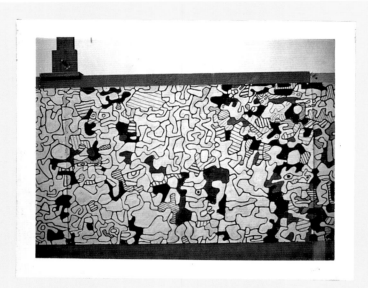

Photo 12
14/4/65 - soir
Volet 2

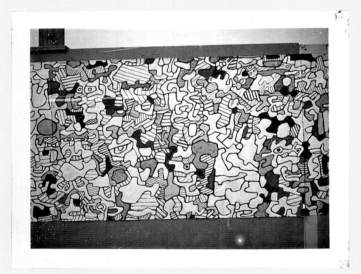

Photo 13
15/4/65 - 12ʰ
Volet 2

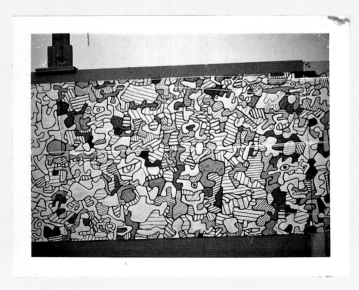

Photo 14
15/4/65 - 15ʰ
Volet 2

(après prise cette photo
viendra la très payante
opération de conformation
des traits (avec du noir
en les grossissant un peu)

Photo 15

15/4/65 - soir

à cheval volets 1 et 2
les traits ont été confirmés
au volet 2
et le volet 1 est commencé
(en allant de droite à gauche)

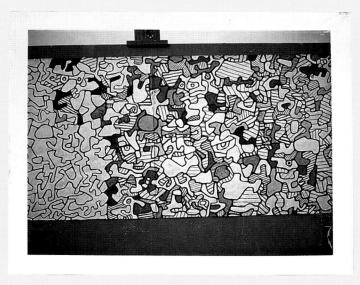

Photo 16
16/4/65 - 10ᴴ
Volet 1
Simplification des tracés

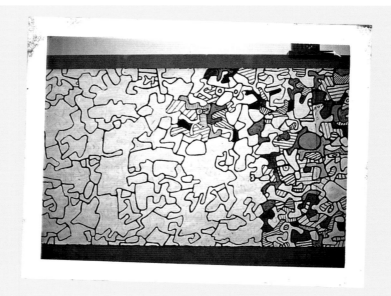

Photo 17
16/4/65 - 10ᴴ30
Volet 1
Remaniement des tracés

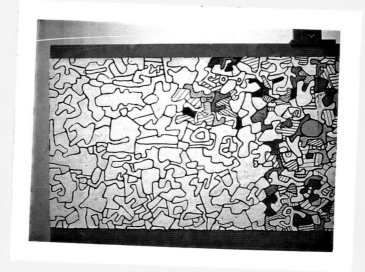

Photo 18
16/4/65 - 12ᴴ
Volet 1

colorations aires
bleues ⎫ et rayures
rouges ⎬
noires

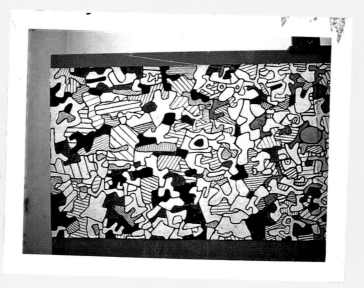

Photo 19
16/4/65 - 15ᴴ30
Volet 1
(reste à confirmer les
traits noirs)

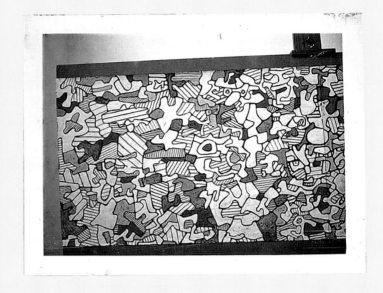

Photo 20
16/4/65 - 15ᴴ30
Volet 2-
(en de nombreuses aires
les rayures ont été effacées
pour faire place à du blanc
(afin de rendre ce volet
central plus homogène
aux volets 1 et 3

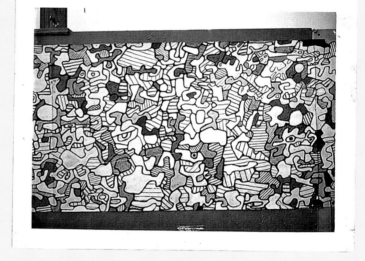

Photo 21
Volet 1
16/4/65 - 17ᴴ
Confirmation des traits

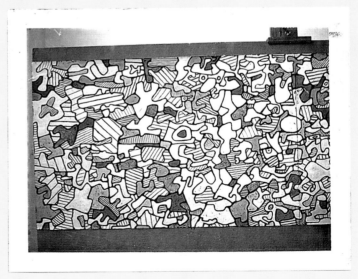

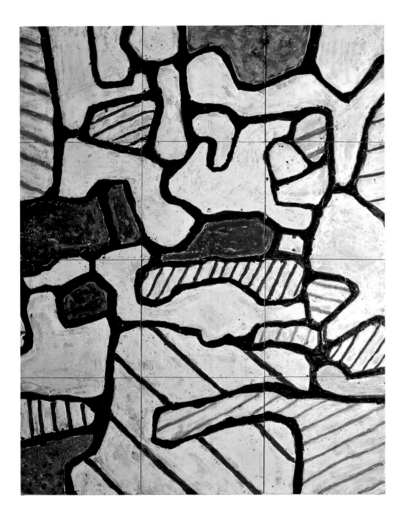

Ceramic trial for *Épokhê*
made by Eryk Nyholm
(12 tiles)
160 × 120 cm
September 1976
Fondation Dubuffet, Paris

N.B. another trial is in the
collections of the Henie Onstad
Kunstsenter, Høvikodden

The master copy of *Nunc Stans*, scaled up on to canvas 8.19 metres long, was bought by the Solomon R. Guggenheim Museum in New York. Dubuffet felt it had become the definitive work, as it was never transposed into ceramic. Then, in 1976, three years after Asger Jorn's death, Dubuffet gave his full and free permission to the town of Silkeborg to reproduce *Épokhê* as a ceramic mural work, transcribed by the Danish ceramicist Eryk Nyholm for the future museum to be built in the artist's honour.

The work started on 6 March 1976 following a visit from Troels Andersen, and was executed in one year from September 1976 to September 1977. The museum building was designed by Niels Frithiof Truelsen in 1979. Dubuffet's ceramic mural piece was installed for its inauguration.

After meeting Troels Andersen, the museum's curator, for the first time, Dubuffet wrote to him ten days later on 16 March 1976:
"You write in your letter that the project involves a ceramic relief being installed inside the building, whereas I understood when we talked that it would be outside. I think an outside wall would be better.

But if I understand correctly, the plans for the building have not as yet been drawn up, nor even designed. I think that before going any further with this large project, the building plans should be drawn up, with a specific location for the ceramic piece."

A far cry from the lengthy meanderings of the Nanterre project, Troels Andersen replied on 14 September: "Here we have just finished the trials for your ceramic relief *Épokhê*. They were carried out by Eryk Nyholm, who visited the Henie Onstad museum and took notes on the painting, and the museum also sent us photos. . . . The Henie Onstad museum is in principle willing to lend us the painting for a period while work is going on, and we have also found a ceramic studio ready to do the definitive execution of the piece."

A long letter from Eryk Nyholm dated 18 October details this procedure to Jean Dubuffet:
"So far, we have not been able to borrow the painting for the mural piece which is in the Henie Onstad museum in Oslo. So this summer I visited the museum there. I spent a long time looking at your work, and made the following observations: all the areas in the painting seem

to have a dark background covered with a lighter colour (the backgrounds are often reminiscent of coloured chalk drawings on a blackboard). The charcoal grey and the pinkish grey are the most dappled, the most material. The yellows stand out – cadmium – lemon – pale yellow. Certain bluish-green areas are painted in a colour that in this country is used for ships. The dark red is like Italian Pompeii red with purpurin. The red and blue stripes are in light colours. In the large light blue areas, one can clearly see that dark blue has been painted over a lighter blue. In a section in the middle of the painting, the blue areas become much darker; the same goes for the charcoal grey areas, which become almost black. This technique and the changing values inspire me greatly when I think of the painting being transposed into a large-scale ceramic work. . . .

When a small museum in a small town in a small country decides to do something new and great, the economy plays a certain part. We have given this a lot of thought, and have found an efficient, safe and inexpensive method. By using prefabricated tiles 40 centimetres square (2 centimetres thick) for the ceramic image, we obtain a material that can be easily cemented and that will stand up to the northern climate. As it is an outside wall, the glazes applied must be fired between 1250–1300°. The glazes can be applied quite roughly, brilliant or matt etc. as you wish. . . . For the definitive firing of the whole relief, it would be too complicated to use my workshop. But near Silkeborg, two quite young ceramicists have set up a large new workshop with plenty of space and modern equipment. Moreover, they are both highly skilled technicians, with a great understanding and love of their work. In their workshop it would be possible to do the definitive firing of the whole relief under my direction. It is in the nature of things that when a painting is scaled up by ten for a ceramic work, a lot is left to interpretation, which I regard as a very rewarding opportunity – for this reason I am very much looking forward to our meeting on 26 October."

In a letter to Troels Andersen (28 December 1976), after seeing the first panel, Dubuffet writes how fully appreciative he is of the work accomplished in Silkeborg: "I was filled with wonder at the ceramic panel M. Nyholm has already done, and what you showed me."

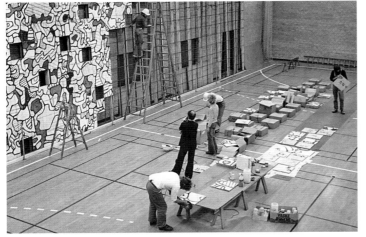

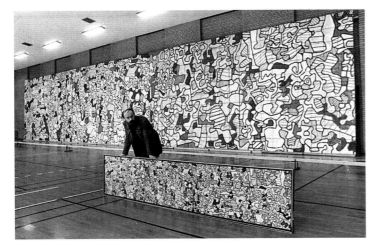

23 September 1977

Troels Andersen announces to Jean Dubuffet that the mural piece will soon be finished and will be on show briefly before the museum opens: "Now that work on the relief is being completed, we have found a room in Silkeborg that is big enough to show it in its entirety. The relief will be installed for a few days from 18 October to 23 October. (The room in the local school will be closed during this period.)"

On receiving, in September 1981, photographs of the ceramic relief definitively installed on the new museum building (this was inaugurated in March the following year), Jean Dubuffet wrote to Troels Andersen: "Well done for the ceramic, seeing it installed makes me very happy, and I think the effect is superb. With the snow, it will look great."

TOP
The *Épokhê* ceramic
being made
Denmark, 1977

CENTRE AND BOTTOM
Temporary presentation
of the *Épokhê* ceramic
in the Norrevang school
gymnasium, Silkeborg
18–23 October 1977

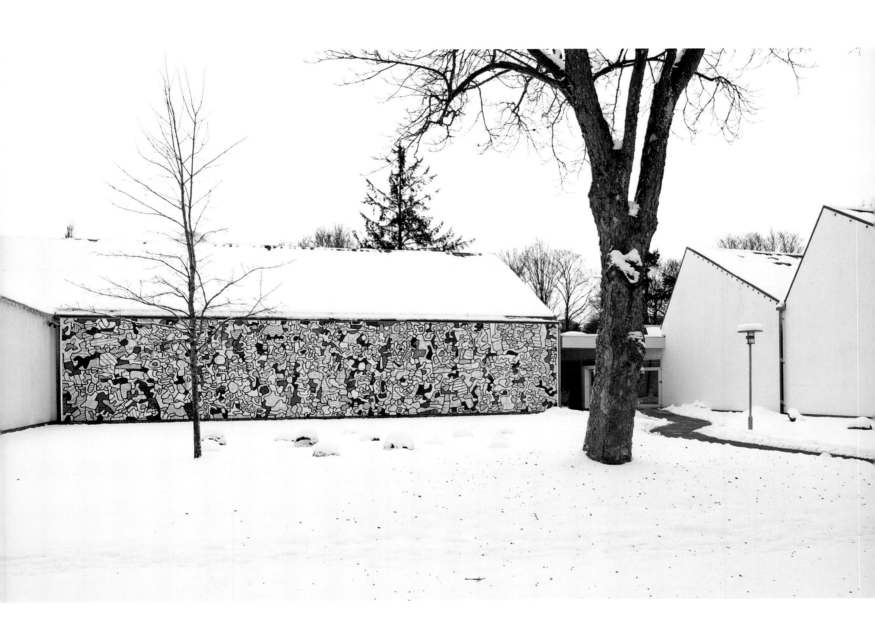

Épokhê*
Ceramic
4.50 × 22.5 m
6 June–9 September 1977
Museum Jorn,
Silkeborg, Denmark

From Painting to Sculpture

It is likely that the nine months Dubuffet spent reflecting on the commission for the School of Humanities in Nanterre and his relations with the building departments and the ceramicist led him to think of architecture as not merely a frame for the action, as in *Paris Circus*, but as the actual subject itself.

It was only after he abandoned this ceramic mural project that architectural elements become a part of the world inventory that *L'Hourloupe* was systematically carrying out at the time. On 21 March 1966, a first drawing entitled *Demeure* paved the way for a series of felt-pen drawings; these increased in number, soon turning into paintings with different attributes ("with threshold and chimney" on 25 March, "with wings to the side" on the 28th, "with stairs and many bedrooms" on 8 April). Then it was stairs, resembling mille-feuille pastry, showing the artist's inventiveness more than anything else, as the element repeated is never identical from one line to another, even though nothing resembles one step more than the one before and the one after.

Although the *Demeures* adhere to the principles governing the creation of *L'Hourloupe* whereby more recognisable elements – entrance steps, threshold, stairs – are enclosed within a complex composition, the ambiguity with which they can be read meant that the *Réchauds fours à gaz* and the *Autoportraits* succeeded each other in an illogical yet utterly obvious way, whereas the *Villas* that followed (on 17 and 18 April 1966) with their jigsaw outlines assert on the contrary a desire to evoke an immediate image of bourgeois residences, elegant follies in the suburbs or by the sea, cousins of the houses in Étaples which in summer 1964 had filled the *L'Hourloupe* paintings with their carved friezes and TV aerials.

In order to materialize the idea of "paintings expanded in space" that the idea of architecture naturally brings to mind, Dubuffet discovered a material that was satisfyingly easy to use: expanded polystyrene. The compact white foam, a petro-chemical product, in everyday use as packaging for fragile items (televisions and other household goods), was not a likely material for use in sculpture. For Dubuffet, it had the advantage of being light – a few dozen grams per cubic metre – and so requiring no assistant to manipulate it. Further, the negligible cost and the lack of resistance when cut or sculpted meant that it was open to experimentation. Lastly, but no doubt not the least in Dubuffet's eyes, the fact that expanded polystyrene was an ordinary industrial material, far removed from the bronzes and marbles that had fashioned the history of sculpture, a material that had no references and no past, opened all avenues of research for him. It had only attracted the interest of a few young artists, with whom he quickly made contact.

On 24 July 1966, he started making his first painted volumes, introducing relief on to the surface of a foam block, and then "historiating" it with lines of colour in vinyl paint. His first attempts (*Le Domino* on 24 July, *Scène au hanap* on the 26th, *Scène au loup* on the 28th, *L'Inca* on the 29th and *La famille* on 30 July) are reminiscent in their approach to the tests Roland Brice carried out for *Le lampeur* and *L'horloger*. But unlike for the ceramics, there was no intermediary, it was the painter who decided, in the instant, as he worked, what the reliefs would be. From 1 August to 3 September, in his summer quarters in Le Touquet, where he had had a studio since 1962, Dubuffet went back

BELOW, LEFT
Demeure*
Marker on paper
27 × 21 cm
26 March 1966
Fondation Dubuffet, Paris

BELOW, CENTRE
Demeure*
Marker on paper
27 × 21 cm
28 March 1966
Fondation Dubuffet, Paris

BELOW, RIGHT
Demeure*
Marker on paper
27 × 21 cm
21 March 1966
Fondation Dubuffet, Paris

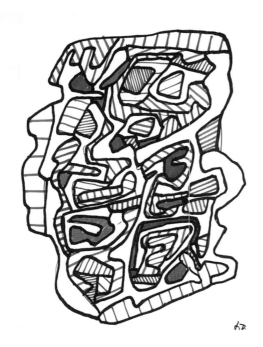

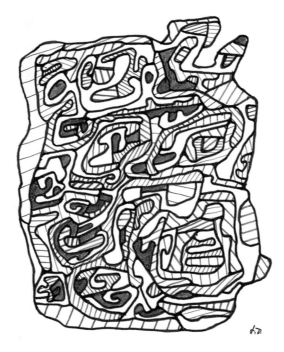

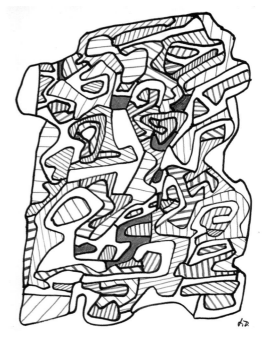

FACING PAGE
Réchaud-four à gaz*
Marker and pencil
on paper
27 × 21 cm
18 March 1966
Centre Pompidou,
Musée national
d'Art moderne, Paris

RIGHT
Demeure*
Marker on paper
27 × 20 cm
27 March 1966
Fondation Dubuffet, Paris

FAR RIGHT
**Demeure (aux escaliers
et perron d'entrée)***
Marker on paper
27 × 21 cm
30 March 1966
Fondation Dubuffet, Paris

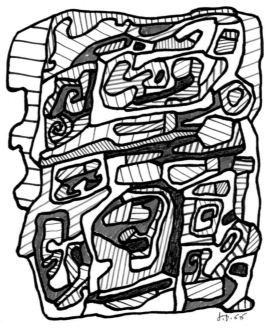

ABOVE
Escalier*
Marker and vinyl on paper
41.5 × 28 cm
11 April 1967
Fondation Dubuffet, Paris

FACING PAGE
Demeure VI*
Vinyl on canvas
162 × 130 cm
18 May 1967
Nasjonalmuseet for kunst,
arkitektur og design/The National
Museum of Art, Architecture
and Design, Oslo (Norway)

to the *Peintures monumentées* (*Théière et Tasse de thé I* and *II*, the latter, painted on both front and reverse sides, being the first he intended for a situation in space). Pleased with his new discovery, Dubuffet went naturally from felt-pen drawings on paper – a modest memorial celebrating everyday life: afternoon tea on holiday – to reliefs where the same themes, eluding the flatness of paper, changed scale. The new method of working meant that his "monumented paintings" had no model; there was no preparatory drawing for them. They in fact became a natural part, like the paintings, of work underway, a formal variation on the drawings. It even happened, as with *Le verre d'eau I*, that the sculpture version (made 21 October 1966) preceded the series of drawings done between 17 November 1966 to 11 January 1967, and that the second relief of *Le verre d'eau II* (3 December 1966) came before the paintings done in January and February 1967.

The last of the pieces to be made during this stay in Le Touquet, on 30 August and 1 September 1966, before returning to Paris on 3 September, were the first two *Bornes* (Milestones), which marked a major departure in his work. The first, initially called *Borne sur le chemin de l'Hourloupe* before becoming *Borne au logos*, was Dubuffet's first painting in volume. A painter and not a sculptor, he further developed the idea of the *Tasse à thé II* and the double-sided reading of it, this time giving the sides of the piece the same thickness and painting them, making a sort of four-sided painting. For the second *Borne*, he noted in his *Journal des Travaux*: "The block is sculpted only along the edges and the drawing is done in an elliptic way."

Back in Paris, then in Vence, he made more sculptures (eight in September, twelve in October). A letter sent from Vence on 24 October 1966 to Gérard Singer, who had been working with polystyrene for several years and happened to be a neighbour of Dubuffet's in the rue Vaugirard, sheds light on the developments in his work on form: "I have made considerable use of the tools you so obligingly lent me – I mean one of them, the straight one – which I tried to have copied by an electrician in Vence, who managed more or less to make a similar instrument, but not as convenient by far, much more complicated to use. I have been working assiduously on my painted polystyrene sculptures during this month's stay in Vence." The tool – of which he obtained "a perfect copy" in Paris (letter to Gérard Singer dated

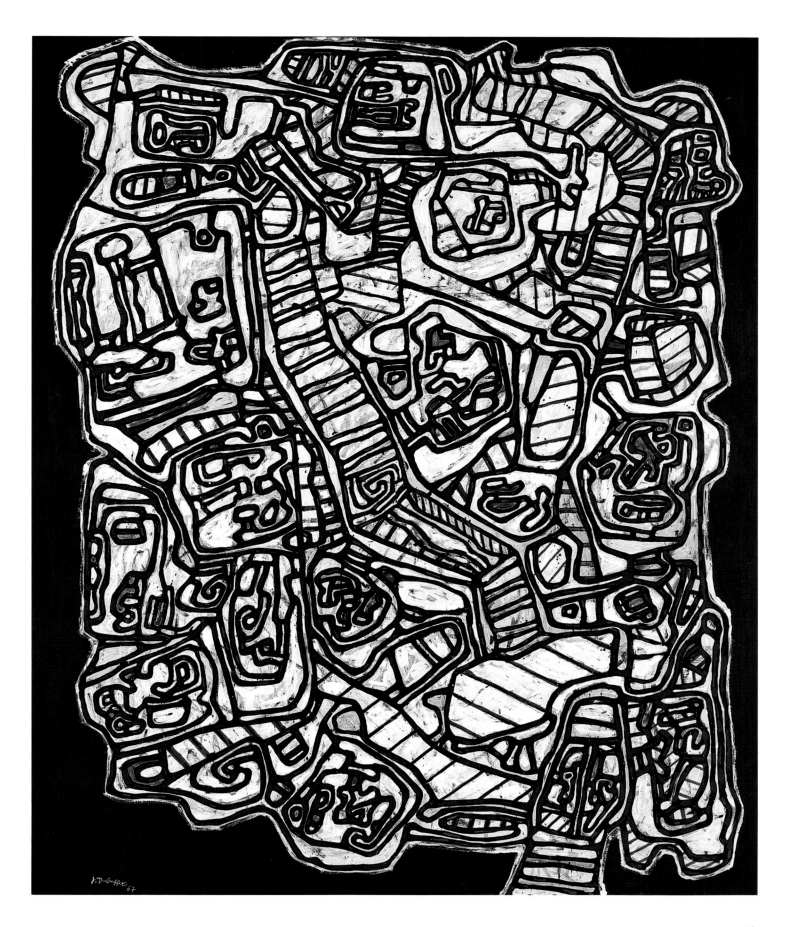

ABOVE
Villa 1*
Marker on paper
27 × 21 cm
17 April 1966
Fondation Dubuffet, Paris

FACING PAGE
Borne au Logos II*
Transfert on polyester
100 × 50 × 50 cm
1 September 1966
Fondation Dubuffet, Paris

4 November 1966) – was a cutting wire, as for cheese, heated by an electrical resistance. The hot wire cut through the polystyrene smoothly without the foam crumbling.

As the number of works increased and he began to master volume – the *Borne au logos VII* (10 October 1966) has nothing in common with the rudimentary character of the first piece in the series – technical issues arose. He acknowledged the many advantages of polystyrene, its lightness and ease of carving, but not being designed to last, it aged badly. It was fragile, any impact dented it, and moreover, it had a natural tendency to disintegrate. The solution called for was to transpose the sculptures into a long-lasting material whilst retaining polystyrene for its ease of use. Thinking of the transcriptions Roland Brice had done for the Nanterre project, Dubuffet looked for another ceramicist. Serge Gauthier, the director of the Manufacture de Sèvres, told him of Jean-André Cante, who taught at the École des Arts Appliqués: "I think I have the right firing," Gauthier wrote to him on 21 November 1966, "Monsieur Cante, the teacher at the Arts Appliqués, is doing some tests from polystyrene and has a small team working on a technique that will interest you; he would be very happy to work with you, and he told me on the phone that he likes your work."

On 30 November, Dubuffet replied to Serge Gauthier in anticipation of meeting Cante: "I understood, however, that Monsieur Cante is thinking of moulding my objects with a view to reproducing them not in ceramic, but in polystyrene or other similar materials. This is what seems to particularly interest him rather than ceramic." Dubuffet seems to have been very attached to the latter solution, adding: "However, this wouldn't prevent tests in ceramic being done, maybe at the same time." Dubuffet was worried about the transfer problems and had also sought other technical advice. He continued: "The first step in these various trials is to find the right varnish that will enable me to mould the originals without spoiling them. A study is underway and nearly completed; a trial will be carried out over the next few days, which, I think, is almost bound to be successful."

After Cante's visit on 11 December, a long letter to him shows the extreme care and precision Dubuffet paid to the technical issues. For his monumental works, he oversaw all the technical details of construction with the contractor:

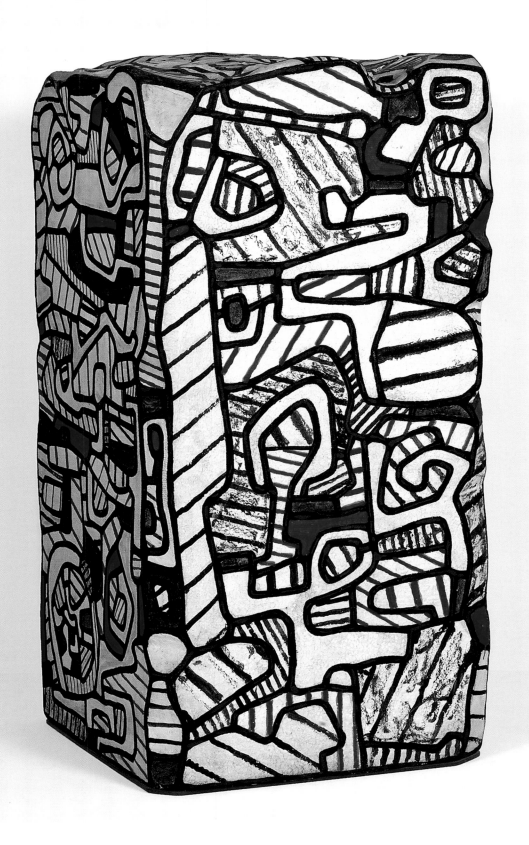

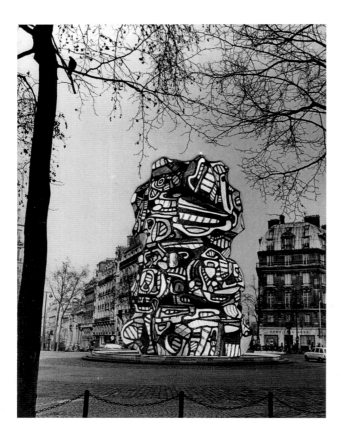

"Here are the details from M. Edouard Adam [then the largest artists' supplies distributor in Paris and a noted technical expert] concerning the two-part varnishing test you saw in my studio which was carried out by him on a polystyrene board that I painted with Flashe paint.

Part of the board received 1°/ 2 coats of Rhodopas 5.425 (applied with a paintbrush) and 2°/ 3 coats of polyester varnish. As you noted, the polyester varnish went through the Rhodopas and attacked the polystyrene; this test is therefore negative.

The other part of the board received 1°/ as previously, 2 coats of Rhodopas 5.425 (applied with a paintbrush) and 2°/ 3 coats of acrylic varnish (diluted with benzene) that were sprayed on. The result is satisfying. When we examined it the day before yesterday, we thought we could see a very slight deterioration in the surface of the polystyrene; but I have examined it carefully since and think this was a mistake, and that in fact there is no deterioration, at least not visibly.

After this, an unmoulding agent will be needed as a plaster (or other material) mould will be made. M. Edouard Adam recommends using a fine coat of vaseline oil which is easily removed with a cloth once the mould is made. However, we need to be sure that the vaseline oil will not penetrate the varnish; it will have to be tested.

I wonder if the acrylic varnish underneath the Rhodopas 5.425 is entirely necessary. Maybe the two coats of Rhodopas 5.425 will be sufficient protection in themselves, without needing to have another coat on top.

M. Edouard Adam is aware of your research and is expecting you; he is ready to carry out any testing with you.

Of course I only spoke to M. Edouard Adam of the moulds, and not the idea of combining it with paint transfers, as you asked me not to leak your research in this area. . . .

Moreover, so that the research can proceed methodically, I think it is a good idea not to link the two procedures – just moulding, and moulding with transfer. It would be better first to carry out the simpler of the two, the straightforward moulding, and have an exact polyester replica that I will then paint (or get an assistant to paint) according to the model. In that case, which is likely, should the polyester material not be as white as the polystyrene, we will give it a coating of white before it is painted. But the polyester copy must be complete, with its six sides. As the subjects are in low relief, a background is necessary."

The method advocated by Cante not only enabled the form of the sculptures to be moulded, but also allowed the painted parts to be mechanically transferred. Dubuffet soon realized the significance of this procedure and asked him to make the original polyester copies, which were then shown in the Pace Gallery in New York in April 1968 and the Galerie Jeanne Bucher in Paris in December. Cante's process did away with any outside intervention as regards the painting of the sculptures, but had the disadvantage of the polystyrene original being destroyed during the transfer process, which in turn produced another single copy. This was the technique used for *Mur bleu* (1967), a seminal work 3.5 metres high and 7 metres long, which assembled nineteen sculpted and painted panels, achieving what had been the

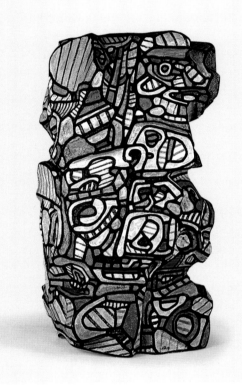 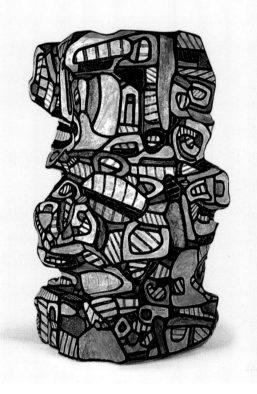 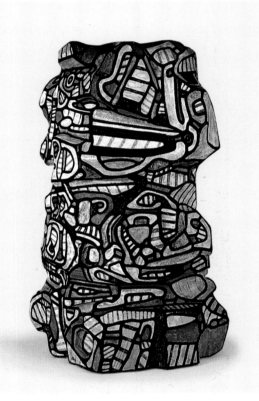

ABOVE, FROM LEFT TO RIGHT
Tour aux figures (maquette)
Transfert on polyester
100 × 50 × 50 cm
18 July 1967
Fondation Dubuffet, Paris

BELOW LEFT

Le Gastrovolve
(third maquette
for the inside of
the *Tour aux figures*)
Epoxy resin
80 × 50 × 50 cm
July 1968
Fondation Dubuffet, Paris

BELOW CENTRE AND RIGHT

L'Aérogire
(second maquette
for the inside of
the *Tour aux figures*)
Transfert on polyester
80 × 50 × 50 cm
June 1968
Fondation Dubuffet, Paris

FACING PAGE

Tour aux figures
Painted epoxy resin
over concrete structure
Height: 24 m
1985-1988,
from the maquette dated 1967
Commissied by the Ministère de la
Culture et de la Communication (C.N.A.P.)
Parc de l'île Saint-Germain,
Issy-les-Moulineaux

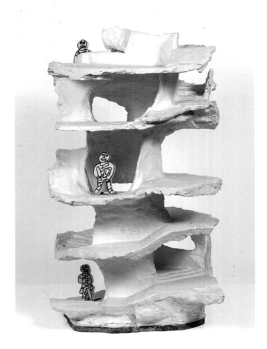 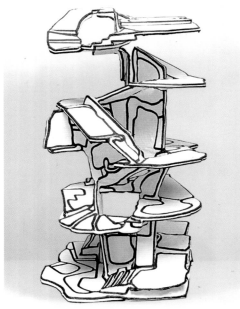 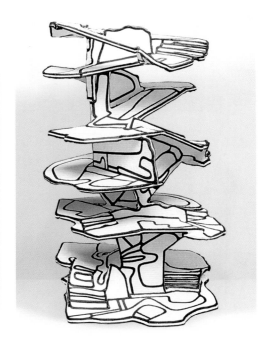

"May I say that this tower was not designed with a view to providing housing in a form
that is currently in use in our habitations, as any cumbersome facilities such as kitchen
and bathroom etc. have been done away with. Neither is any furniture intended; nor chairs,
beds and tables apart from those which are offered by certain opportune protuberances
in the uneven configuration of the ground. The advantage is that without having to move
anything the entire house can be cleaned at any moment, with a fire hose. However,
one is forced into a life without belongings. Anyone using this abode, if neither unmarried
nor disposed to a hermit's existence, would therefore have to use it only occasionally
as a place for retreat and reverie. For want of any other luxury, the user will enjoy an
exceptional profusion of space in which to move freely about without going through doors.
And with the pleasure of a habitat that climbs, as for mountain goats."

Jean Dubuffet, *Tour aux figures*, in *Édifices*, 1968.

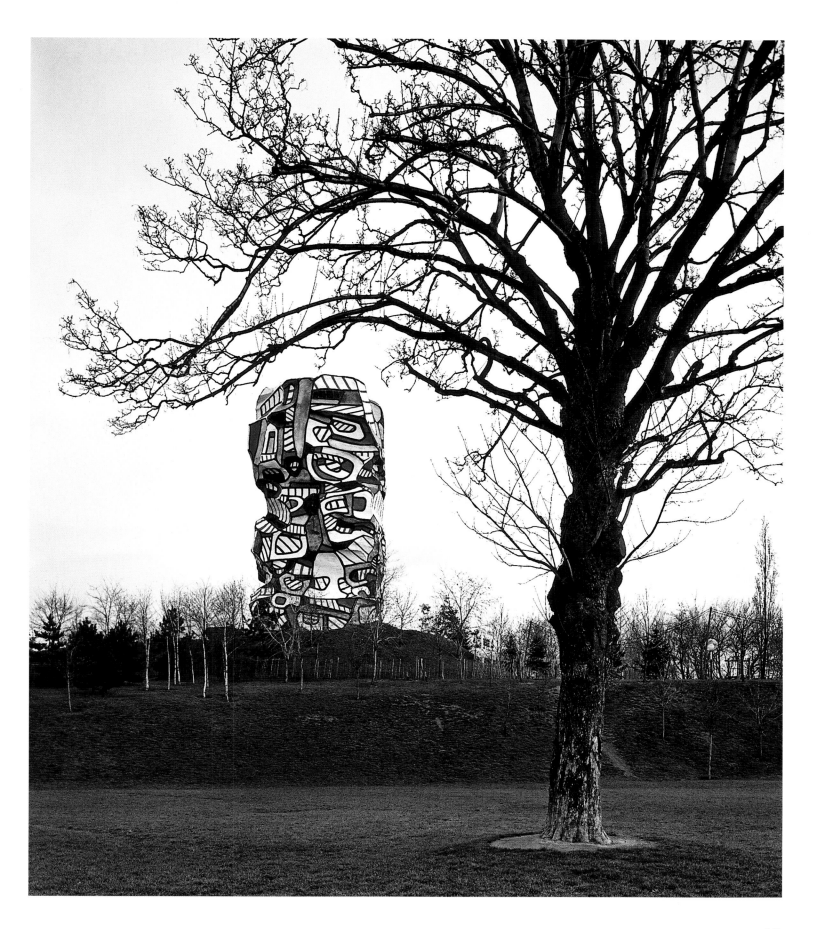

RIGHT, TOP
***Élément bleu XI
(maquette pour
un petit hôtel particulier)***
Transfert on polyester
50 × 46 × 10 cm
28 June–2 July 1967
Fondation Dubuffet, Paris

RIGHT, BOTTOM
***Élément bleu XI
(maquette pour
un petit hôtel particulier)***
Photomontage

FACING PAGE, TOP LEFT
Château bleu (maquette)
Transfert on polyester
100 × 70 × 46 cm
2 August 1967
Fondation Dubuffet, Paris

FACING PAGE, BOTTOM LEFT
Château bleu
Photomontage

FACING PAGE, FAR RIGHT
Maison (façade d'apparat)
Marker (black)
on paper (cut out and
glued on to kraft paper)
30 × 21 cm
15 August 1970
Fondation Dubuffet, Paris

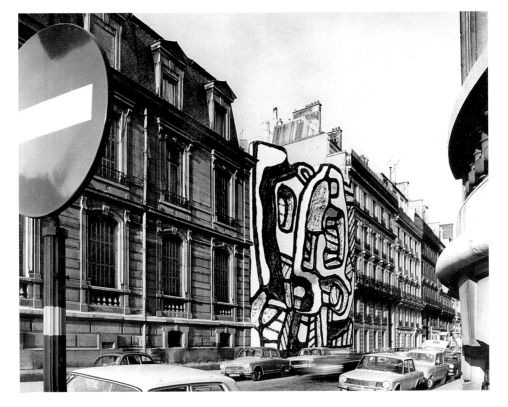

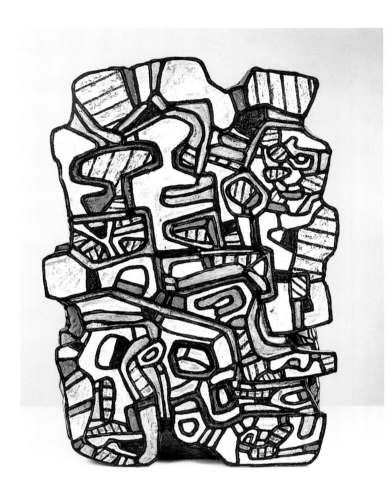

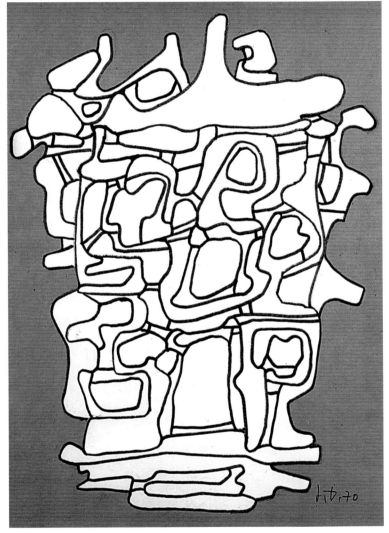

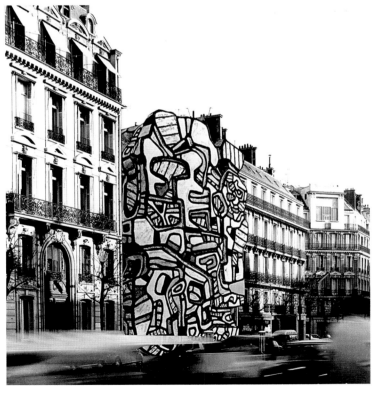

RIGHT
Villa Duplex II
Marker (black) on paper
(with yellow kraft paper
and letter paper glued
on to beige kraft paper)
36.5 × 21 cm
16 August 1970
Fondation Dubuffet, Paris

FACING PAGE
Villa Trapèze
Marker (black) on paper
(cut out and glued on
kraft paper with tracing
paper added and glued)
33 × 39 cm
15 August 1970
Fondation Dubuffet, Paris

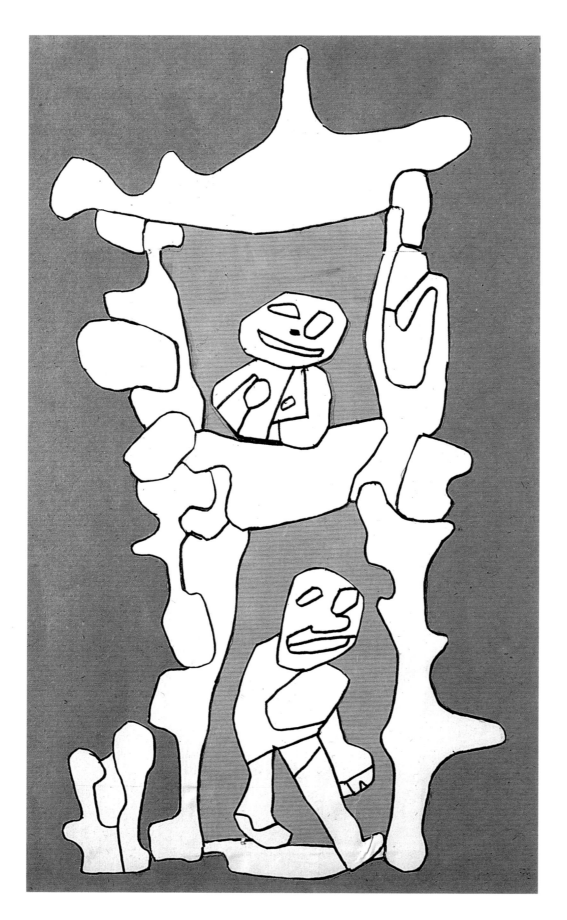

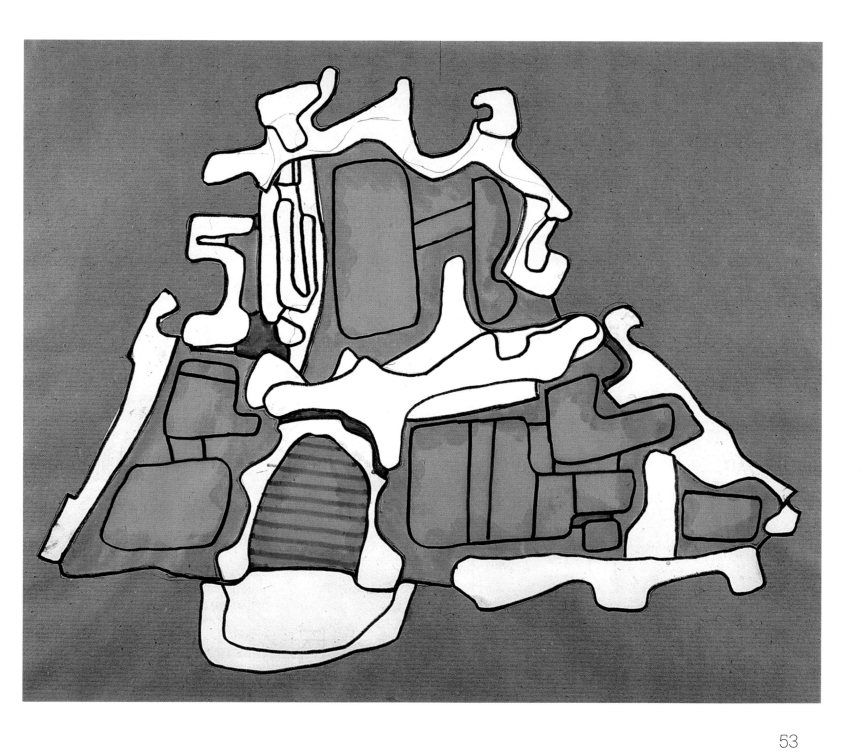

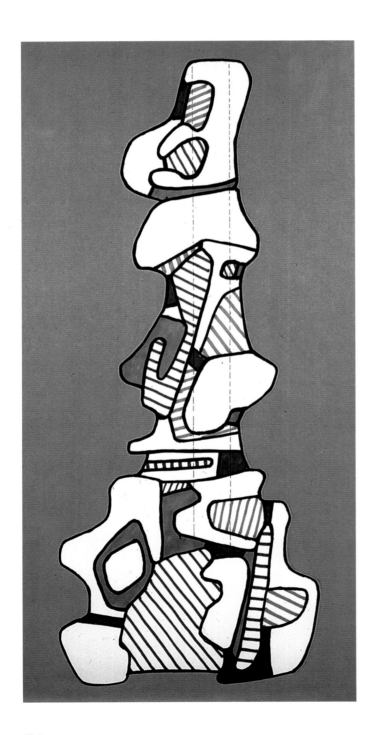

painter's ambition for *Nunc Stans* and *Épokhê*. Furthermore, by adding the *Personnage au calot*, and subsequently the *Siégeant* and the *Meuble au tiroir en position angulaire*, to the initial sixteen elements in blue, Dubuffet moved into the third dimension, seizing physical space, so that in a way this wall piece was his first approach of the enclosed space that came into being with the *Cabinet logologique*, while also laying the foundations for the *Édifices*.

At the same time, Dubuffet, anxious to preserve the polystyrene sculptures, asked Robert Haligon, who had just made Niki de Saint-Phalle's *Nanas* in polyester for *Le Paradis fantastique* at Expo 67 in Montreal, to make the moulds for them and then the polyester or epoxy resin casts. This made it possible to produce editions of the work to the same specifications as for traditional bronze sculpture. The painter then only needed to get his assistants to manually transfer the lines and colours onto the casts painted in white.

However, the main contribution of Haligon's workshops, which had specialized in enlarging sculptures since Rodin's time, was that Dubuffet discovered the pantograph. This machine, which could produce a precise enlarged copy of a model, gave Dubuffet access to the monumental dimension, a whole other approach to sculpture.

Chaufferie avec cheminée
Draft for the *Villa Falbala*
boiler room project.
Marker on paper (cut out
and glued on to kraft paper)
61 × 30 cm
12 September 1970
Fondation Dubuffet, Paris

La seringue and the *Pavillon à deux étages*
Photomontage

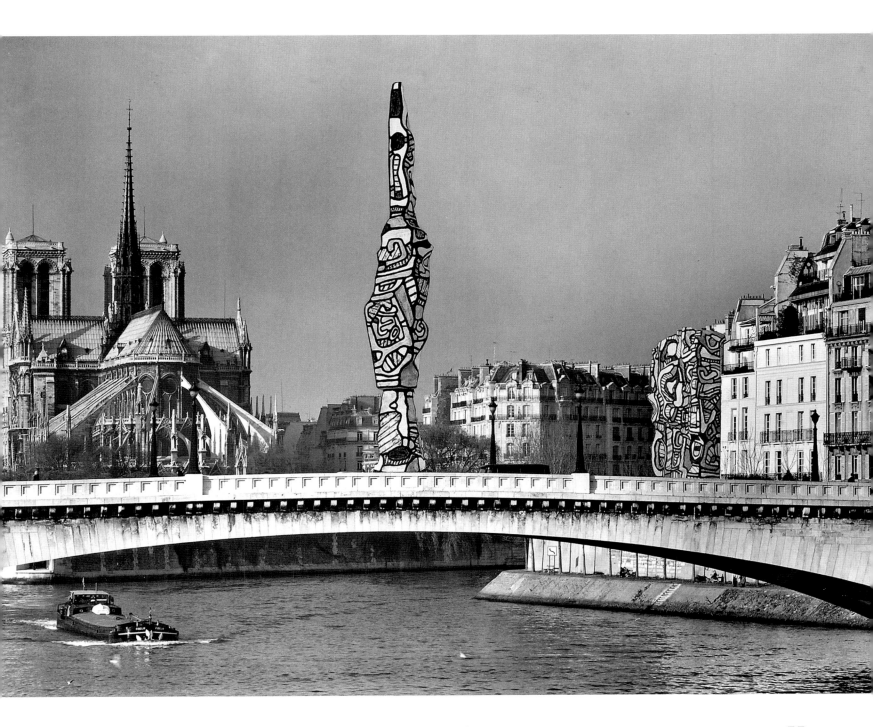

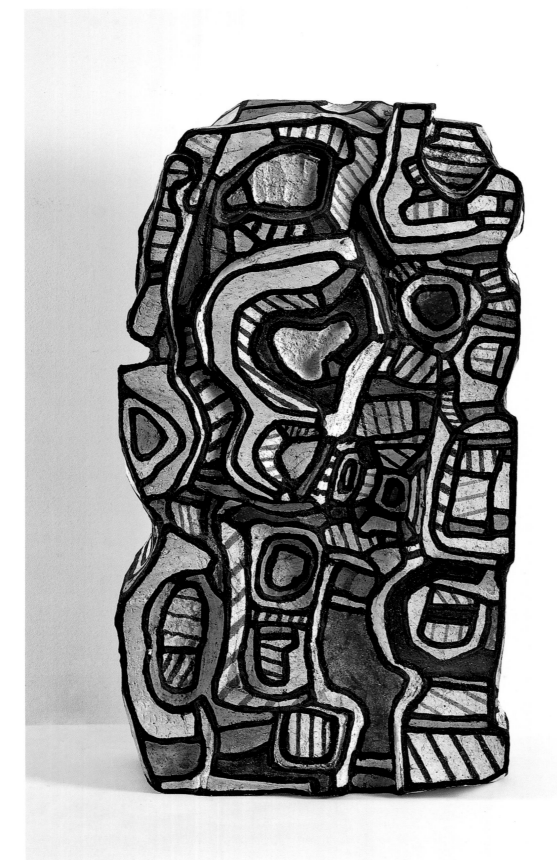

Pavillon à deux étages
(maquette)
Transfer on polyester
85 × 47 × 23 cm
8 August 1967
Fondation Dubuffet, Paris

Pavillon à deux étages
Photomontage

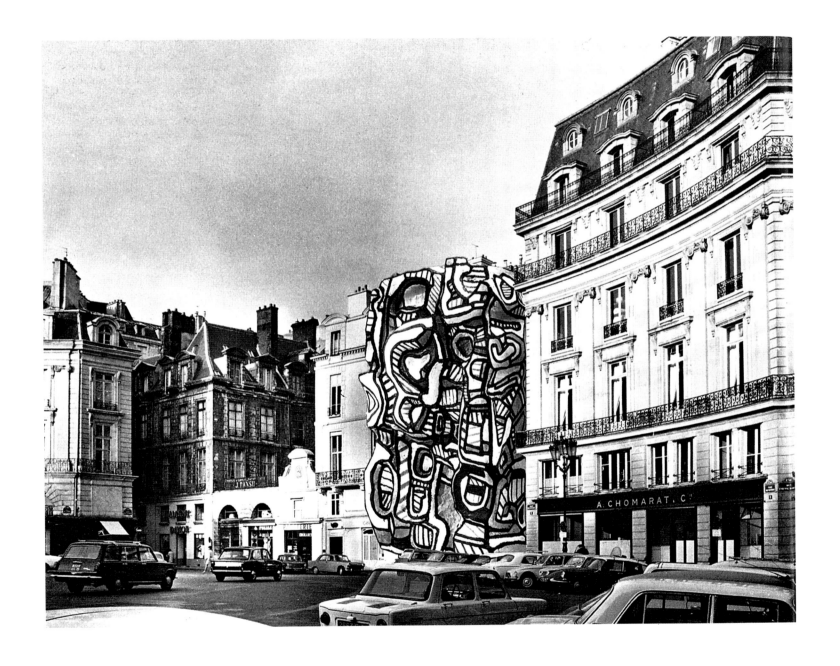

"The set of *Éléments bleus* made in polystyrene in June and July 1967 was undertaken with a view to forming
an entire room at some later date, and for now must be considered as unfinished. In October 1967, it included
around twenty separate elements of various dimensions (200 × 100, 100 × 100, etc.). When all of them were thus
grouped together, they were about 5 metres in length and 3.6 metres high. I then intended to have the separate
elements cast in polyester, so in the final installation they could be put into their places in the walls in such a
way that would enable me to continue them and unite them using lines and paintings as linking elements. […]
however, I grew attached to each of the elements when taken separately and erected vertically on a plinth. I
consequently took the decision to make a moulded replica of each of them which I would then paint so it was
identical to the original, and at the same time make a polyester cast. I could therefore have the elements
as separate subjects, and moreover be able to unite them all in the way I had first imagined.
As yet, I know neither what nor where this room will be."

Jean Dubuffet, June 1968.

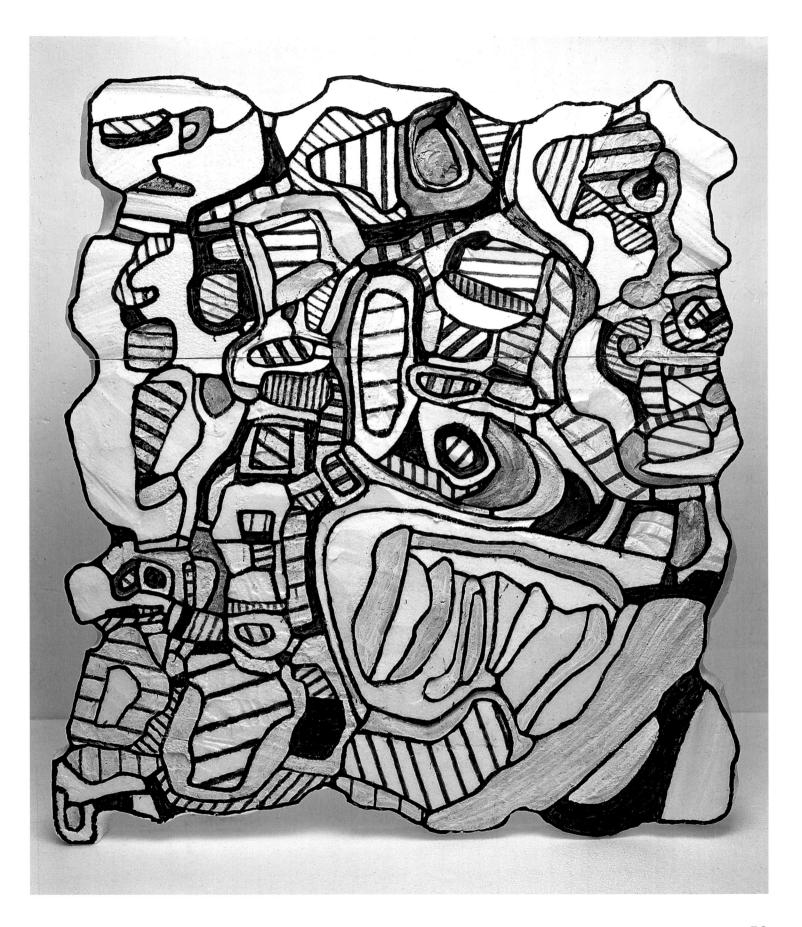

BELOW AND FACING PAGE
Jean Dubuffet working on
"elements" for the *Mur bleu*
in his rue de Vaugirard studios
Paris, June 1967

FOLLOWING DOUBLE PAGE
Le Mur bleu
Polyester with polyurethane paint
350 × 700 cm
June–July 1967
Collection Renault, Boulogne-Billancourt

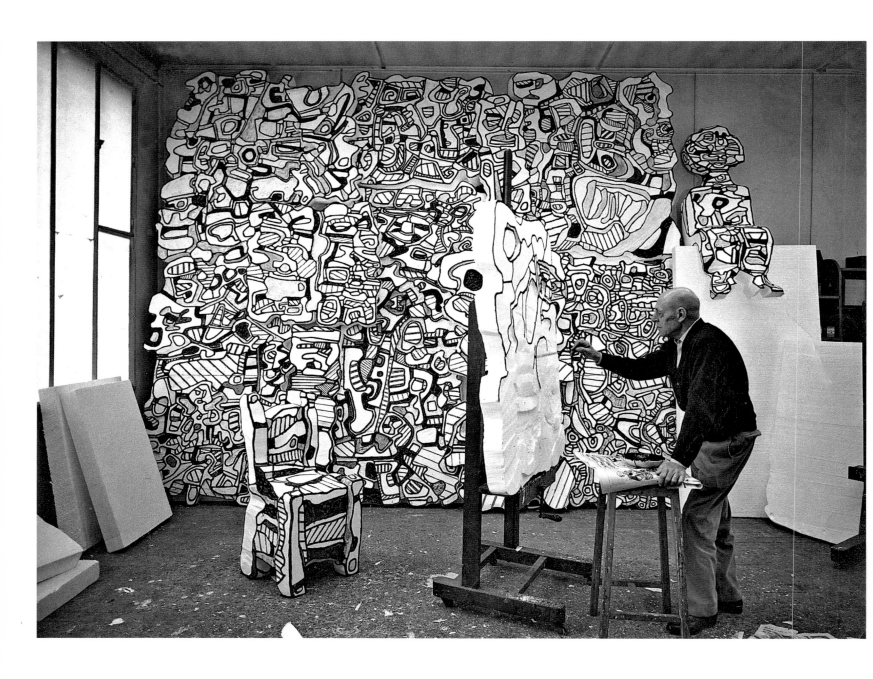

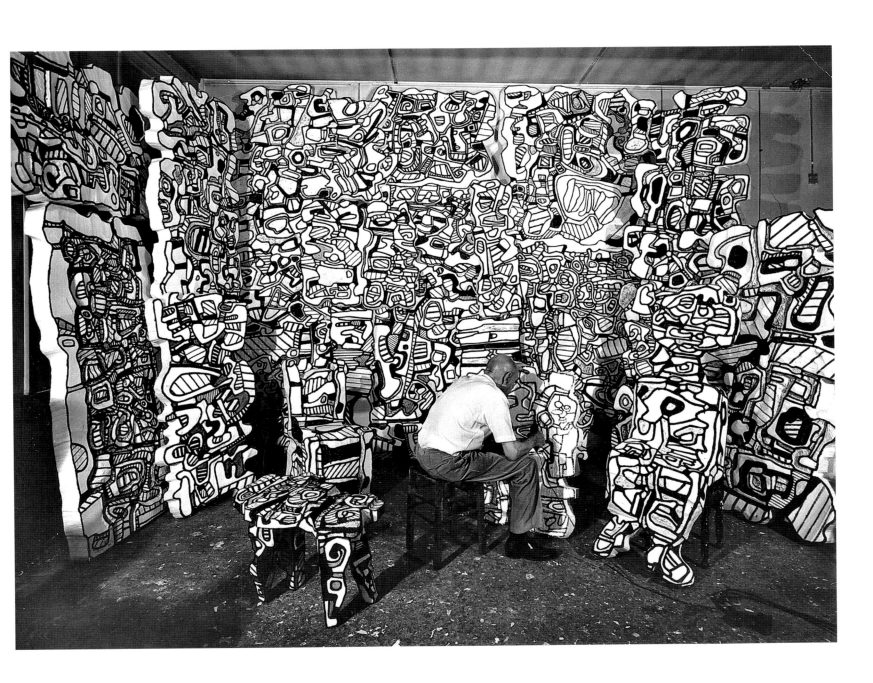

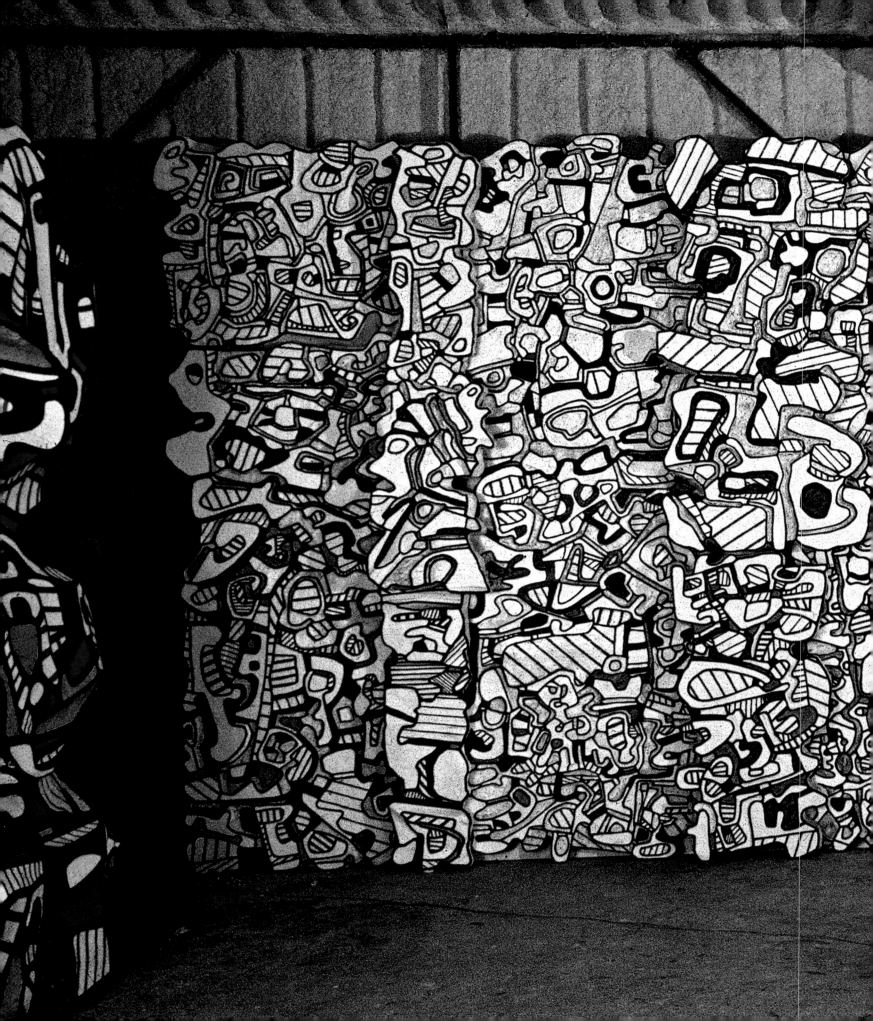

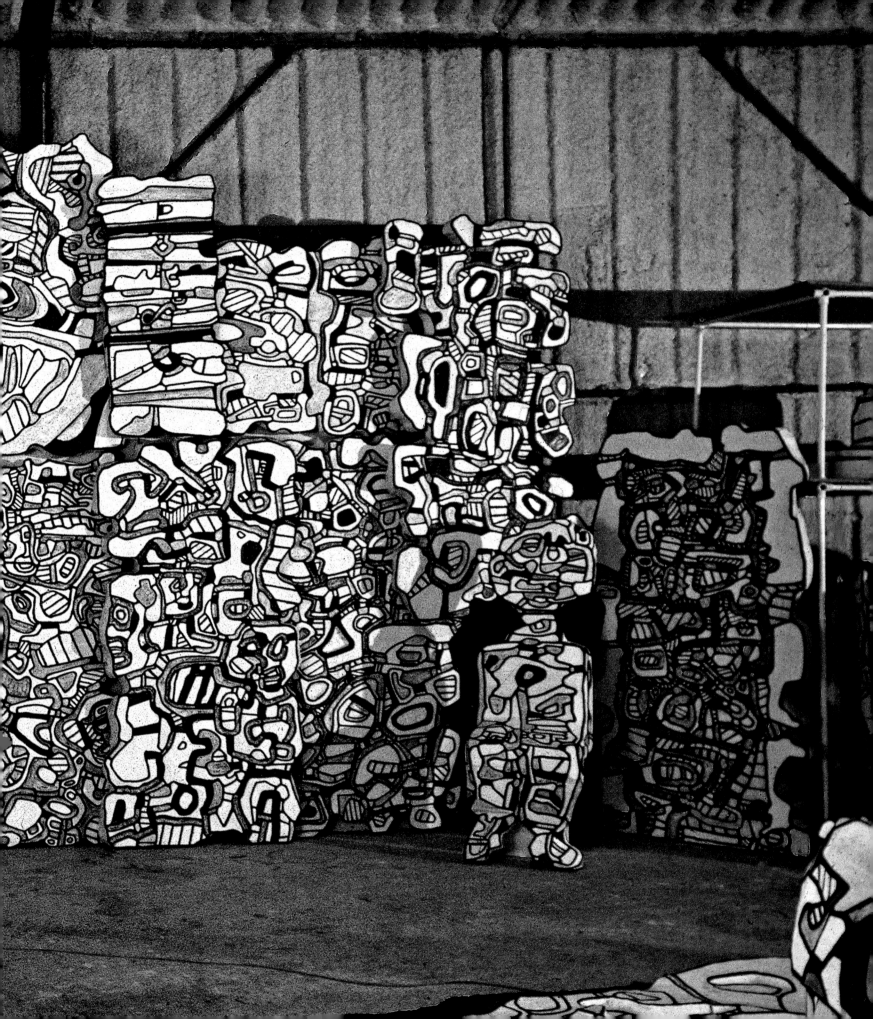

Rhizomes, Arborescences

In 1957, architect Gordon Bunshaft from the celebrated Skidmore, Owings & Merrill agency was commissioned by David Rockefeller, then executive vice-president of the Chase Manhattan Bank, to build the bank's new head offices in the Wall Street area of New York. The building was finished in 1961. With its sixty stories, standing 813 feet high, the design incorporated alternating panels in anodized aluminium and glass to reflect the light. The anodized aluminium columns accentuated the building's verticality and gave it a lightness that set if off from the dark narrow streets around the Stock Exchange. This was further enhanced by the slightly trapezoidal shape of the extensive 2½-acre plaza area. In the southern part of the plaza a sunken garden in the Ryoan-ji spirit was installed in 1964, below the paving and invisible from street level, together with a fountain, both designed by Noguchi, covering an area of roughly 50,000 square feet. But Gordon Bunshaft had always intended that a monumental sculpture should be erected on the plaza level.

In 1968, David Rockefeller, who was by now chairman and chief executive of the Chase, decided that a monumental sculpture would finally be erected on the plaza in order to celebrate the twenty-fifth anniversary of the bank's Wall Street building in 1971. Gordon Bunshaft had been interested in Jean Dubuffet's work for over twenty years and had already purchased a sculpture from the *Amoncellements* series for his own private collection. He was particularly impressed by the *Édifices* exhibition at the Musée des Arts décoratifs, and through the Galerie Jeanne Bucher he approached Dubuffet in December 1968 regarding the commission for the monumental sculpture.

20 December 1968

Dubuffet writes to Gordon Bunshaft:

"Mr J-F Jaeger tells me that you might be thinking of installing one of my Monuments in New York, and I find this very exciting.

What would be of greatest interest to me would be building my *Tour aux figures*, 80 feet high, with the inner structure (*Gastrovolve*) as described in the *Édifices* brochure.

It might be built in concrete (sprayed on to mesh using the gunnite [sic] process for the outer skin) or in epoxy resin. I think it would be better to make it in epoxy. Alternately, the inner structure could be made in concrete and the envelope in epoxy.

Should the project be implemented, I am willing to come to New York in order to go over it with you. And I can forward you the maquettes for the engineers to make their calculations."

22 January 1969

In reply to Dubuffet, Gordon Bunshaft first dismisses the idea of the 80-foot-high *Tour aux figures* ("A sculpture 30 or 35 feet high is what is required for this situation and this building"), then gives him the following information about the possible installation: "The building I'm speaking of is the Chase Manhattan Bank near Wall Street in New York. It has sixty stories and is about 800 feet high. In front of the building there is a plaza about 60 by 90 metres with a circular sunken well containing fountains and rocks designed by Isamu Noguchi. At another point on the plaza, we architects had always intended there should be a large sculpture. The Chairman of the Chase Manhattan is David Rockefeller, and there are six people on his arts committee, one of whom is me, with Alfred Baar, James Sweeney and so on. We hope to hold a meeting with Mr Rockefeller in about two months' time to discuss the various possibilities and the different artists who might make a sculpture for this Plaza. . . . If you are interested, I could put your name forward to the other Committee members when we meet. The result, and the choice of sculptor, will be decided by Mr Rockefeller with all the other members on the arts committee. I am not in a position to take the decision. I am only a member of the committee. I'm explaining all this to you so that you can understand clearly how the project works.

I would be grateful if you could let me know if this project interests you and if you think a material for the outside of the sculpture can be found so that the sculpture will last a good many years."

27 January 1969

In reply to Gordon Bunshaft's letter, Dubuffet agrees to his name being put forward to the Committee, then modifies but does not entirely go back on his initial suggestion:

"The monument could be an enlargement in concrete (covered in polyurethane paint) of one or other of the two polychrome *Tours* described in the *Édifices* brochure.

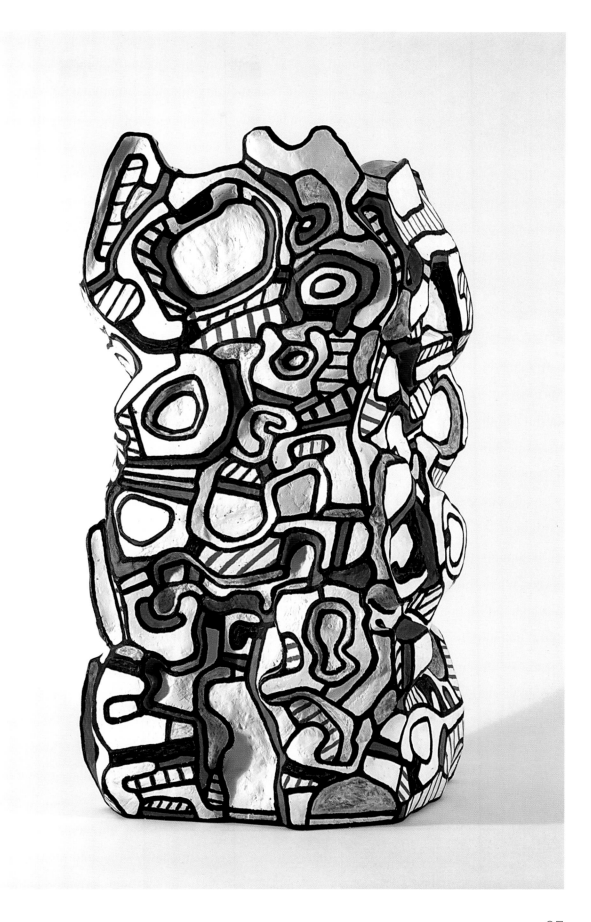

Tour de Chantourne
(2nd version) (maquette)
Epoxy with polyurethane paint
100 × 50 × 50 cm
28 March 1969
Fondation Dubuffet, Paris

PAGES 66–67
Album 3
Le Boqueteau
9 May 1969
Archives Fondation Dubuffet, Paris

PAGES 68–70
Album 3
Monument au fantôme
23 August [1969]
Archives Fondation Dubuffet, Paris

(183) "Le Boqueteau" 9 mai 1969

Groupement de 8 arbres :

 1 . Le Papillon (arbre du "Jardin d'émail")
 2 . Le Bulbe (~~~~~~) (N°177)
 3 . Le Grand Lobé (~~~~~~) (N°178)
 4 × L'Antenne (~~~~~~) (N°179)
 5 . L'Infléchi (~~~~~~) (N°180)
 6 × ~~Le Petit Lobé~~ Arbre d'éploiement plane (N°176)
 7 × Le Petit Lobé (N°181)
 8 × Le Soleil (N°182) (ensuite devenu après modification, "Arbre Poumons couplés")

ensemble vu de face

vu de la gauche

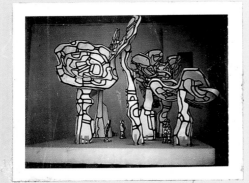

vu de derrière

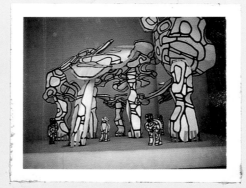

pour mémoire (pas de photos)
 29 mai (191 Bis) La forêt (assemblage de 16 arbres)

pour mémoire
Arbre "Le Papillon"
(N°1 du Boqueteau
(c'est l'arbre du "Jardin d'émail")

Arbre "Le Bulbe"
(177) (La pièce supérieure est le cerf-volant "Le Nébuleux")
(N° 2 du Boqueteau)

(178) Arbre "Le grand Lobé"
La pièce supérieure est la pièce 175-A qui intervient dans l'"Arbre au complé torse" (N°175)
N° 3 du Boqueteau

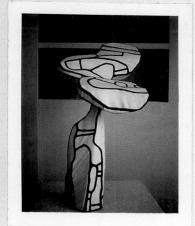

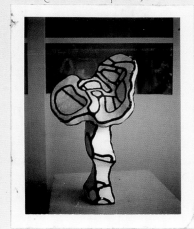

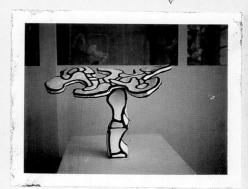

Arbre "L'Antenne" (179)
N° 4 du Boqueteau ↓

Arbre "L'Infléchi" (180)
N° 5 du Boqueteau ↓

(181)
Arbre "Le petit Lobé"
N° 7 du Boqueteau ↓

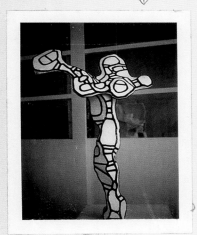

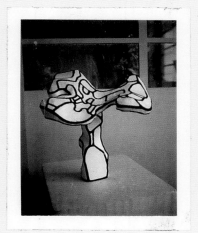

(182) Arbre "Le Soleil" (1er état)
N° 8 du Boqueteau ↓

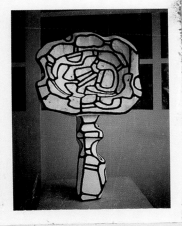

(modifié vers 25 mai voir photo plus loin)
a reçu pour nouveau titre :
Arbre "Poumons couplés"

Nota - Le N°6 du Boqueteau est l'"Arbre d'éploiement plane"
(N° 176) (dont la photo figure à la page précédente)

(214) Monument au fantôme

~~2e projet de monument pour la Chase Bank~~ 23 août

formé de 7 éléments : 1 - L'église
 2 - L'arbre
 3 - Le mât
 4 - Le fantôme
 5 - Le chien
 6 - Le buisson
 7 - La cheminée fumante

vu de devant

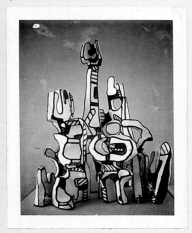

vu de la gauche

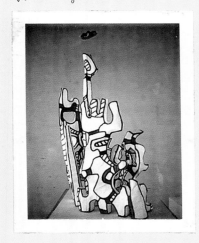

vu de la droite

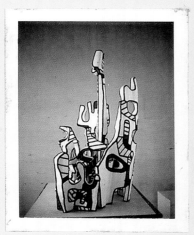

vu de derrière

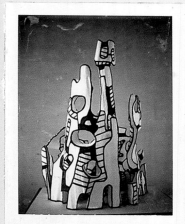

Les éléments constitutifs de (214) (du 2ᵉ projet de monument pour la Chase Bank
Monument au fantôme

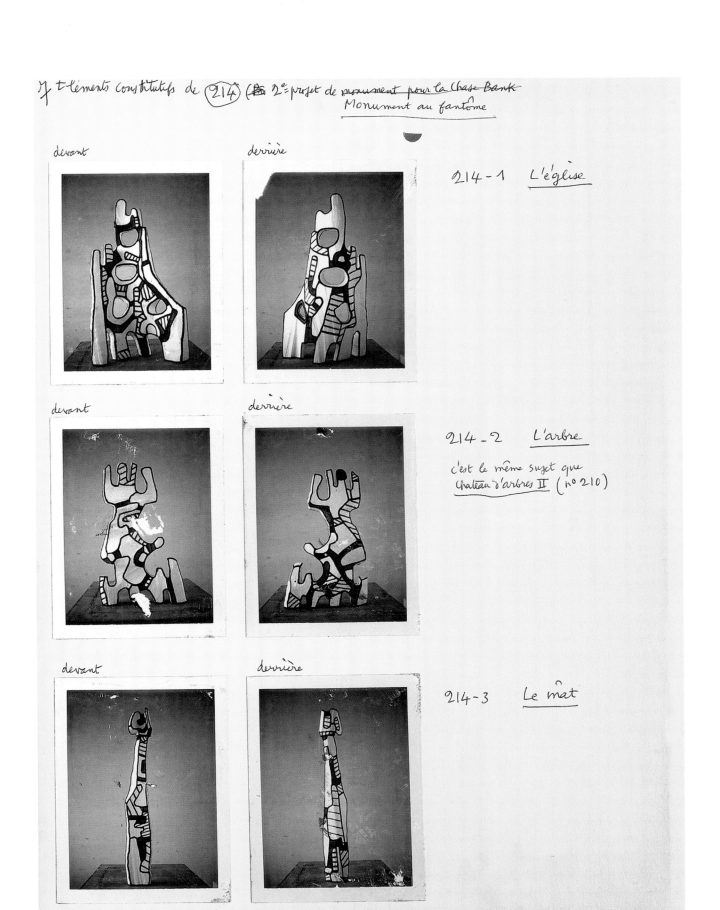

devant derrière

214 - 1 L'église

devant derrière

214 - 2 L'arbre

c'est le même sujet que
Château d'arbres II (n° 210)

devant derrière

214 - 3 Le mât

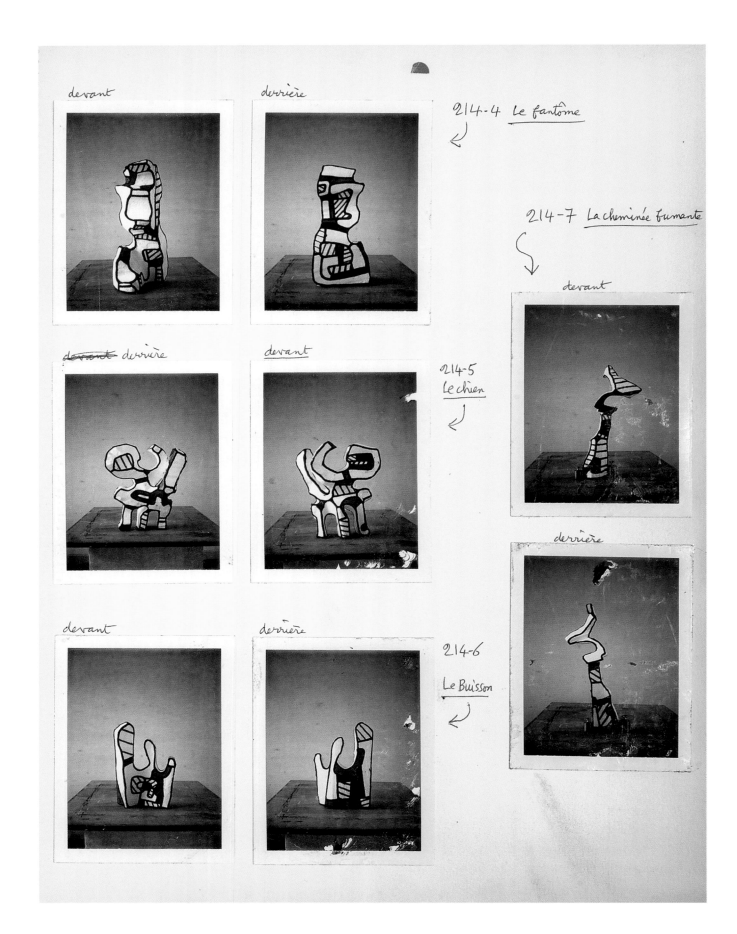

devant derrière 214-4 Le fantôme

214-7 La cheminée fumante

~~devant~~ derrière devant 214-5 Le chien

devant

devant derrière 214-6 Le Buisson

derrière

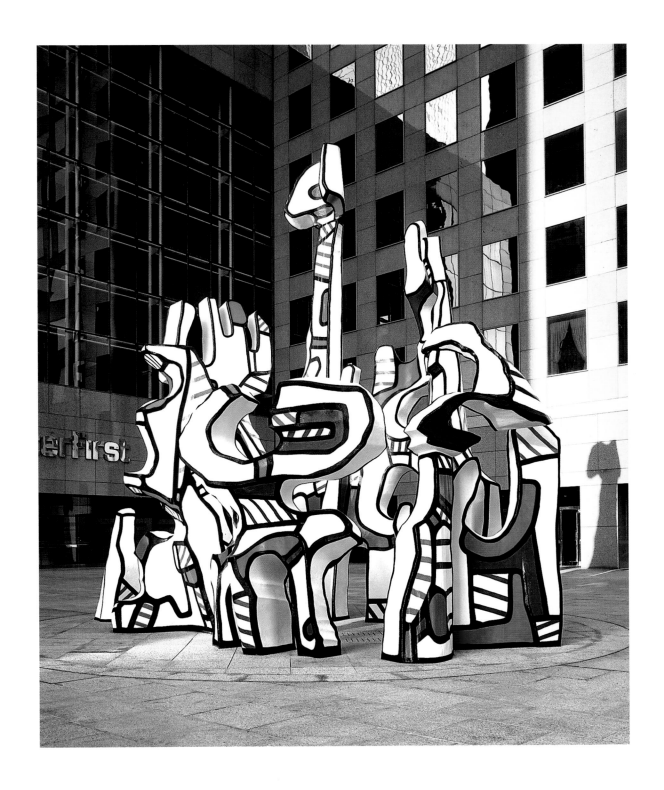

Monument au fantôme
Painted epoxy resin
Height: 10 m
1983, from the maquette dated 1969
Interfirst Plaza, Houston, Texas
(reinstalled in the Discovery
Green Park in 2008)

FACING PAGE
Jean Dubuffet's New York travel log,
5–12 October 1969
Archives Fondation Dubuffet, Paris

Alternately (and I think I would prefer this choice) an enlargement of a subject representing a tree (very much a mental figure of a tree) entitled *Arbre d'expansion ascendante* coloured only in black and white. This subject is not in the Jeanne Bucher Gallery's exhibition catalogue. I will forward you a photograph of it soon. It could be made either in concrete or (preferably) epoxy resin, and in both cases, coated in polyurethane paint.

My polyurethane paint manufacturer provides a ten-year warranty for complete resistance to weathering; and he further asserts his total certainty that complete resistance can be expected for a much longer period; he is convinced it will not be necessary to redo the painting for fifty years. The paints will of course be the proper polyurethane ones (with two components that are mixed just before being applied) and not the polyurethane-based paint with only one component that is not long-lasting."

Excited by the possibility of a monumental installation in an urban setting, something he already anticipated in the *Édifices* exhibition in 1968, Dubuffet begins work on his first project on 8 and 9 May: *Le Boqueteau*, a group of eight already existing maquettes of trees (some modified for the occasion) are fixed in specific places on a polystyrene board measuring 149 × 121.5 centimetres. After calculating an enlargement with the elements scaled up by ten, the largest element measuring 95 centimetres, Dubuffet notes in his *Journal des Travaux*: "Scaling up by 13 would be preferable; this would make: length 18 metres, depth 16.5 metres, height 12.35 metres at the apex." Thinking about its use by the public, he also notes that the height under the smallest element would be 3.50 metres.

8 May 1969

On learning the date for Gordon Bunshaft's next Paris visit, Dubuffet asks him for some "photographs of the plaza at the foot of the Chase Manhattan building, and a plan of the plaza showing the place where the monument is to be installed", and tells him how work on the *Boqueteau* maquette is progressing (five days later he sends him "a little photo" of it including human figures in order to "give an idea of the scale"): "I am currently busy working on the maquette for a rather complicated subject . . . This subject may well suit very nicely. . . . I'll show you the maquette when you come to Paris.

This subject could either be made in concrete, or (preferably in my opinion) in epoxide resin.

The different elements of the maquette will be moulded and the mould then enlarged (in expanded polystyrene) using a pantograph. Following this, the concrete (or the stratified resin) will be cast into the scaled up polystyrene mould.

This will of course require a strong internal steel armature.

The work could be carried out in Paris, or equally well in New York."

During this period, Dubuffet makes numerous maquettes for outside spaces, some specifically for the Chase Manhattan Bank, and others with no particular end in view, simply exploring other developments for his work in progress.

18 May 1969

On receiving the plans and photographs of the Plaza, Dubuffet writes to Gordon Bunshaft: "Having examined these documents, my feeling now is that the little wood (group of trees) I recently made in maquette form (I posted you a photo of it recently) will not be suitable. There are already trees – real trees – on the plaza. The subject in question will undoubtedly take up too much space. The idea must be abandoned, and I must go back to an idea that is closer to the *Tour aux figures* in the MoMA, in the dimensions you suggested. My research will go forward in this direction."

5 October 1969

Dubuffet goes in person to New York in order to see for himself the site where the future commission is to be set up, staying until 12 October. On 7 October, at 11.15 am, he has an appointment on the Chase Manhattan Plaza with Gordon Bunshaft. In a notebook he has taken for the purpose, he registers every detail (measurements for the elements on the façade, the number of trees, the distance from the sunken well [Noguchi's garden] to the trees), and makes a number of sketches. He also notes Gordon Bunshaft's advice regarding the most suitable measurements for the sculpture ("about 35 feet high and 20 feet long (maybe 30 feet in places) and 20 feet deep"), adding that the lines on them would have to be between 7 and 10 centimetres thick.

Max Loreau
22 Avenue des Alouettes
Braine l'Alleud
(Brabant) Belgique
54.08.24

Bernard Teyssèdre
~~9 Boulevard Denain~~
~~Paris 10e~~ 166 Av. du Maine
~~878.83.36~~ Paris 15e
 783.74.87

Jacques Berne
17 rue de Paris
76 Le Havre (Seine Mar.me)

DU DIMANCHE 5 AU DI-
-MANCHE 12 OCTOBRE 69

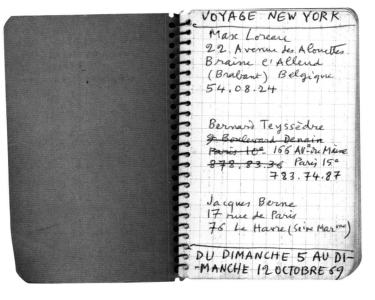

largeur du passage
entre les piliers et la ligne
 12m

largeur de l'escalier
à peine 6m
(6en comptant les contreforts)

~~d'une to~~
les travées ont 9m de
long (et 9m de haut)

le puits environ 20m

la distance du puits aux arbres
(grilles circulaires autour des arbres)
pas beaucoup plus de 20m

Place du côté Nassau
(Marine Midland)
9 arbres (entourés de
cercles de diamètre
près de 5m

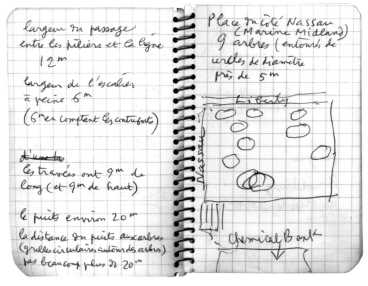

Bernard Friedman
(Bob)
écrivain
ami de Alfonso Ossorio
auteur de romans
(sans succès)

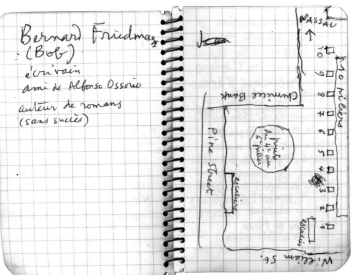

la ligne du muret
aux petits arbustes avec les
gens assis se situe à
l'alignement du 7e pilier
(un peu au delà de ce 7e pilier
en allant vers le 8e)

le mur de la Chemical
Bank se situe à peu près
alignement de la moitié
entre le 7e pilier et le 8e pilier

mais pratiquement avec
le jeu de perspective les
8 piliers semblent former
le fond de la Plaza

le puits est à l'alignement
du 6e pilier (légèrement
au delà de ce 6e pilier vers
le 7e)
et de l'autre côté à
l'alignement du 4e pilier
très (à peine)
légèrement au delà de ce
4e pilier vers le 3e)

l'escalier sur Pine Street
à l'alignement de presque
alignement du puits (4e pilier)
(un tout petit peu plus vers
3e pilier)

et l'autre côté de l'escalier
est exactement à l'aligne-

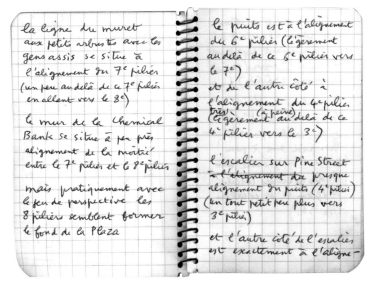

ment du petit escalier
de William St. c'est à
dire alignement dépassant
un peu le 1er pilier (en
allant vers 2e pilier)

les arbres sont à
l'alignement du 1er pilier
et les cercles qui entourent
leur pied sont à peu
près à l'alignement ~~des~~
~~les~~ des escaliers (escaliers
William St. et escaliers
Pine St.)

donc je dis bien l'escalier
sur Pine St. va du 1er pilier
au 4e pilier (pas tout à
fait; perd un grand mètre
sur le 4e et un grand mètre
sur le 1er)

Banque Fédérale

Chase
M.B.

RIGHT PAGE
Album 4
Ébauche pour un monument
(first models for *Le Manège*)
5 November [1969]
Archives Fondation Dubuffet, Paris

Returning to the place alone, he jots plans and notes in the same notebook:

"The lines from the low wall to the small shrubs with the people sitting are aligned with the 7th column (just past the 7th column towards the 8th).

The wall of the Chemical Bank is aligned just about halfway between the 7th and the 8th columns.

In reality, with the trick of perspective, the 8th columns seem to form a backdrop to the Plaza.

The well is aligned with the 6th column (slightly after the 6th towards the 7th and on the other side it is aligned with the 4th column (very slightly (barely) beyond the 4th column towards the 3rd).

The Pine Street stairs are almost aligned with the well (4th column) (just a little towards the 3rd column) and the other side of the stairs is exactly aligned with the William St stairs, i.e. aligned just beyond the 1st column (towards the 2nd column).

The trees are aligned with the 1st column and the circles at their base are just about aligned with the stairs (William St and Pine St).

So in fact, I mean that the Pine St stairs go from the 1st column to the 4th column (not quite: minus a good metre on the 4th and a good metre on the 1st)."

15 October 1969

Now back in Paris, Dubuffet writes to Gordon Bunshaft: "I am now going to begin work on making a maquette for a monument that I feel will suit the intended site. Obviously I am not sure that I will succeed. Before I manage something that entirely satisfies me, I may have to make several successive trials, and so there may be some delay."

23 October 1969

David Rockefeller has just visited Jean Dubuffet's studio. "He was very much interested in the various subjects and maquettes in my studio," the painter writes to Gordon Bunshaft (November 1969), adding: "I have not yet made a maquette specifically for the Chase monument, having been delayed by several urgent matters since I got back from New York, and also having had a slight attack of lumbago."

11 November 1969

Writing again to Gordon Bunshaft, Dubuffet says:
"My lumbago is better and I have locked myself away at home for a week in order to work in peace on a project for the Plaza monument. The maquette is now finished, and you will find enclosed some little photographs of it. [This was the maquette for the *Manège*.] It is in expanded polystyrene and is 120 centimetres high and about 70 centimetres in depth and width. It is just in black and white, as I will add colours later. I must now make a mould and a hard resin casting (or two or three), on to which all my black lines will be drawn, and later I will do the colours.

The idea of the monument . . . is that the fixed base will house the machine that makes the rotating movement with a turnplate above. In a circle all around the plate, there will be six large standing figures (cut out dynamically to more or less vaguely evoke enigmatic, uncertain characters).

When the maquette has been moulded and I have a hard resin casting (polyester or epoxy), I will finish it on the inside with some arrangement so that the cut-outs will be solidly attached to one another and well fixed at least at certain points; the current state of my polystyrene maquette means that these high, flat cut-outs, which are fixed to the base only by their feet, would offer too much wind resistance. This is an additional issue, but not so awkward that an appropriate solution cannot be found.

I would like the monument to turn (very slowly however), a quarter of a revolution every four hours, meaning that it will rotate completely once every sixteen hours."

21 November 1969

On receiving the photographs, Gordon Bunshaft writes: "I think your design for the Chase Manhattan Plaza is very exciting . . . because the composition is completely freestanding and this is what is needed for it to be equally interesting when viewed from every direction. I think the height of 12 metres is certainly dramatic and well in the scale and dimensions of the Plaza." In a letter dated 10 December 1969, Gordon Bunshaft returns to another aspect of the project: "As for making the monument turn, I think the idea is excellent but it depends on the

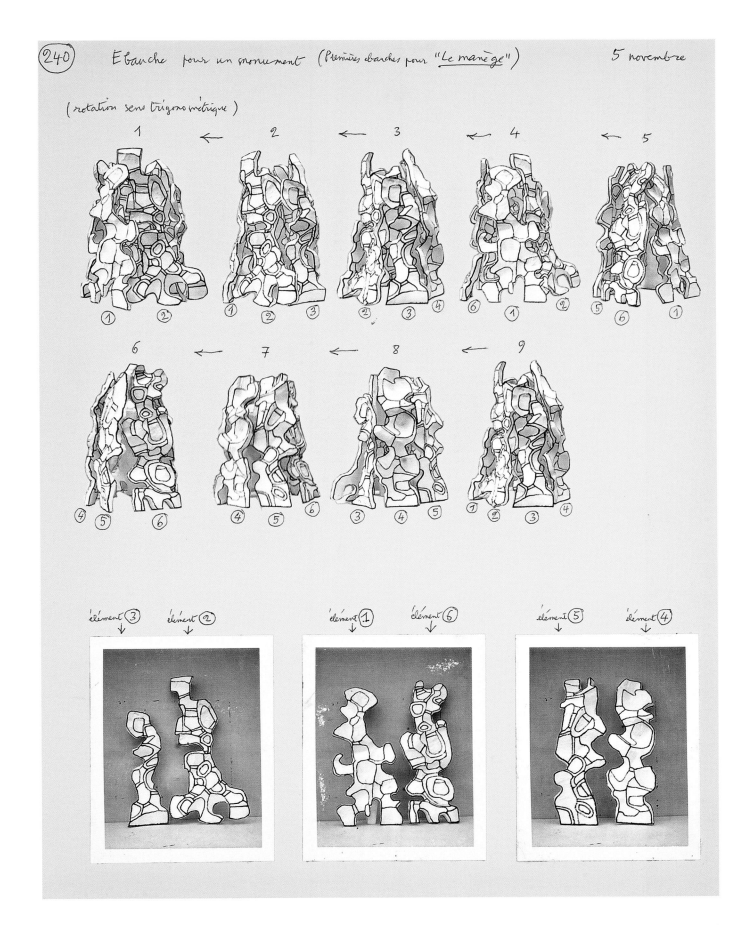

(240) Ébauche pour un monument (Premières ébauches pour "Le manège") 5 novembre

(rotation sens trigonométrique)

1 ← 2 ← 3 ← 4 ← 5

① ② ① ② ③ ② ③ ④ ⑥ ① ② ⑤ ⑥ ①

6 ← 7 ← 8 ← 9

④ ⑤ ⑥ ④ ⑤ ⑥ ③ ④ ⑤ ① ② ③ ④

élément ③ élément ② élément ① élément ⑥ élément ⑤ élément ④

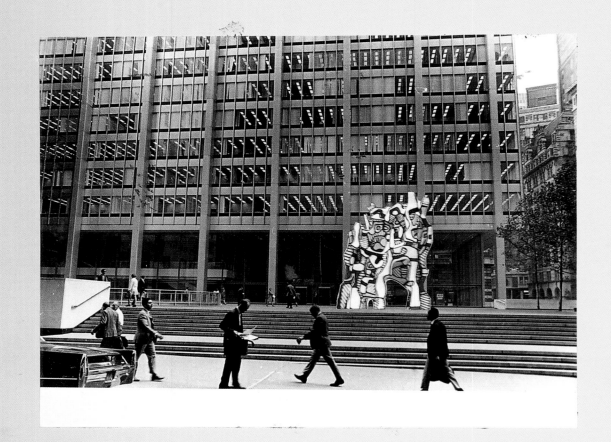

character of the final sculpture and whether or not it will lend itself to rotation. I'm not sure if making it turn so slowly will produce a great effect, but the idea of slow rotation is very exciting."

26 November 1969

This very positive reaction on the part of Gordon Bunshaft is tempered by Dubuffet: "Your very kind enthusiasm regarding the photos of my first maquette gives me great pleasure. However, this maquette must not be viewed as the definitive one. I sent you the photos so you can see that I am working. But I will certainly make others, and not stop at the first one I make. I am indeed at the present time engaged on something very different. I always like to try out several ideas before deciding on anything. So I will need another ten or twelve weeks before any definitive decision can be arrived at."

Following this letter, photographs of the other projects are duly sent to Gordon Bunshaft: photos of the *Château Traverse* on the 18 February 1970 (for which he states: "Its special feature is that it can be entered from all sides. . . . I think the interior area of the monument for anyone going through it would be quite moving. But because of the many openings, I fear that it might be horribly draughty."), photos of the *Kiosque l'Évidé* on 27 February, and finally of the *Cosmorama* on 3 March 1970, and *Cosmorama II* on 10 March. This maquette is modified (*Cosmorama III*) just before Gordon Bunshaft arrives on 19 March, and following his advice during his stay, Dubuffet carries out the definitive modifications (*Cosmorama IV*), reducing the final maquette from seven to four elements. Gordon Bunshaft wishes the project to be sent to New York as quickly as possible so that it can be submitted to David Rockefeller, which requires, in addition to transport and customs clearance, time for the maquette to be cast in polyester resin. Dubuffet pressures his various associates, announcing to Gordon Bunshaft: "You will have the maquette by Monday 11 May or Tuesday 12." Yet, to the artist's annoyance when he is informed of the decision by Gordon Bunshaft on 3 June, the maquette does not meet with David Rockefeller's approval. It is then decided that two other already existing maquettes will be proposed: those of the *Monument à la bête debout* and the *Monument au fantôme*. In a letter dated 2 September, Gordon Bunshaft reminds the artist:

"At our last meeting on 3 June in your studio rue Labrouste, I understood at the end of our conversation that you intended to get two maquettes ready and send them here to us in September so they could be shown to David Rockefeller and his associates.

If I remember correctly, one of the maquettes was already finished and the second needed moulding and painting. As I have not heard from you since my visit, I wonder if and when you intend to send us the maquettes."

Dubuffet writes by return of post on 10 September: "I am a little concerned as to the timeliness of sending Mr David Rockefeller and his associates new maquettes. I cannot hide the fact that I was a little disappointed by the outcome of the previous presentation. I do not feel very keen to expose myself to a further refusal. But I will follow your advice. The two maquettes you saw and chose (the *Monument au fantôme* and the *Monument à la bête debout*) are soon going to be sent off to the Chicago Art Institute for an exhibition of my monuments and architectures starting in early December. But I have two identical copies which, if you wish, can be sent to you from Paris by 1 October."

18 September 1970

David Rockefeller is informed of Dubuffet's misgivings by Gordon Bunshaft and, stopping off in Paris, pays him a visit. The day after this visit, Dubuffet writes to Gordon Bunshaft:

"Yesterday I received a visit from Mr David Rockefeller at my studio in rue Labrouste which gave me great pleasure. He is obviously very interested in the Plaza monument and wishes to entrust me with the making of it. The very kind words he used to inform me of this touched me deeply. At his request, I will despatch four maquettes to New York in a week's time.

First there will be the two maquettes you yourself selected (the *Monument à la bête debout,* which has only black lines without colour; and the *Monument au fantôme*, which has colours). Then there will be the *Groupe de quatre arbres* (which you do not know), which is also in black and white. And there will also be the *Cosmorama III* (which has colours).

Cosmorama III is the version of the *Cosmorama* I showed you in the rue Vaugirard studio during your visit. You felt that it was too bulky, so we removed the pieces that extend the central motif out in several

directions, keeping only the central motif to make version IV of the *Cosmorama*, the one that was sent to New York and which was refused.

It was quite by chance that Mr Rockefeller saw version III of the *Cosmorama* in my studio, and looked at it with interest, apparently much preferring it to the simplified version IV.

Whatever the decision taken regarding the four maquettes, I am ready to modify or transform them in whatever manner seems desirable, and even to make other new ones. I feel more enthusiasm now I see that Mr Rockefeller is genuinely interested in the project's outcome.

The 4 maquettes will be with you within a fortnight, and a new meeting of the Committee will be set up around 10 October to examine them."

7 October 1970

In the end, when the committee meets, it is the *Groupe de quatre arbres*, improvised on 17 August 1970 by uniting four already existing elements (and also the project closest to the initial *Le Boqueteau* group) that is selected by the Chase Manhattan Bank's arts committee. The maquette is to be enlarged twelve times, with the monument's highest point reaching 11.5 metres.

31 October 1970

Informed of the committee's decision, Dubuffet writes to David Rockefeller to thank him:

"I am very happy that you and your committee have finally decided to award me the commission for the monument for the Chase Manhattan Plaza based on the maquette entitled *Groupe de quatre arbres* that I put forward.

It is of great importance to me to see this monument installed in a location that is so impressive, and one which I particularly appreciate.

Regarding the price, it is currently very difficult for me to establish with any degree of accuracy what the fabrication will cost me. To calculate this, I first need to have the maquette which is still in New York and which will be sent back to me, I am told, on 12 November. I do not have a copy or a mould.

When I have the maquette back, various studies will need to be carried out to precisely determine which will be the best techniques to use. Different options for making the structures are available. Studies and trials will be performed to this end.

But even when the construction technique has been completely defined, an evaluation of cost can only be approximate.

However, the question of price cannot be left in abeyance. I therefore suggest that the price of 1 million French francs be fixed herewith. I am ready to commit to this price if it suits you.

For this price, it is understood that the work will be executed in my studios in Périgny, bringing to a finished state all the elements that constitute the monument. They will be decorated and painted. I will deliver them to New York. I will therefore meet all costs regarding packaging and shipment, as well as transport insurance.

The mechanical resistance and structural engineering of the framework and armatures will be calculated by Mr Paul Weidlinger and will be his responsibility. Payment due to Mr Weidlinger for this will be met by me.

You will take care of the expenses for haulage from the port of New York to the Plaza, the assembly of the elements at the point of installation and also the attachment of the whole of the monument to the ground. I think that you will appoint Mr Weidlinger to carry out this operation. But his payment for this will be met by you."

5 December 1970

When the original maquette returns from New York, it undergoes a few slight modifications (the positioning of the four trees, and a change to one of the leaves; these changes mean that all the elements touch one another in the upper part of the structure, thus increasing the monument's stability). Acknowledging the return of the maquette in a letter to Gordon Bunshaft dated 21 December 1970, Dubuffet outlines the future procedures:

"The first operation will be to mould all the elements on the maquette in order to have one or two replicas of it. One will be sent to Mr Weidlinger [in charge of the internal armature of the work]. I hope that we will be able to do this in ten days or so.

The second operation is to scale up all the elements from 1 to 3 in expanded polystyrene. This can be done at the same time as the first operation. Work on it has in fact already started. When it is entirely

Paul Weidlinger with one of the maquettes
for the *Groupe de quatre arbres*, 1974

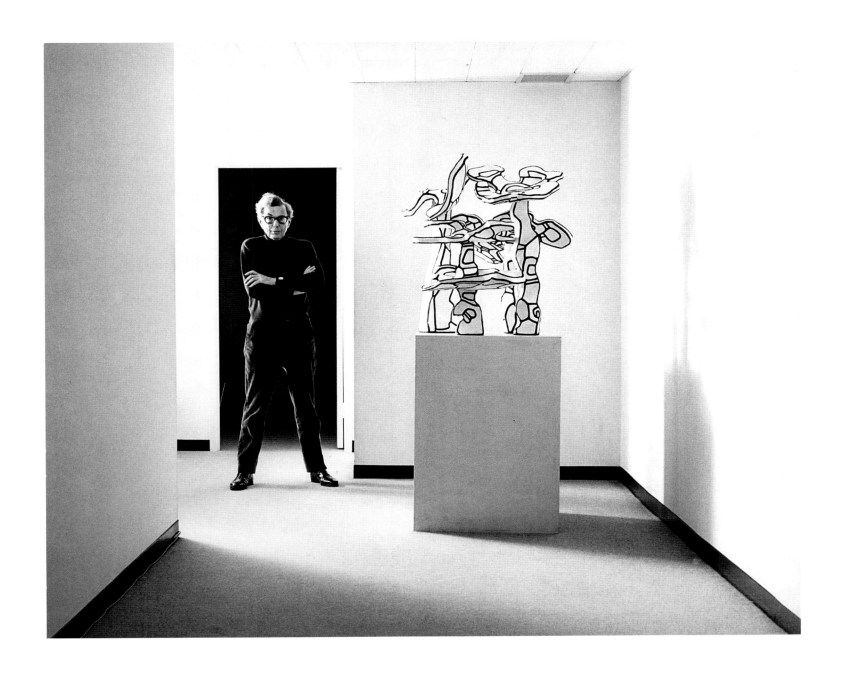

FACING PAGE, TOP
Making the *Groupe de quatre arbres*:
mounting the leaf on tree A
Périgny-sur-Yerres, December 1971

FACING PAGE, BOTTOM
Making the *Groupe de quatre arbres*:
setting up the metal structure
for tree C
Périgny-sur-Yerres,
December 1971–January 1972

finished, I intend to have a mould made of the whole scaled up by 3, in stratified resin: this will make a nice maquette 3 metres high, more evocative of the final monument than the current small maquette.

Then there will be the final scaling up by 4 of the first enlargement. It will also be made in expanded polystyrene, but this time it will be the negatives (i.e. the moulds) that are enlarged and not the positives.

Of course, the second scaling up by 4 will take place at the same time as the first scaling up by 3, as I have two pointing machines that will work simultaneously.

The structure in layers of stratified resin sandwiched together and the technique for fabrication will be carefully tried and tested. Two trial plates are now being made; and two other little monuments, which are currently being made in my Périgny studios, will be made using this stratification technique. It will be a useful exercise and testing procedure."

Letters from Dubuffet show that his work schedule goes according to plan: the first expanded polystyrene enlargement is finished on 25 January and moulds are being made on 31 January 1971, the epoxy casts on 25 February, the scaling up from one to three to create a plaster "master model" is completed on 12 March 1971; then over the next five and a half months, until 30 September, seventy new moulds are made for scaling up by four, with the pantograph working sixteen hours a day seven days a week so as to keep to schedule. Stratification for the moulds starts on 20 May 1971, lasting ten months through to 30 March 1972, while for the metal armature it begins on 1 October 1971 going through to 30 March 1972. This titanic undertaking necessitates 8 metric tonnes of sisal-reinforced plaster, 400 cubic metres of expanded polystyrene, 500 litres of polystyrene glue, 1 kilometre of timber . . . and the building of new workshops in Périgny.

3 February 1971

While work is underway in France, safety norms for the monument are being tested in the US. Gordon Bunshaft asks Dubuffet for samples of the materials he is using:

"Panels must be made using materials that are exactly like those for the final monument. They must be painted in white and black in the same paint as for the monument. Could you also send with the panels

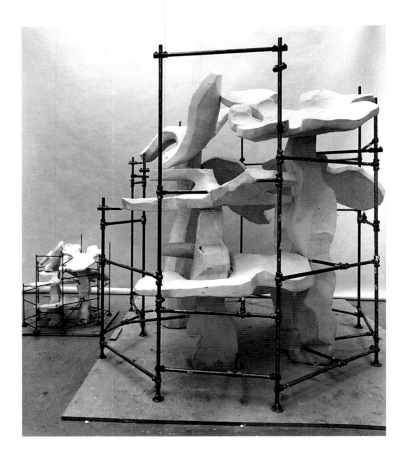

ABOVE
Groupe de quatre arbres
definitive plaster "model
master" with templates
January–March 1971

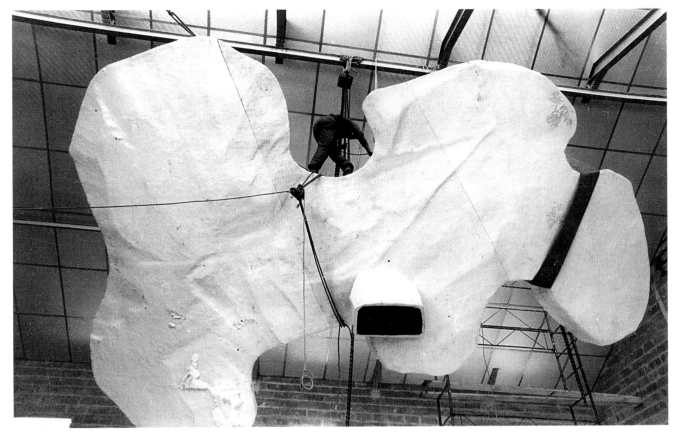

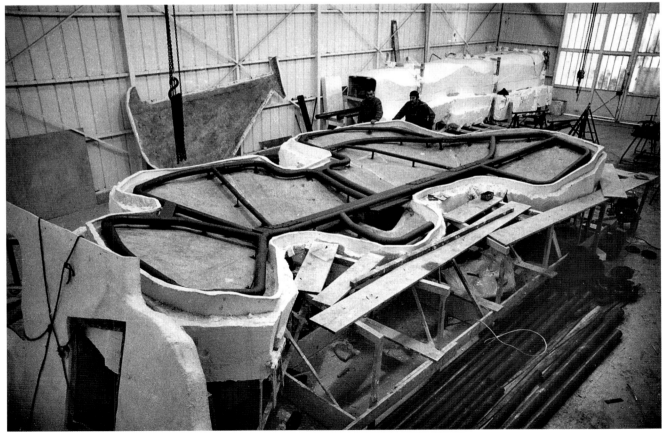

RIGHT
Plan of the framework-tubular
support for the *Groupe de quatre
arbres*, drawn up by the Société
Parisienne de Canalisations
(S.P.A.C.), 22 September 1971
Archives Fondation Dubuffet, Paris

BELOW
Making the *Groupe de quatre arbres*:
setting of the metal structure
into the stratified "trunk"
of a tree still in its mould
Périgny-sur-Yerres,
December 1971–January 1972

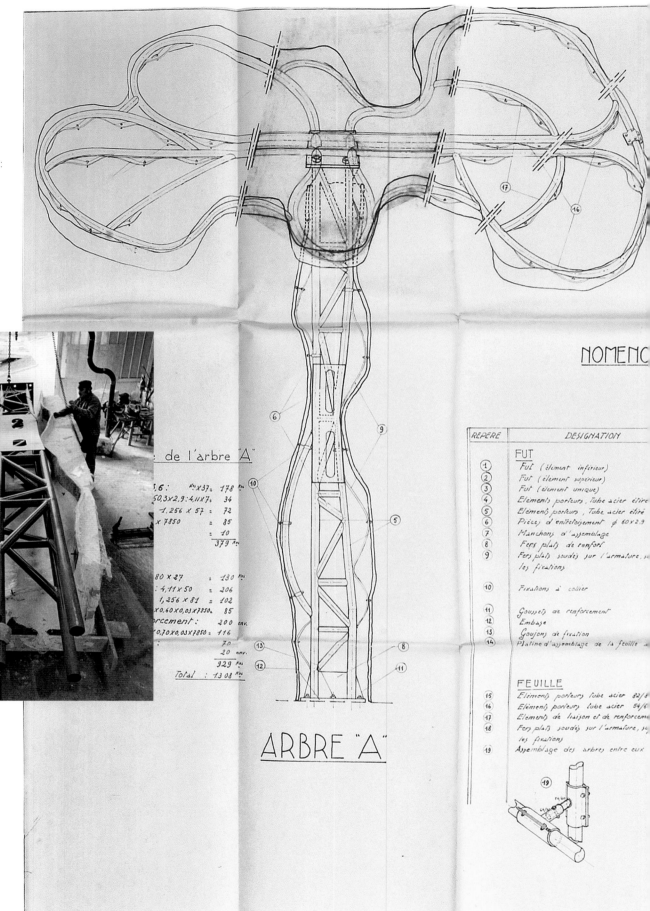

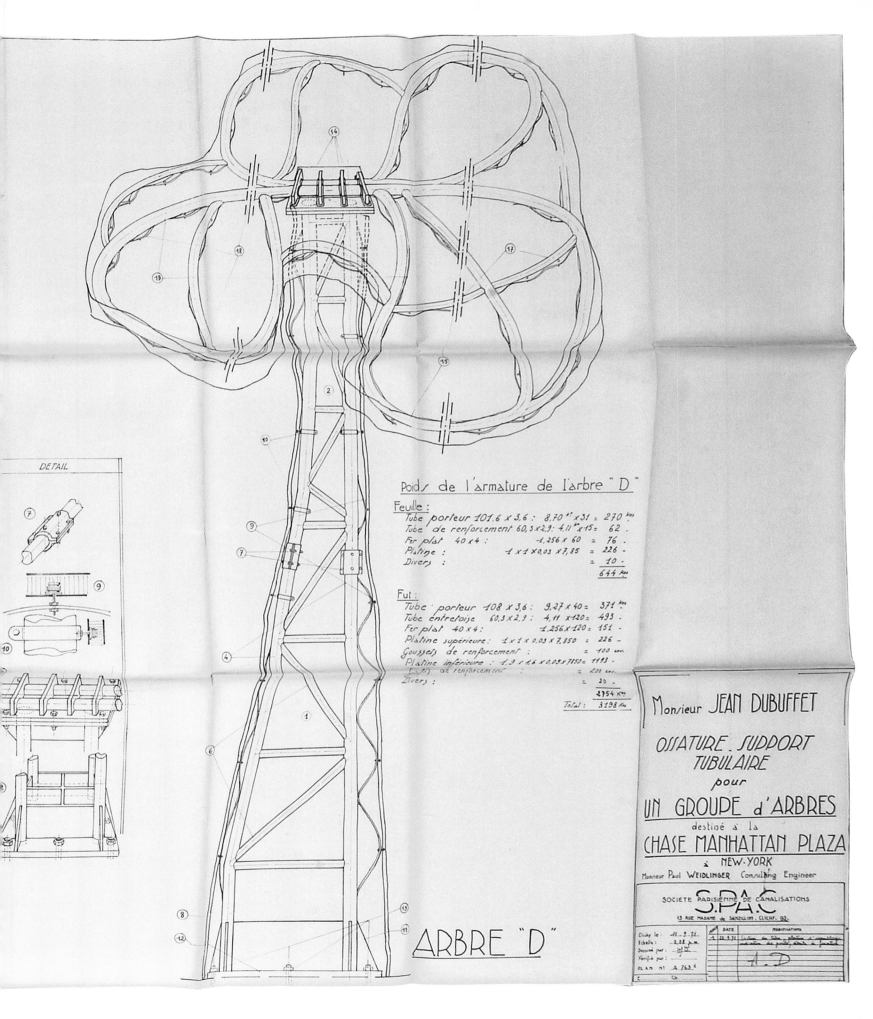

BELOW

Making the *Groupe de quatre arbres*:
setting of the metal structure
into the stratified "trunk"
of a tree still in its mould
Périgny-sur-Yerres,
December 1971–January 1972

FACING PAGE

Groupe de quatre arbres:
first pre-assemblage
Périgny-sur-Yerres,
March 1972

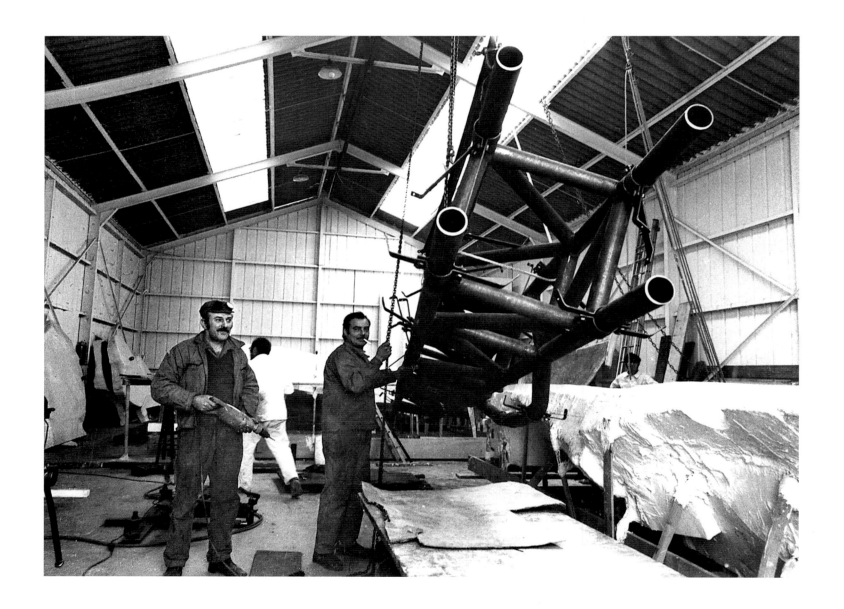

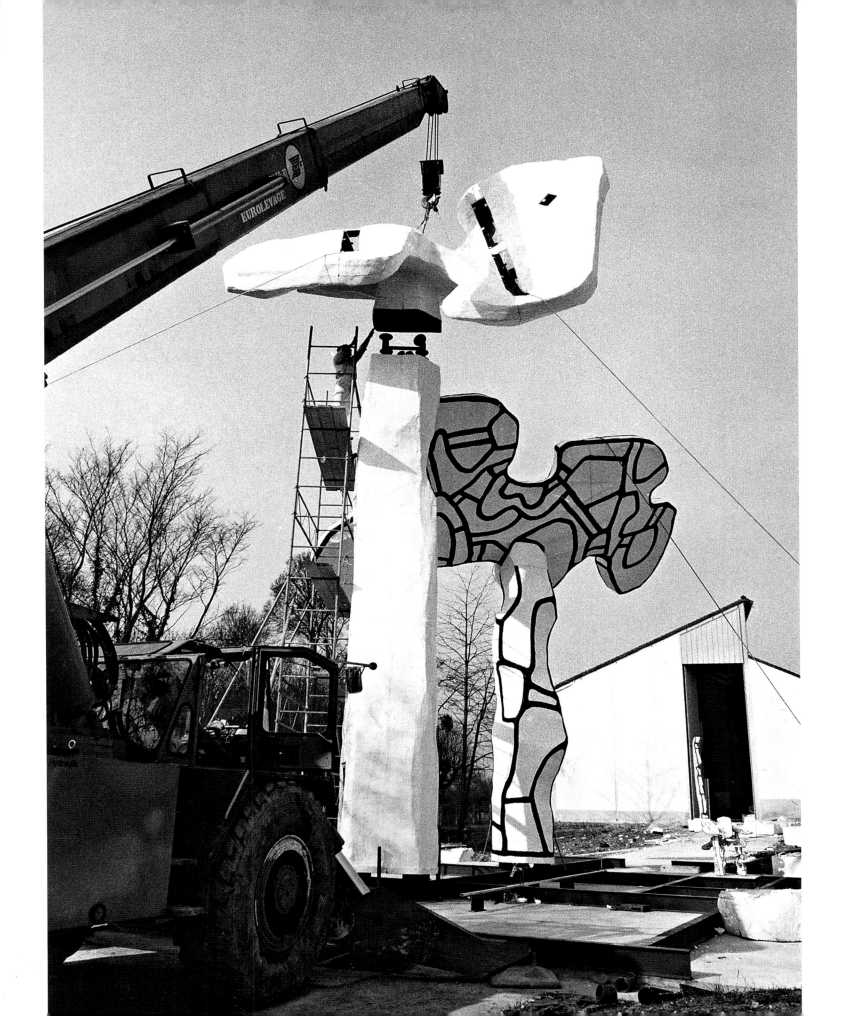

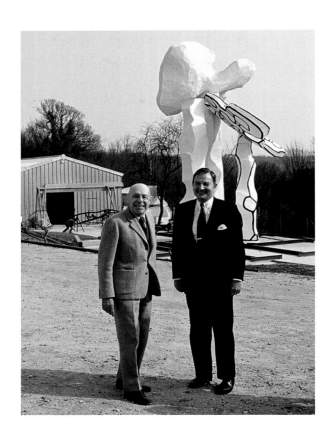

a pot of the white paint and one of the black with their names and a detailed description of their composition. Here, we will have to test the painted panels to see how weather- and fireproof they are, as well as their structural solidity. More especially we would like to test the painted surface using methods that accelerate weathering to simulate 10 years' ageing. The pots of paint will enable the laboratories to make a complete analysis.

The second point is that before commencing work on the final 12-metre-high sculpture, you and Paul [Weidlinger] should decide on a definitive structure for the whole of the monument with drawings to be submitted to the City of New York for approval. When we have seen these drawings, obtained the City's approval and received favourable laboratory results, then I think work on the definitive monument to its ultimate scale can be safely commenced."

9 January 1972

Dubuffet receives a letter from David Rockefeller informing him that he will soon be coming to Paris, whereupon the artist is most insistent that he should visit the work in progress for the *Groupe de quatre arbres*, detailing the work already accomplished:

"All my staff and myself are very desirous that you should visit Périgny-sur-Yerres and see what has already been achieved for our *Groupe de quatre arbres*. . . . Construction is going ahead in favourable conditions. It seems that the dates that were fixed for our schedule are being adhered to more or less, so I think we are on time. The number of staff has been increased and new premises have been hastily built.

The lengthy enlargement operation on the machine is completely finished. As is the stratification for the first two trees and the trunks of trees 3 and 4. Stratification for the leaf of the 3rd tree and the two leaves of the 4th still remains to be done.

There has only been a brief delay in the construction of the steel infrastructure for the first tree, which took longer than expected. The first tree will be erected in a few days, and the second around 15 February.

I feel indebted to you for your generous acquittal of eight-tenths of the agreed price for the monument, even though its construction is

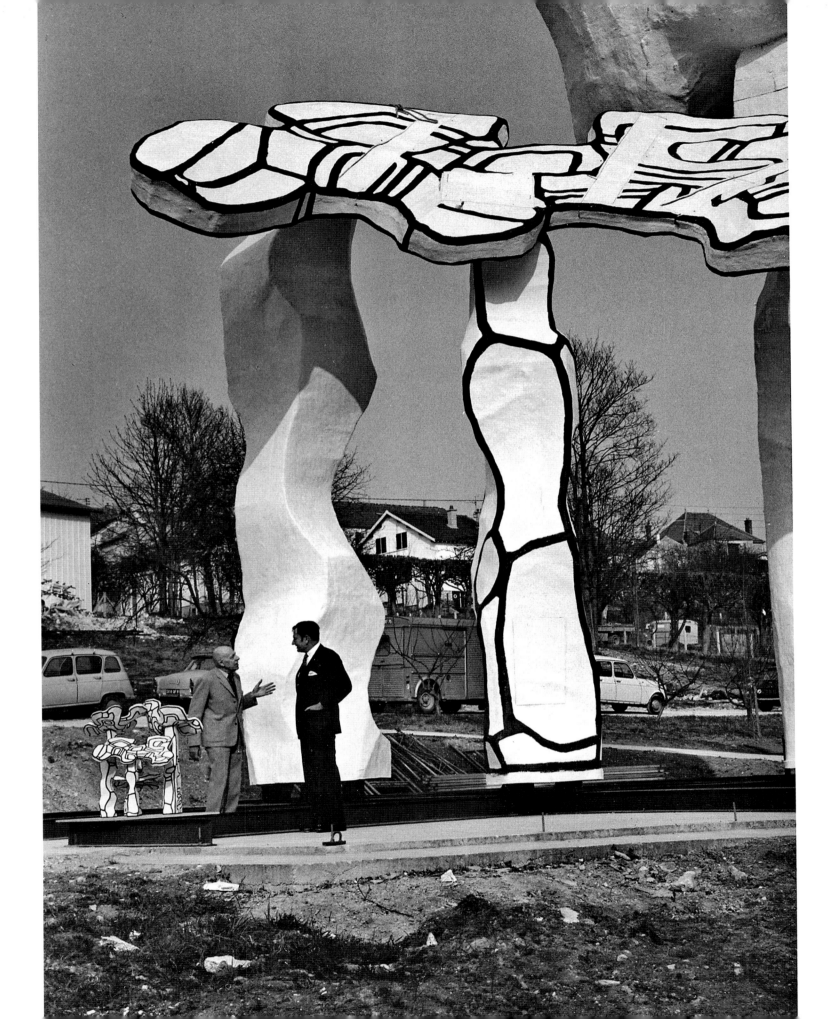

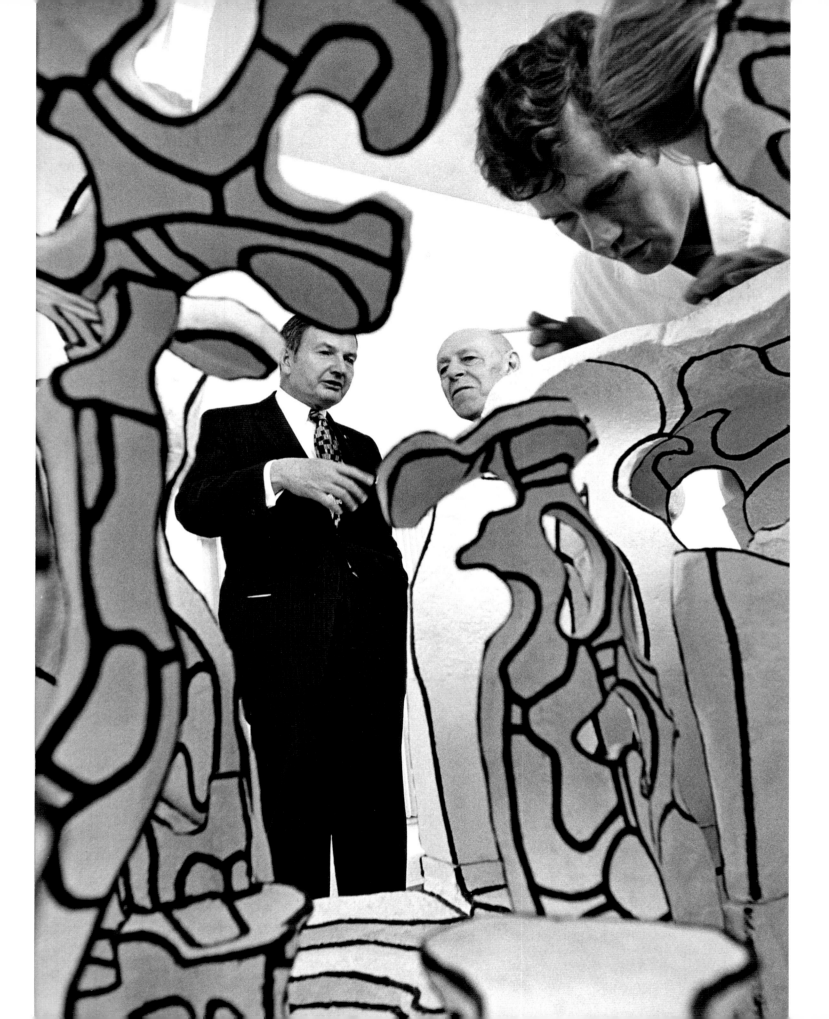

David Rockefeller visiting
the Périgny studios
with Jean Dubuffet
Périgny-sur-Yerres, 23 March 1972

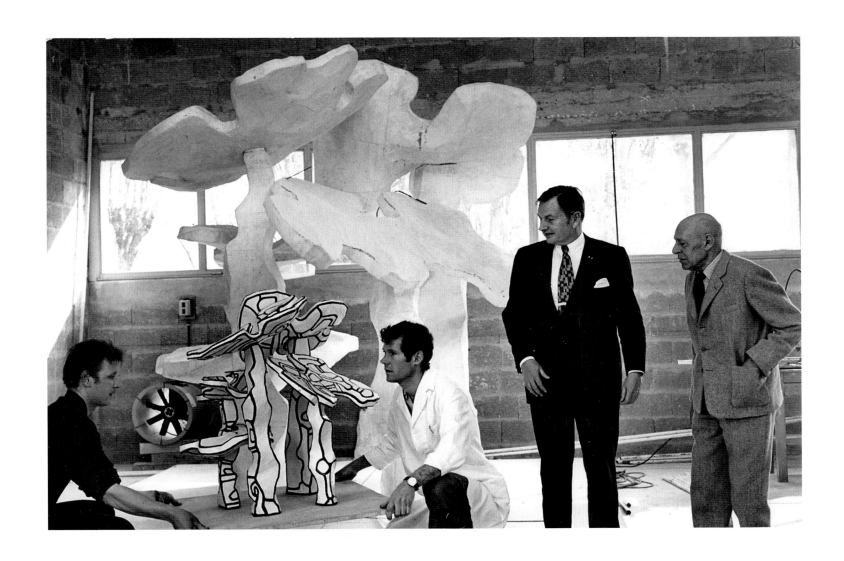

BELOW AND FACING PAGE
Installing the *Groupe de quatre arbres*
on the Chase Manhattan Plaza
New York, September–October 1972

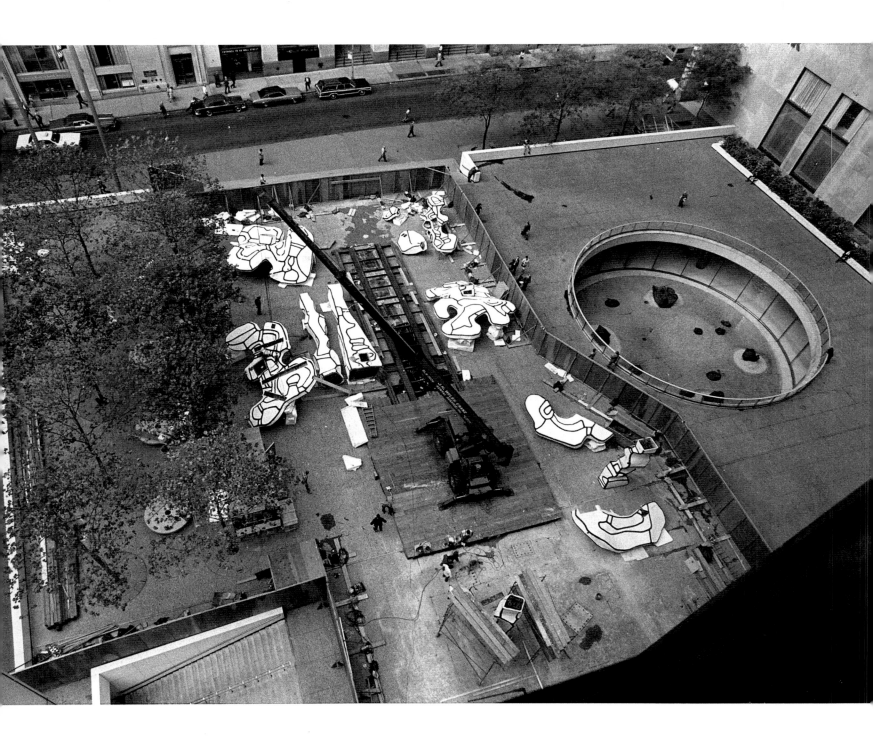

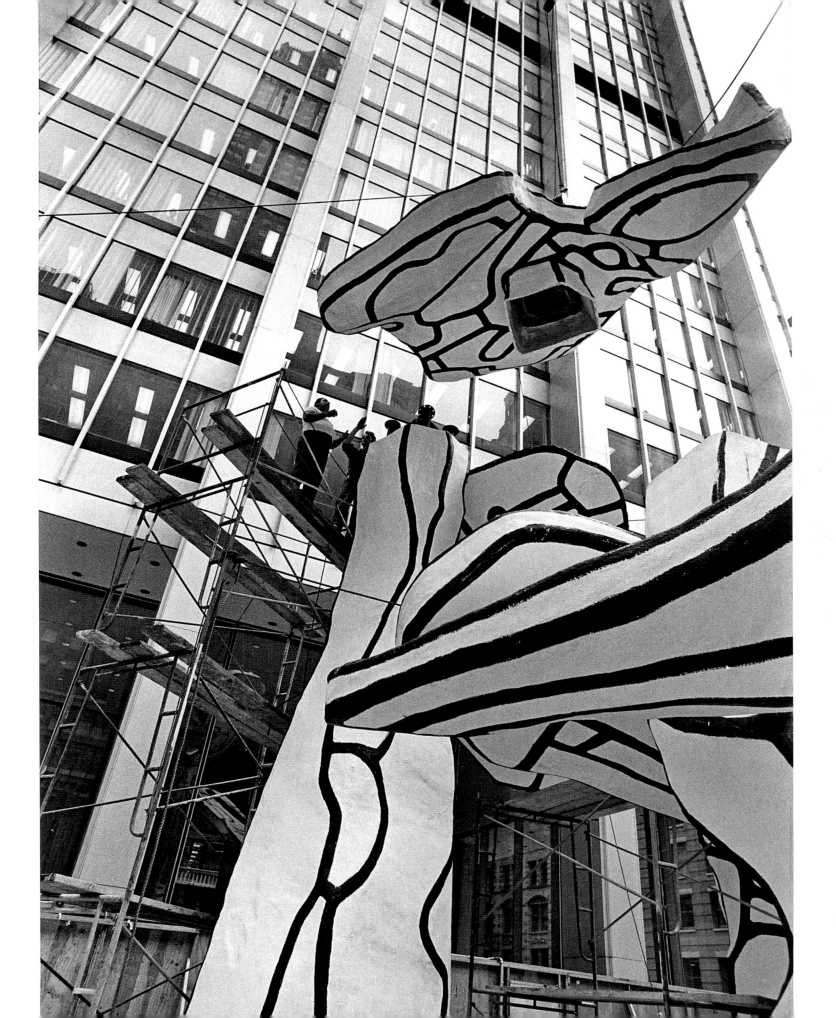

only three-quarters complete and it will be a good six months before it is finished and can be shipped. In this regard, the expenditure has been much greater than forecast, and cannot be far off what I have received from you. I have not as yet done the accounts with any accuracy. But this is secondary and matters little."

23 March 1972

David Rockefeller goes to Périgny and sees the work being done on the *Groupe de quatre arbres*. Erected on a temporary platform outside the workshops, two trees – one already painted, the other not – and the trunk of a third await their patron next to the maquette he selected in New York. The seemingly simple confrontation between project and work in progress has in fact been carefully staged: the 95-centimetre-high maquette also set up on the platform makes the 12-metre-high elements seem even more monumental. In June 1972, the four trees are provisionally assembled, so any potential problems for the definitive installation of the work on the plaza can be anticipated.

1 September 1972

The work is shipped in containers to New York, and installation on the Chase Manhattan Plaza begins. It is carried out by a team of four technicians from the Périgny studios, under studio chief Alain Robert, all of whom have been sent to New York by Jean Dubuffet, together with American technicians from the Chase Manhattan Bank. Despite a few difficulties in understanding between the two teams, the installation proceeds without any hitch and is completed two weeks before the official inauguration on 24 October.

19 October 1972

Jean Dubuffet leaves Paris for New York, having, unusually, agreed to attend the inauguration ceremonies for the *Groupe de quatre arbres*. On 21 August he writes to David Rockefeller: "I am greatly honoured by the festivities you are organizing on this occasion, and am very grateful to you. I wholeheartedly wish to take part even though my annoyingly solitary nature makes me a little allergic to ceremonies, which I usually take pains to avoid; but in these very exceptional circumstances, I wish to respond fittingly to the honour you do me."

Inauguration of the *Groupe de quatre arbres* New York, 24 October 1972

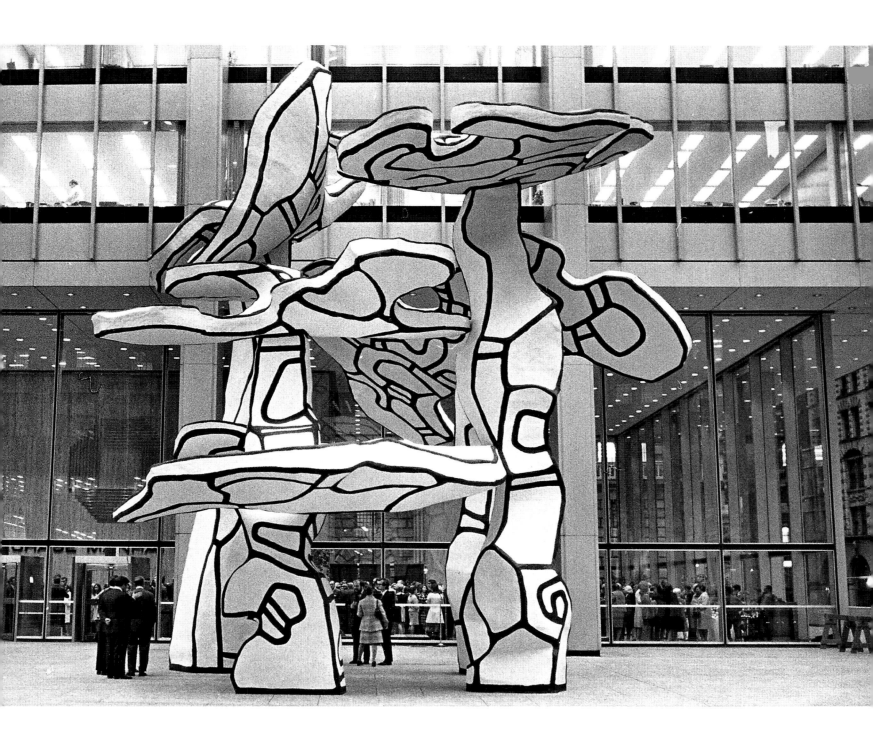

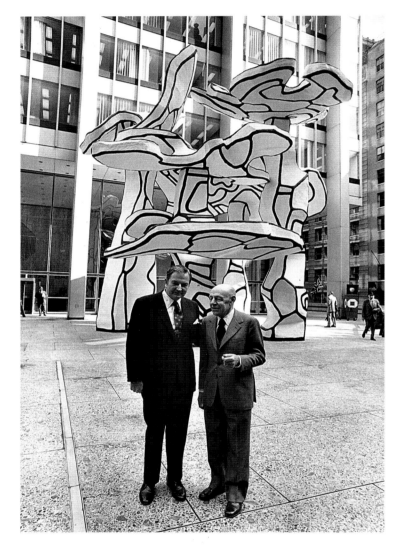

24 October 1972

During the inauguration ceremonies, Dubuffet gives a long speech, in English, in which he goes back over the reasons for *L'Hourloupe* and the way it developed. His closing words are:

"I do not believe that these four trees, which I hope will not be taken as representations of real trees but as semblances of the thrust and fertility of human thought, bear contradiction in any way to the site upon which they now stand. Indeed, in their capricious and aberrant graphisms, they give an impression – and this was intentional – of feverish intoxication. But they seem to me, by this same febrility, to manifest the ardent source of the enormous intellectual machinery of which this plaza is the core. I confess to being deeply moved that New York, this city so marvellously welcoming and marvellously eager to embrace every bold intellectual innovation, fearlessly accepted this allegory."[1]

1. "Remarks on the Unveiling of the *Group of Four Trees*", 24 October, 1972,
spoken by Jean Dubuffet, translated by Benita Eisler, in the catalogue *Jean Dubuffet,
a Retrospective*, Solomon R. Guggenheim Museum, 1973.

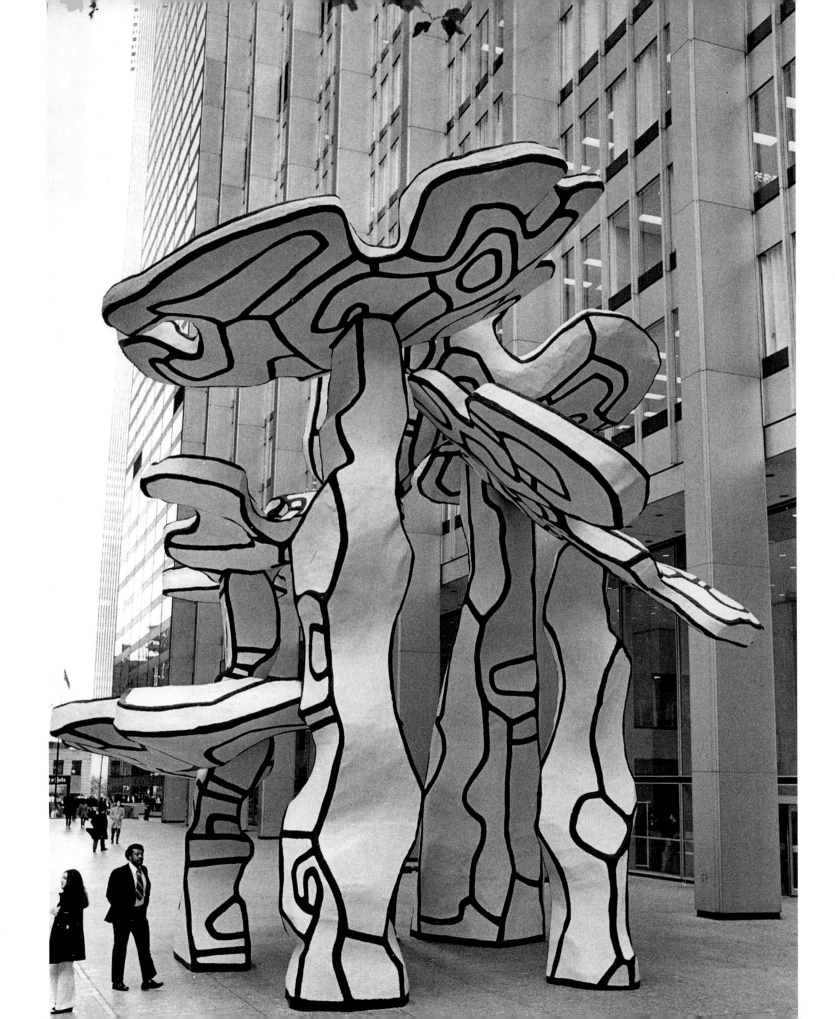

Praise of Folly

As Dubuffet and Marcel Bernet, his accountant, were shrewdly calculating the real cost of making the *Groupe de quatre arbres*, so that David Rockefeller could appreciate the extra costs incurred due to the scale of the construction work, for which the artist had footed the bill, Dubuffet noted incidentally in a letter dated 8 June 1972: "My staff in the studios in Périgny currently numbers 13 people. There were on average 10 people for the 20 months covering the construction period [the work started on 1 December 1970, and was due to finish by the end of July 1972]. When other minor moulding and stratification jobs external to the Chase monument are taken into account, we estimate that the staff have been occupied in a ratio of 4:5 on the construction of the monument."

Alongside the work on the *Groupe de quatre arbres*, Dubuffet, in a state of feverish mental excitement no doubt caused by this first achievement, continued designing and making other sculptures and maquettes (one being the *Salon au nuage*, imagined as an antechamber for the conference centre at the Hôtel PLM Saint-Jacques in Paris, but which in the end never got beyond the project stage). He also made two "indoor" sculptures: the *Jardin d'hiver* and the *Chambre au lit sous l'arbre*. But of the greatest moment was his decision to start work on the *Villa Falbala*, to which he soon added an enclosure and a surrounding wall – harking back to *Hortus Clausus*? – called the *Closerie Falbala*.

After finishing his largest mural work, *Le Cabinet logologique*, whose walls total 26 metres in length, in February 1969, Dubuffet knew that a definitive site had to be found for it. He purchased a 1½-acre building plot next to his studios in Périgny-sur-Yerres near Paris, and in August 1970 began construction work on the plans to which he had been applying himself since 28 February 1969: a building with a central room to house the *Cabinet logologique*. The term *Falbala* that he chose for it was not due to any casual frivolity on his part. As is often the case with Dubuffet, there are two levels of reading: among those who might be charmed by the word's alliterative qualities, few would realize that it is also a metaphor in architecture to designate the archivolts, the wide bands that stand proud of a bare wall and follow an arched opening from side to side, from one impost to the other, calling to mind, in their way, the *L'Hourloupe*'s black lines, as they stand out from the dazzling white building in one continuous movement.

ABOVE
Salon au nuage
Maquette of the project for
the Hôtel PLM, boulevard
Saint-Jacques in Paris
Epoxy with polyurethane paint
62.5 × 101 × 141 cm
Circa 31 December 1971
Fondation Dubuffet, Paris

FACING PAGE
Jean Dubuffet in the
Chambre au lit sous l'arbre
Périgny-sur-Yerres, October 1977

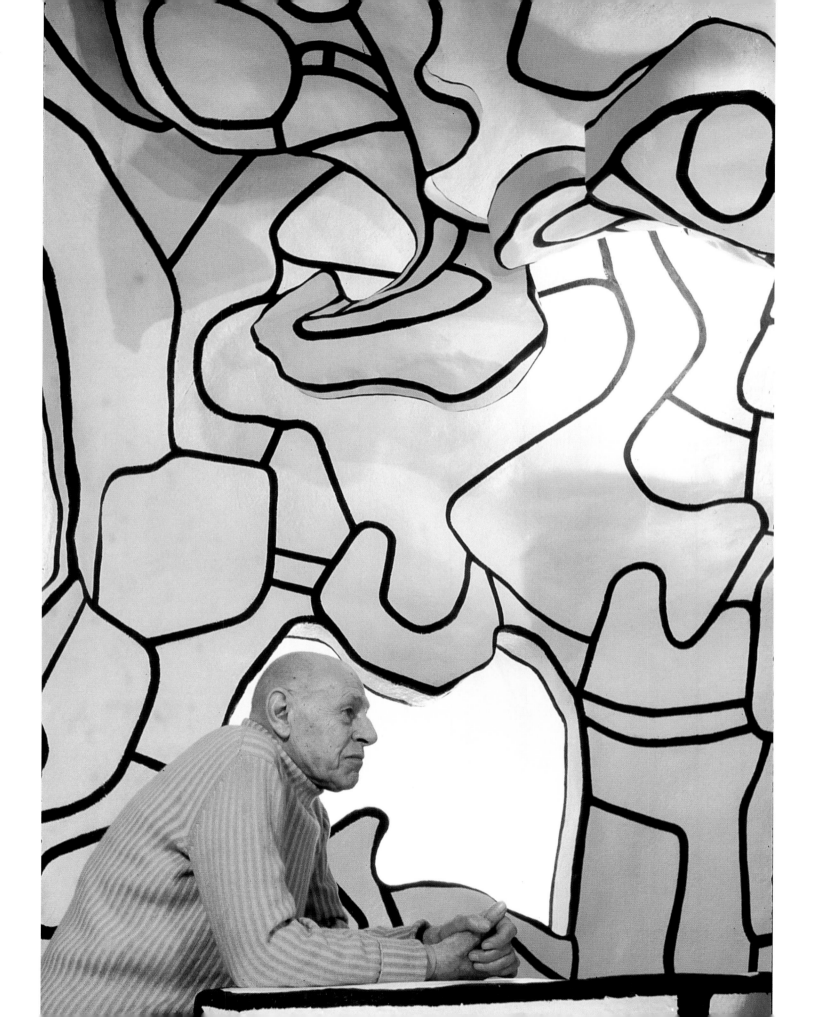

One might also wonder whether the idea for a "Demeure de L'Hourloupe" had not already been present in the artist's mind when he was making the maquette for the *Castelet L'Hourloupe*. This was indeed a little castle (but it was also a puppet theatre that found later its home in *Coucou Bazar*), whose maquette was shown in the *Édifices* exhibition. Regarding the maquette, Dubuffet stated: "The edifice will be in reinforced concrete painted snow white and historiated with black lines in polyurethane paint. . . . It will be entered through two doors of differing height. . . . The inside of the building will be just one large room, except for the system of entrails that is reserved for the utilities." This design that was to a large extent reproduced in the *Villa Falbala*.

Whilst work was going on in the Périgny studios, Dubuffet took on board anything and everything that the *Groupe de quatre arbres* could teach him for creating the *Villa*. Even the studies carried out by Paul Weidlinger, appointed by Gordon Bunshaft to work out the metal structure for the four trees, their wind resistance and solidity, was immediately turned to good account for the *Villa*, right from Dubuffet's very first meeting with Weidlinger in New York in October 1969, helping the artist solve the onerous technical problems that the making of this unconventional building involved. With Weidlinger's assent, in November 1969 a maquette of the *Villa* was sent to him in New York.

Dubuffet's sense of urgency and his fastidiousness were part of his nature: his enthusiasm was immediate and did not brook delay or error. So it is no surprise that between August 1970 and autumn 1973, the duration of the building project, his collaborators came and went in quick succession. Dubuffet was equally self-critical, and writing up the works' progress he stated: "The hardest thing for an artist who is unskilled in building techniques and poorly informed by the architects, engineers and contractors is to find the right technically qualified deputy to administer and oversee operations." The first of them, Bernard Sauvé, who at first he described as "without any proper qualifications as he previously worked in coatings and waterproofing, but probably skilled, and definitely self-confident and fearless", later became "a likeable joker". His successor, Maurice Escande, "very competent and busy", did not have enough time in Dubuffet's eyes to devote to the project and his lack of "assiduity" meant that he in turn was replaced by architect Joël Poilpré, who saw the work through to completion (although

Exhibition poster for *J. Dubuffet – Le Jardin d'hiver*, Musée d'Art Moderne de la Ville de Paris, 28 April–11 June 1972

Le *Jardin d'hiver* on show
in the exhibition *Jean Dubuffet:
édifices, projets et maquettes d'architecture,*
Musée des Arts décoratifs, Paris
11 December 1968–10 February 1969

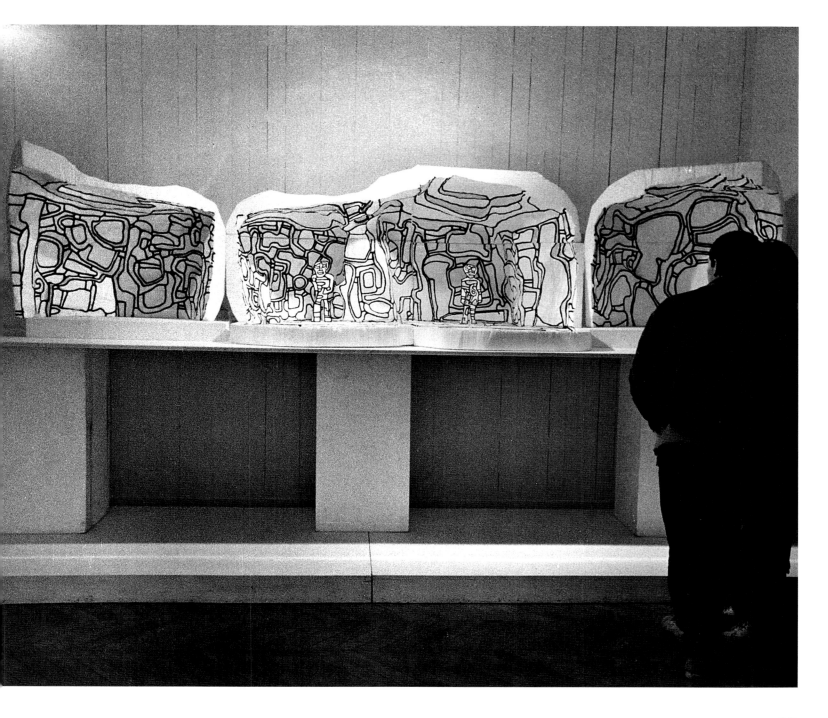

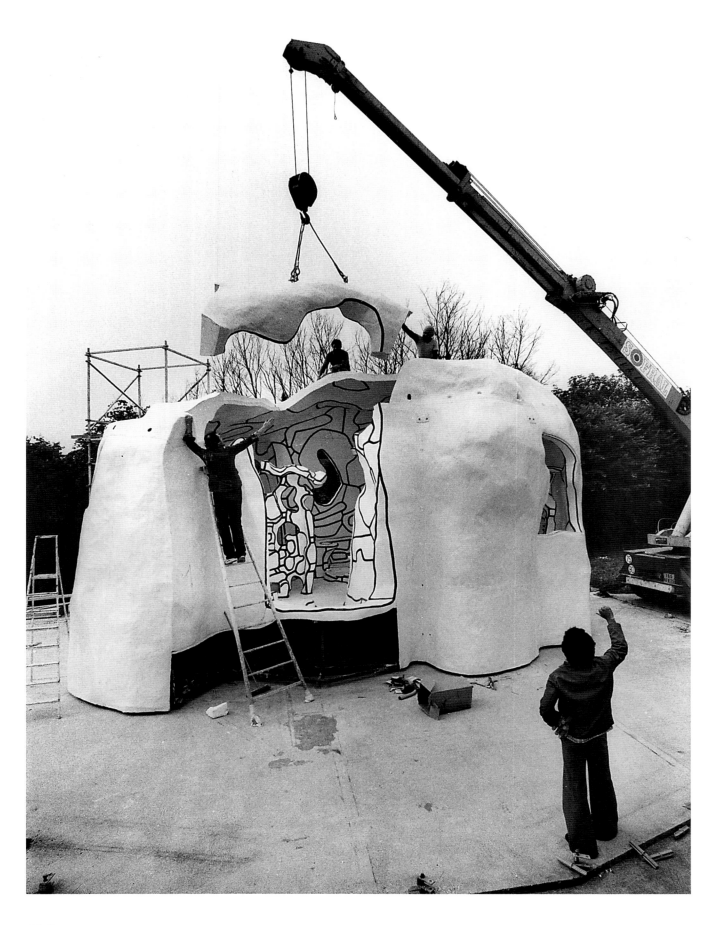

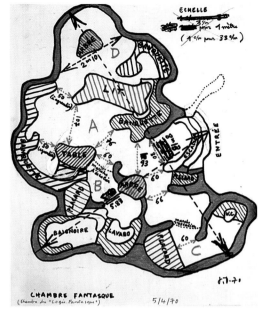

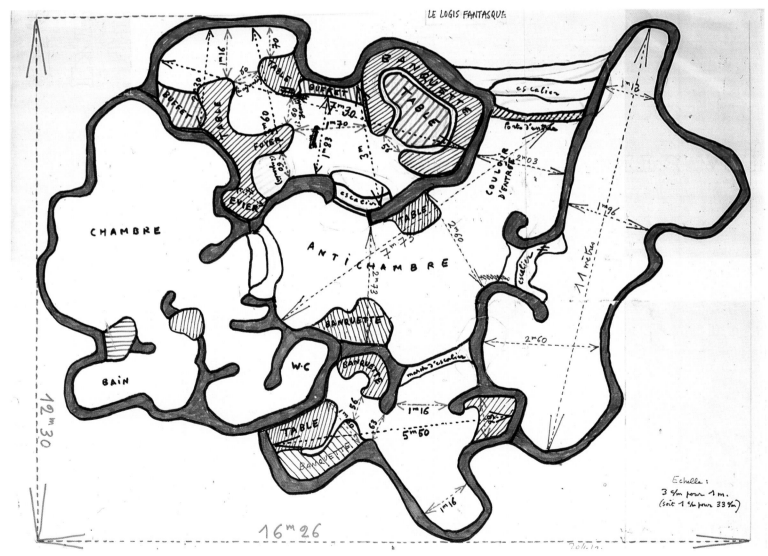

The 1970-77 *Chambre au lit sous l'arbre* is the most complex architectural environment and the one that combines Dubuffet's sculpture and architecture most definitively. It is a summary of his preceding accomplishments. All of the ambiguities present in the sculptured objects – chairs, tables, etc. – are compounded in the *Chambre*. It contains a bed, a banquette, a table, a washbasin, a tub, trees, and a cloud suspended from the ceiling; in the antechamber there is a toilet. One can lie on the bed and sit at the table, but the bathroom facilities are not functional. The walls and the furnishings are all covered in the same meandering black line, disorienting the viewer by totally confusing the space. These ambiguities question whether or not this is architecture or whether architecture is only the subject of this sculpture – as a figure may be the subject of a more classical sculpture. The *Chambre*, as an enclosure is an environment, which is, in itself, a modern idea in the history of art. However, as an environment, it loses its object status and therefore does not exist as a discrete object, like a figure sculpture. At no time is it possible to experience the totality of the architecture, but rather, only the parts in focus at any one time. This is in direct apposition to the way in which one experiences a figurative sculpture as a totality. The *Chambre*'s existence is architectural. All of Dubuffet's work is perplexing and raises more questions than can be readily answered. But these repositories for the spirit, for the imagination, suggest architectural and sculptural solutions to the idea that there are alternative realities.

Arnold Glimcher, *Architectural Digest*

FACING PAGE
Chambre au lit sous l'arbre
Painted epoxy resin
4.85 × 9 × 6.50 m
1977, from the maquette
dated 4 May 1970
Private collection

102

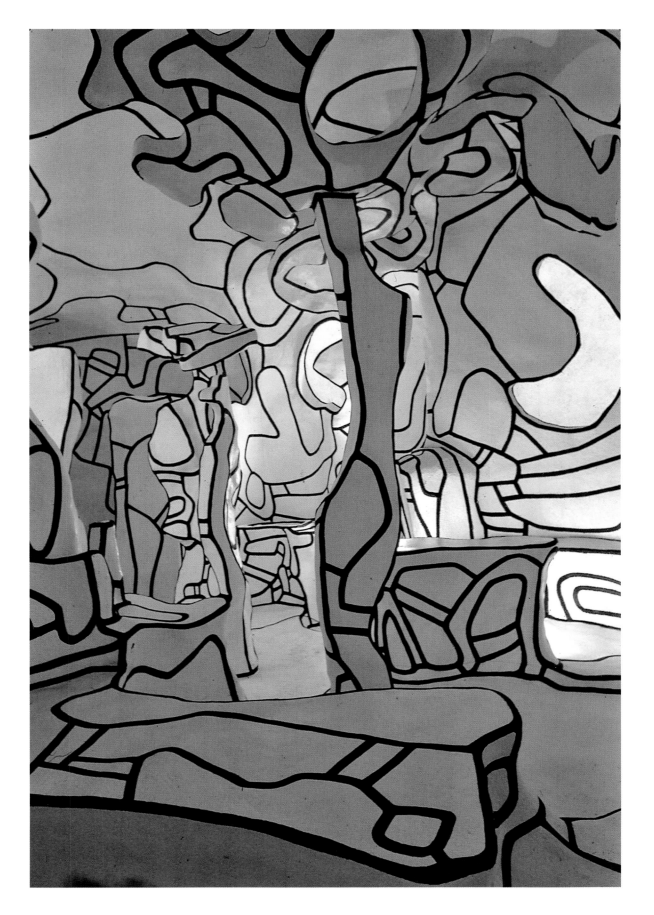

Jean Dubuffet presenting
the first maquette of the *Jardin
de la Villa Falbala*
Périgny-sur-Yerres, September 1970

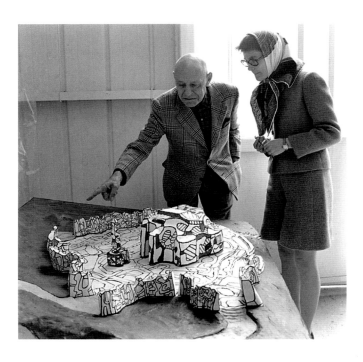

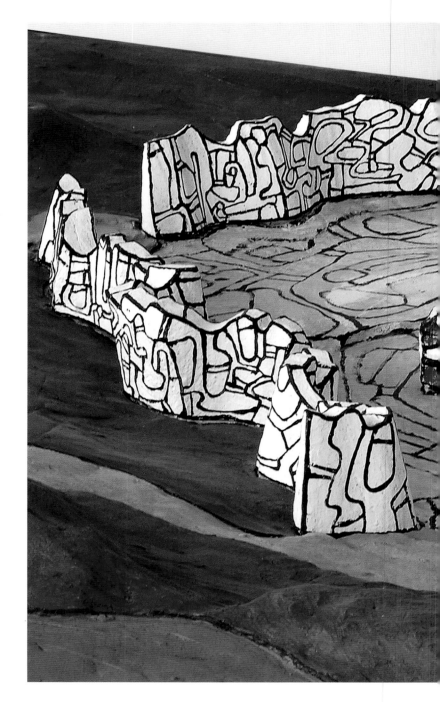

according to the works manager, the recently finished work showed, "various defects that had to be remedied one after the other").

The main difficulty faced by the different collaborators was that the maquette for the *Villa* was carved out of a polystyrene block 2 metres long and 1.5 metres wide, which according to Dubuffet had to be scaled up "with rigorous accuracy" by ten on a clay soil that soon proved unsuitable for such an undertaking. As with the *Villa*, the garden – for which Dubuffet did a first maquette between 31 March and 3 April 1970, with the assistance of architect Roland Morand, before buying the plot – was to be the concrete realisation of the idea of a transitional space, in the form of a sculptured wall, between the *Villa* and its natural environment. Given the semi-bucolic, semi-suburban village environment of Périgny, the idea was completely fitting, but it failed to take soil type into account.

The first job was therefore to landscape the ground to follow the curved planes Dubuffet had imagined. The ground, treated like the rest of the construction, with planes, hollows and relief, creates a form of sculpturally modulated horizontality that ensures continuity

First maquette of the
*Jardin de la Villa Falbala**
Plaster cast from the clay
maquette made with the help
of architect Roland Morand
31 March and 3 April 1970,
painted by Dubuffet in May 1970
Fondation Dubuffet, Paris

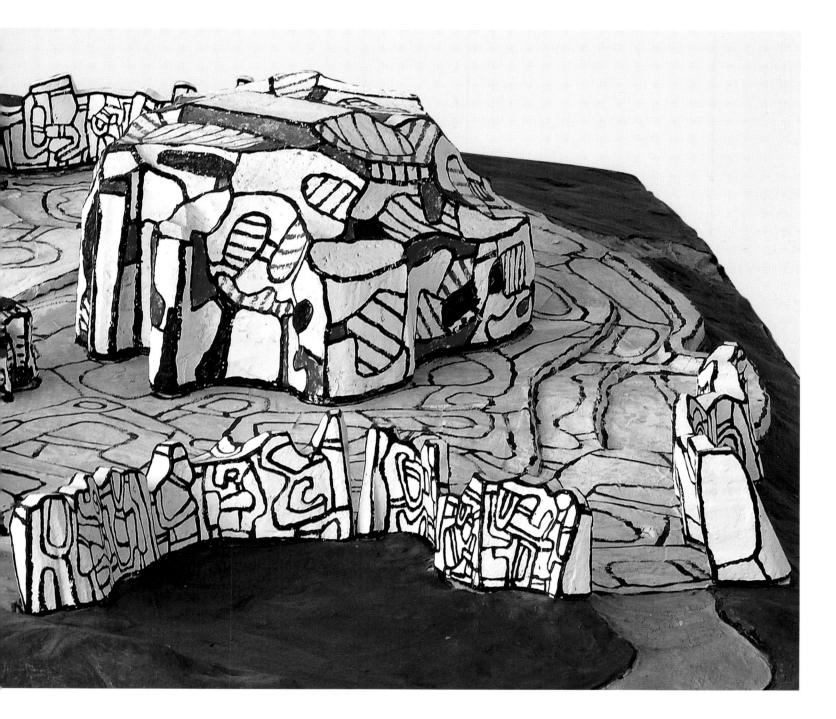

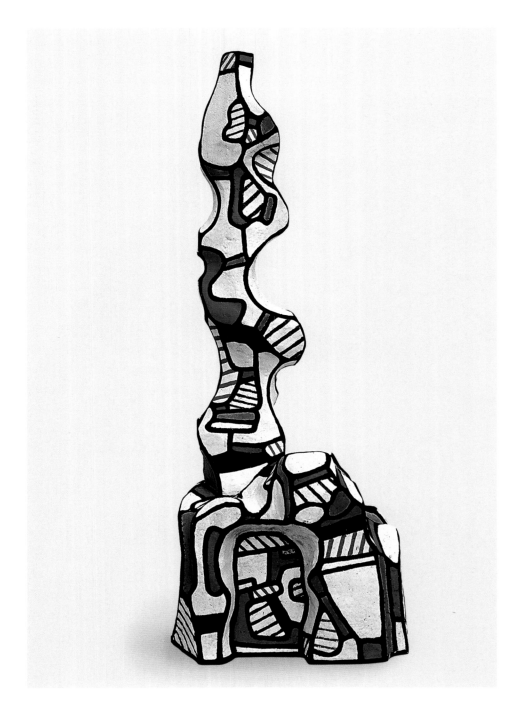

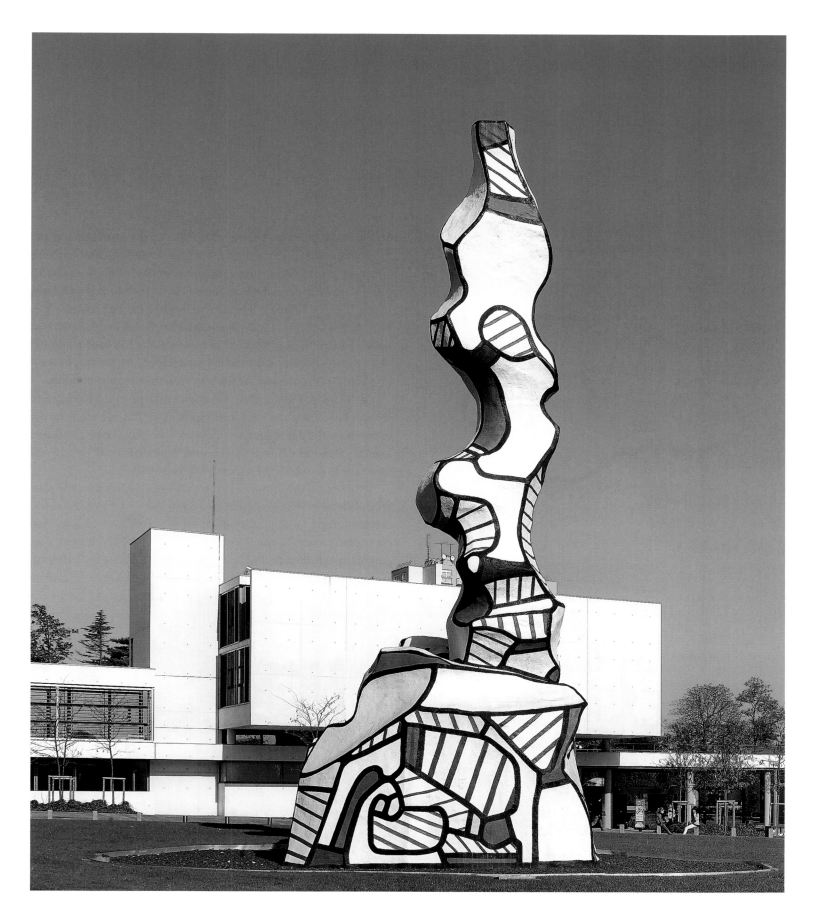

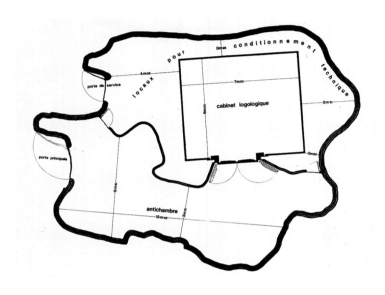

Plan of the *Villa Falbala* *
16 July 1969
Archives Fondation Dubuffet, Paris

Maquette of the *Villa Falbala* *
(1:10) based on the 3,000
measurement points obtained
by Renault's Delta machine
White polyester
85 × 200 × 150 cm
January 1971
Fondation Dubuffet, Paris

***Villa Falbala* (first state)** *
Polystyrene with vinyl paint
85 × 200 × 150 cm
28 February 1969

between the two erect elements that make up the main building and the sculpted surrounding wall. On 4 May 1970, Dubuffet wrote to Paul Weidlinger: "I have made a maquette (in clay) of the site as I wish it to be with a flat esplanade in the centre (at present it is a uniform slope). The *Villa Falbala* will be surrounded by a painted concrete 'garden', itself contained in walls (made in concrete and also painted) that twist and turn. A plaster mould of the maquette has been made and sliced into sections, and the ground, landscaped into the shape I want to give it, has been drawn up as a plan with the contours indicated."

On 11 August 1970, Dubuffet again wrote to Paul Weidlinger to let him know how the work was proceeding: "For the moment the contours on the clay maquette I made are being bulldozed into shape, together with the drainage system and the flat area for the concrete foundations on which the building will be erected."

Establishing the contours in three dimensions based on the plaster maquette proved easy compared to the job of getting the measurements right for the building's metal framework, which had been contracted out to Groupmetal in keeping with Paul Weidlinger's suggestion. It is to him that Dubuffet constantly turns as fresh difficulties crop up. He unhesitatingly admits: "I have no complete trust in fact in either Bernard Sauvé or Roland Morand or Robin. You are the only one I completely trust. How I wish that you were here in Paris to advise me and take matters in hand yourself."

On 28 August 1970, he informs him: "I intend to purchase an 'inflatable structure' with a surface area of 400 or 500 square metres and 10 metres high so that from November onwards we can continue work under cover. I am in touch with a specialist about it. Do you approve?" This plan was designed with the collaboration of Hans Walter Muller, even though in the end an ordinary hangar was the preferred option. Yet the rest of the letter shows to what extent Dubuffet was personally involved in overseeing the works and attempting to anticipate any problems that might arise:

"When we are ready to cast the concrete foundations that will bear the weight of the *Villa Falbala*, you will be needed to determine the exact points where the framework will be set in and especially the exact siting for the pillars you have planned for the corners of the *Cabinet logologique*. Maybe you could deal with this even now. I think

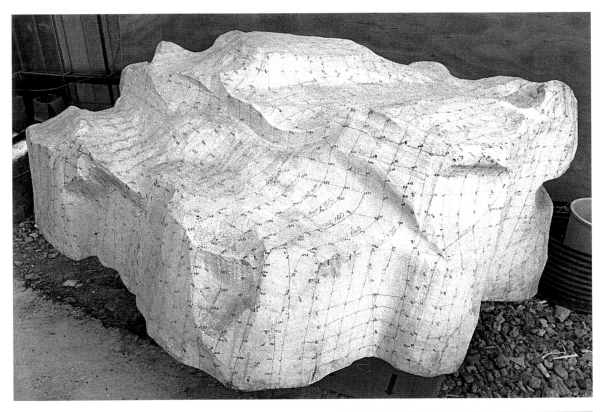

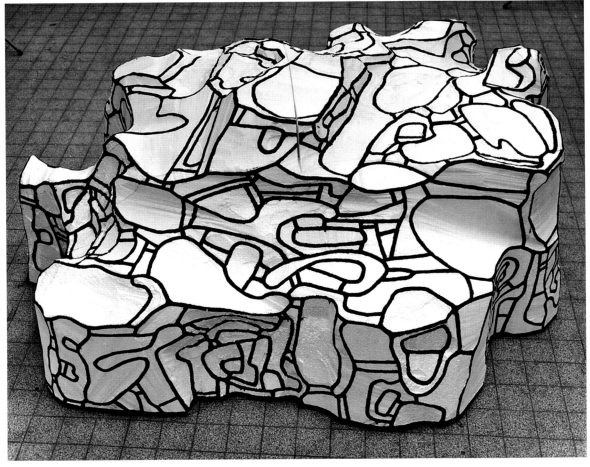

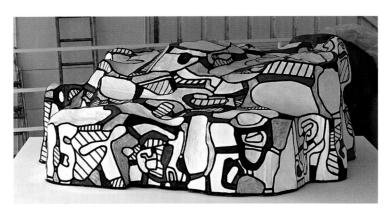

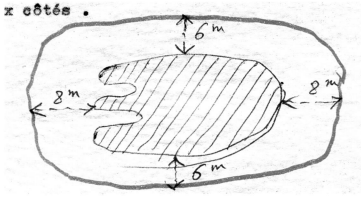

Villa Falbala (final state)*
Transfer on polyester
85 × 200 × 150 cm
28 February
Fondation Dubuffet, Paris

Drawing by Jean Dubuffet
for an inflatable structure
in a letter to Hans Walter Muller
dated 13 November 1970
Archives Fondation Dubuffet, Paris

View of the building plot
for the *Closerie Falbala*
Périgny-sur-Yerres, September 1970

it will soon be necessary to have these details in order to excavate the foundations for the *Villa Falbala*.

There is another question that has not been dealt with up to present – the boiler room and the chimney. I've made a maquette for it but I don't know if the photo of this maquette was sent to you. It's a small outbuilding for the boiler with a chimney stack that goes up 10 metres, and that will be built a few metres away from the villa. An area will also have to be dug out underneath this building, and I will need you to give instructions for this, including what is needed for the foundations so that the chimney stack is firmly bedded in."

(Dubuffet finally abandoned the idea of the *Chaufferie avec cheminée*, which was to have been painted, as he also did for the second maquette of the *Villa Falbala*, with *Hourloupe* colours, when he decided on a uniform treatment in black and white for the *Closerie* and the *Villa*. The 14-metre-high construction was finally built by the Val de Marne *département* in the town of Vitry, at the Carrefour de la Libération, and was inaugurated on 28 March 1996; today it signals the museum of contemporary art in Vitry.)

The main complication that faced Dubuffet in building the *Villa* was accurately surveying the curves and reverse curves of the outer surface, in order to build the metal structure on which the polyester resin stratification would be placed, like canvas over a stretcher. The first attempt by Alain Sauvé involved slicing a plaster cast of the maquette into equal portions, but there were discrepancies between this and Paul Weidlinger's computerized calculations, at the time a new technology. It was once again to Weidlinger that Dubuffet outlined the situation on 16 October 1970:

"Yesterday in the meeting with Groupmetal and M. Escande, I saw that in many places the sections drawn up by M. Sauvé do not correspond to the data indicated on the list of coordinates. M. Escande will clarify this matter with Sauvé.

Data from the drawings and Sauvé's lists of coordinates will be checked by Groupmetal against the 1:10 maquette I did, to ensure we can rely on these data. Groupmetal is also going to make a 1:10 maquette of the metal framework."

But by 10 November, Dubuffet was already looking for other solutions. He wrote to Claude Renard, head of Renault's Art et Industrie department:

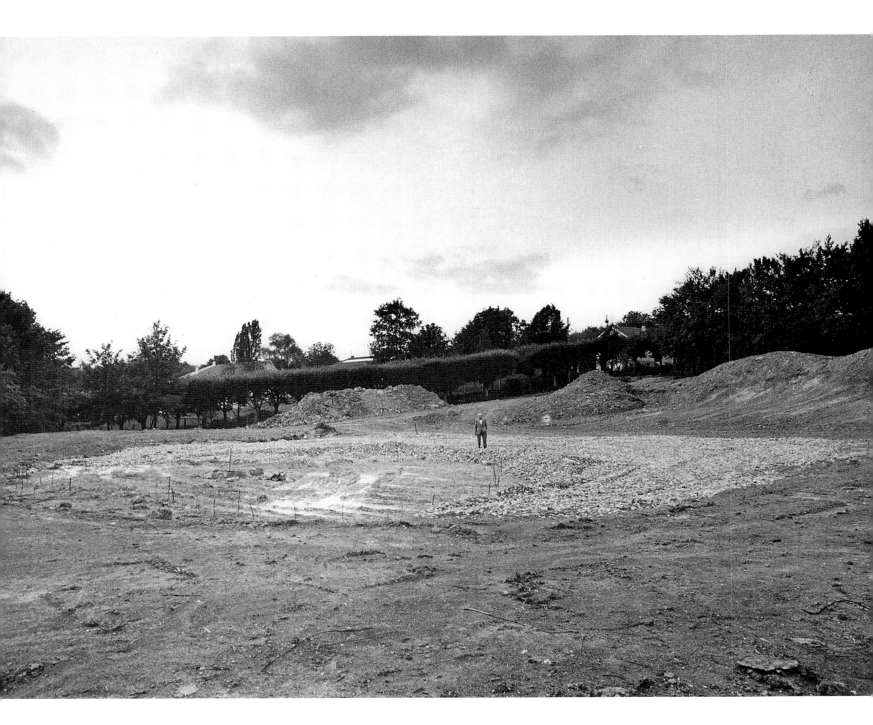

BELOW
Building permit for the *Villa Falbala*
drawn up by Rolland Morand, architect
30 March 1970
Archives Fondation Dubuffet, Paris

FACING PAGE
Jean Dubuffet on the *Closerie
Falbala* construction site
Périgny-sur-Yerres, October 1972

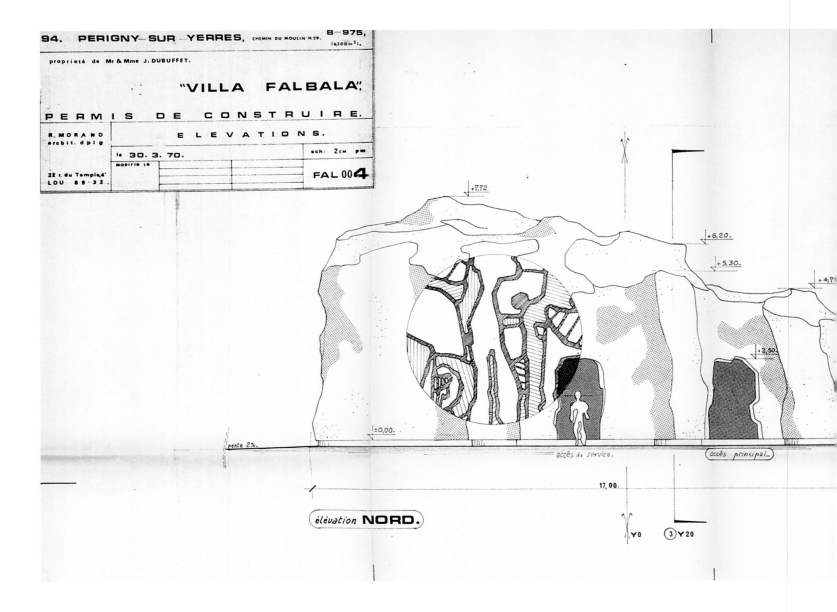

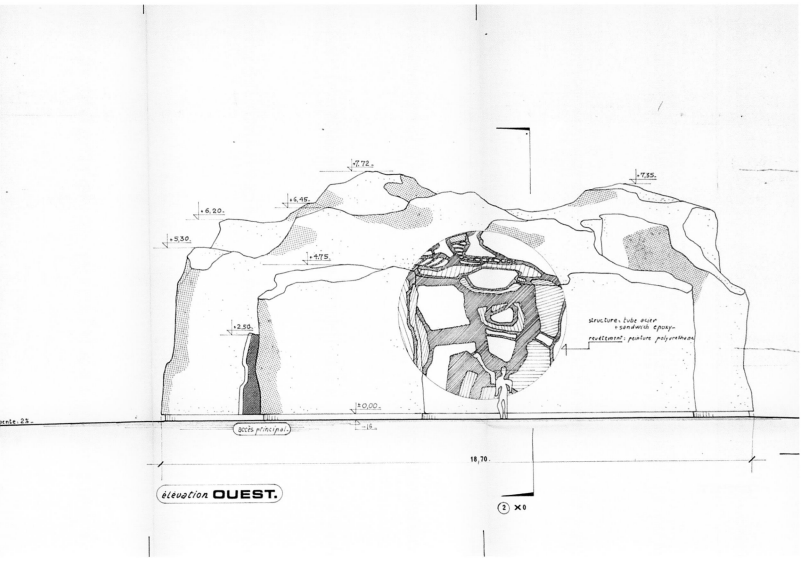

structure: tube acier
+ sandwich epoxy
revêtement: peinture polyurethane

+7,72.
+7,35.
+6,45.
+6,20.
+5,30.
+4,75.
+2,50.
±0,00.
−16
accès principal.
pente: 2%.
18,70.

élévation **OUEST.**

② ×0

The metal structure for
the *Villa Falbala*,
with the inner cladding
Périgny-sur-Yerres, 22 March 1972

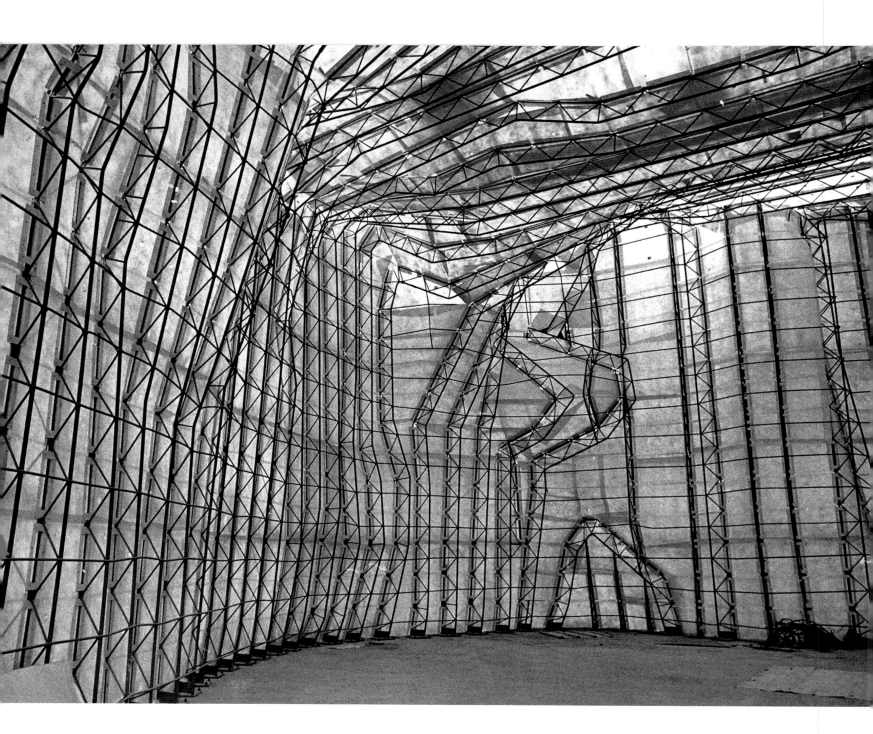

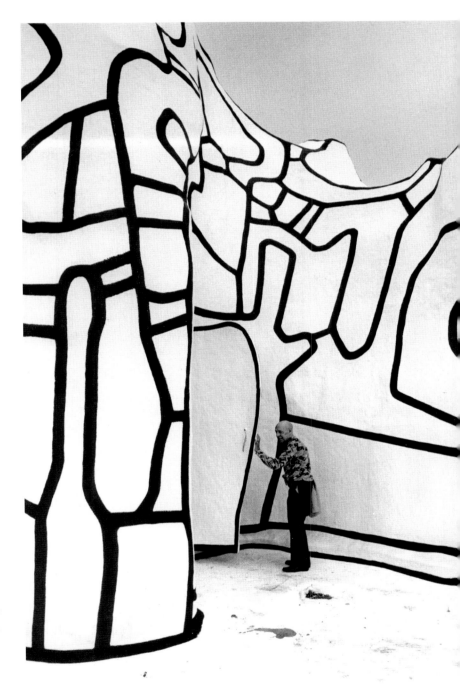

"I have a very difficult job to do determining in the three different planes the cross-sections of my *Villa Falbala* so that it can be built exactly according to my maquette.

Monsieur Jacques Robin, who is assisting me with the resin construction for the *Villa Falbala*, tells me that the Renault factories now have a machine (Italian-made I believe) that is custom-built to perform this operation very quickly. It is a machine that establishes the points on a form and transmits them to a magnetic tape that then supplies all the coordinates. It is a machine in Department 56 called Delta 3D or something like that.

Could you intervene on my behalf so that the operation for the three cross-sections of *Villa Falbala* can be done using this machine?"

He later wrote to Pierre Dreyfus, chairman of Renault, on 31 January 1972, that the success of the operation was beyond all his expectations: "I wish to express my gratitude to you for consenting to the operation which took place the day before yesterday and which established the measurements for the maquette of my *Villa Falbala* in three dimensions using your Delta 3D machine. . . . The operation was a considerable feat requiring two continuous weeks' work for several technicians, who saw to its successful outcome with great care and attentiveness. Over 3,000 points were fixed to a 100th of a millimetre, and marked on my maquette with the corresponding data.

This operation, which will now enable me to carry out the construction with the absolute accuracy that is so vital to me, was generously provided completely free of charge as part of the arts creation programme that, following your impetus, the Régie Renault has so generously implemented, and to which Monsieur Claude Renard contributes his enlightened commitment."

Spurred on by this enthusiasm, an official relationship between Jean Dubuffet and the Renault automobile company commenced. It resulted in one of his two largest projects, the *Salon d'été*, and ended in a manner that could not possibly have been foreseen at the time.

From that point, it took six months to finish work on the villa. A handwritten note from one of Jean Dubuffet's collaborators related the history of its completion:

"To take the weight of the *Villa Falbala*, a metal framework was built. It was not possible to make it to the exact shape of the outer skin.

115

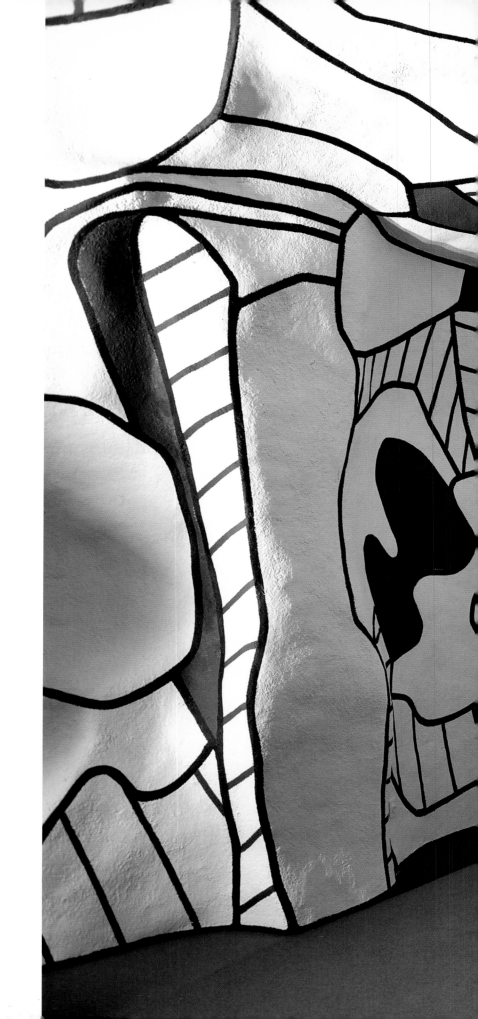

**Antechamber to
the *Villa Falbala***
Epoxy with polyurethane paint
August 1974–July 1976

116

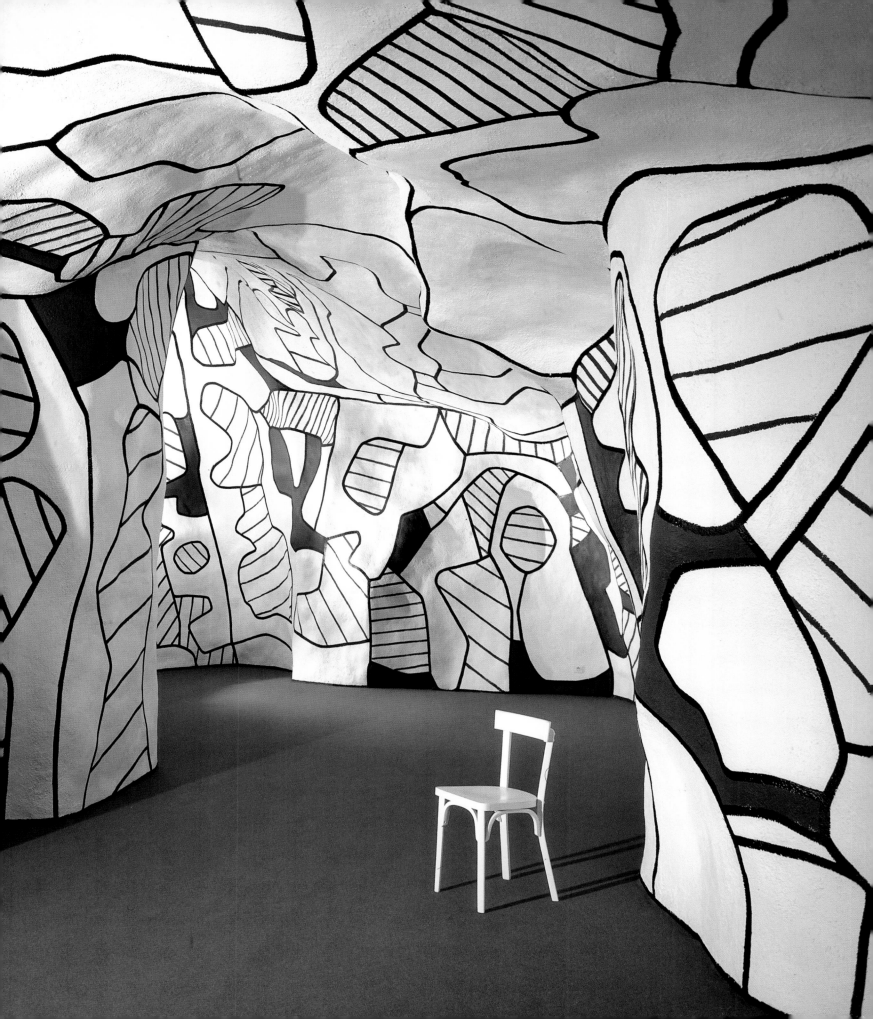

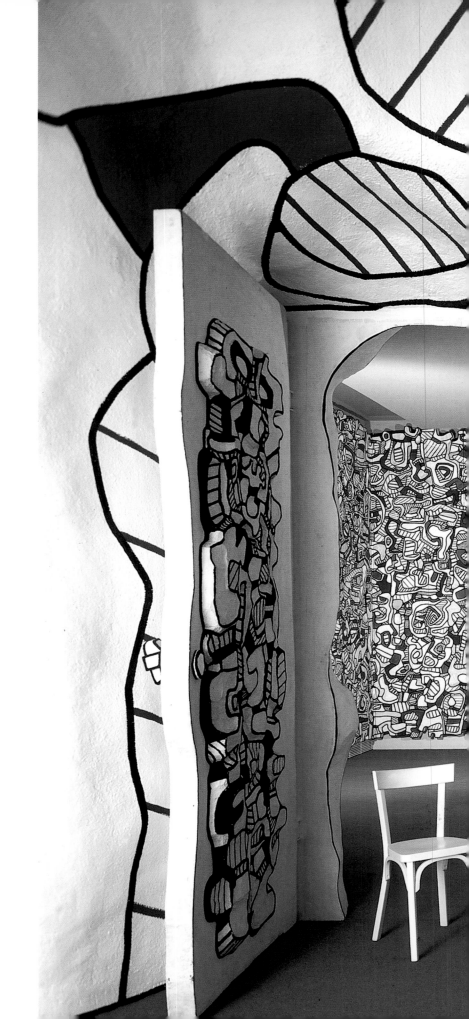

Antechamber to the *Villa Falbala*, doors opened on the *Cabinet logologique*

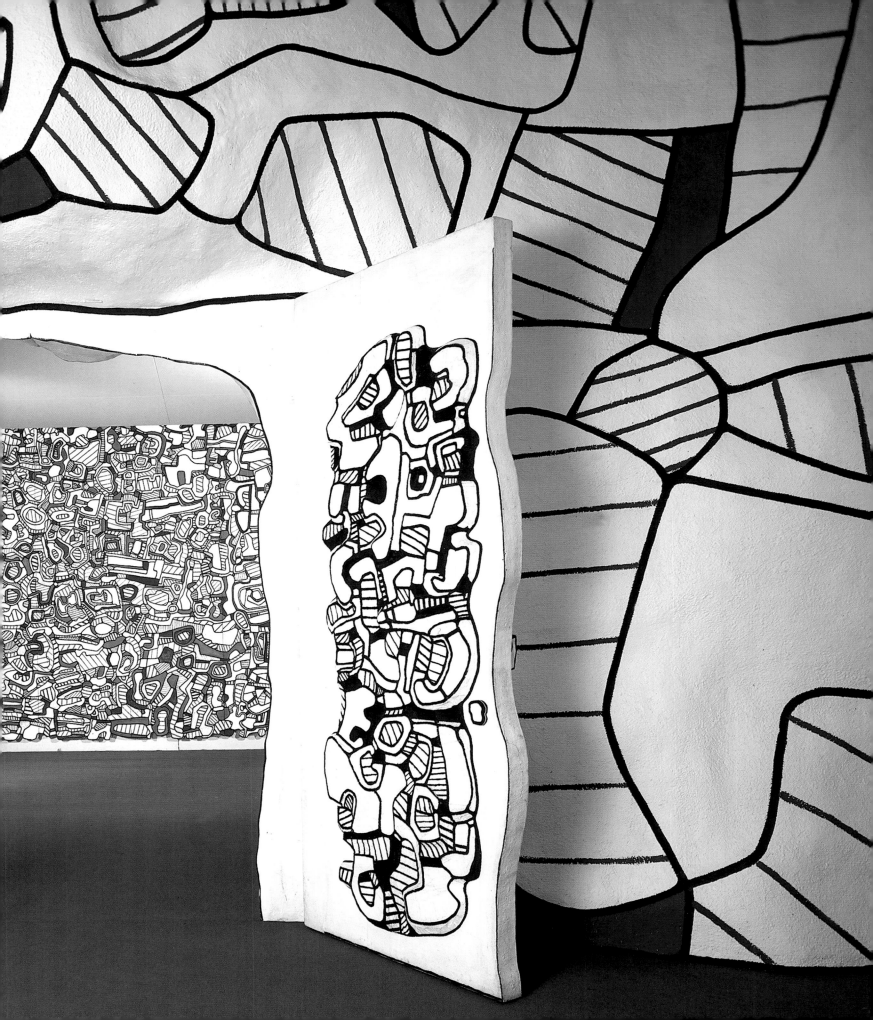

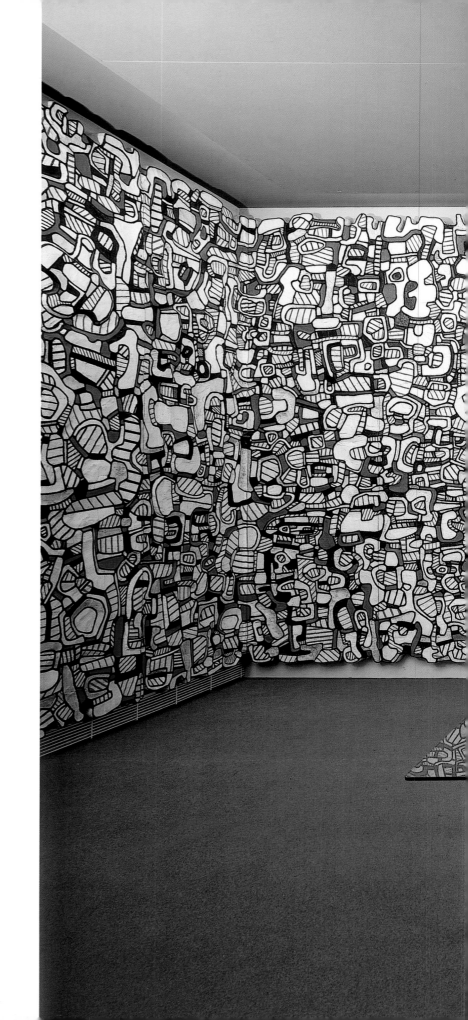

Cabinet logologique
Transfer on polyester
350 × 700 × 600 cm
August 1967–February 1969

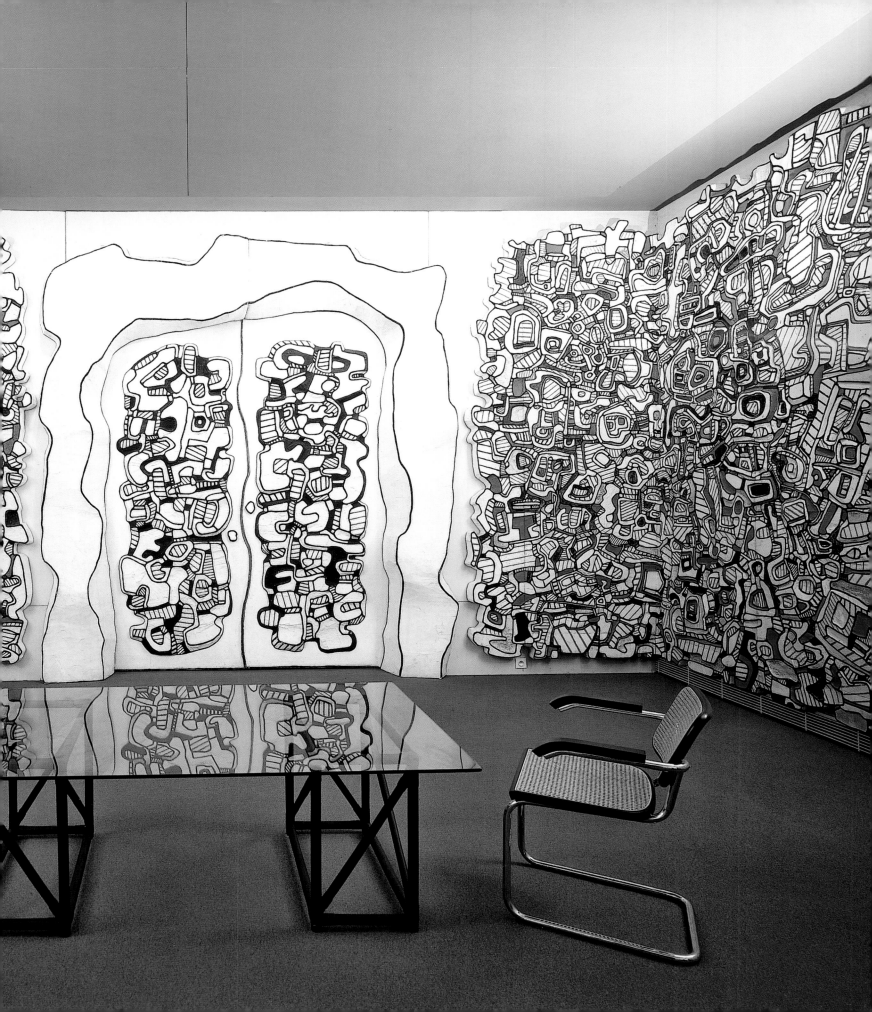

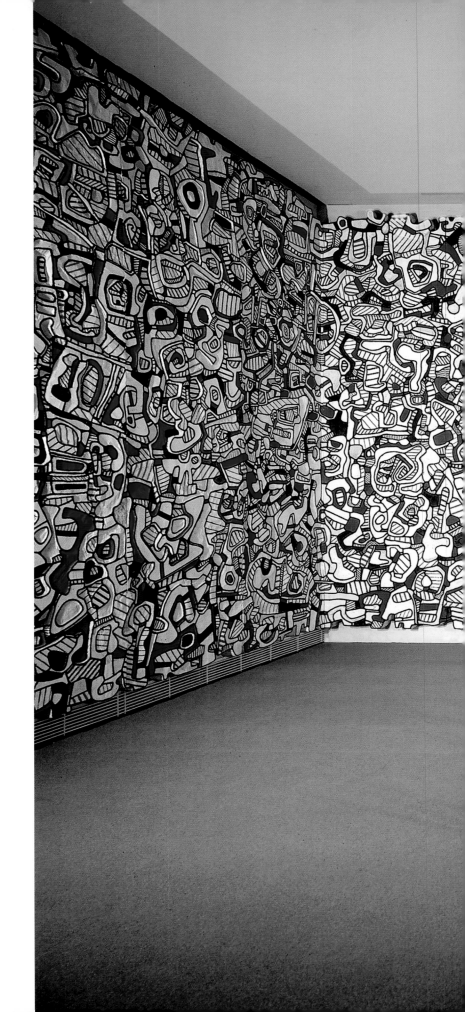

Cabinet logologique

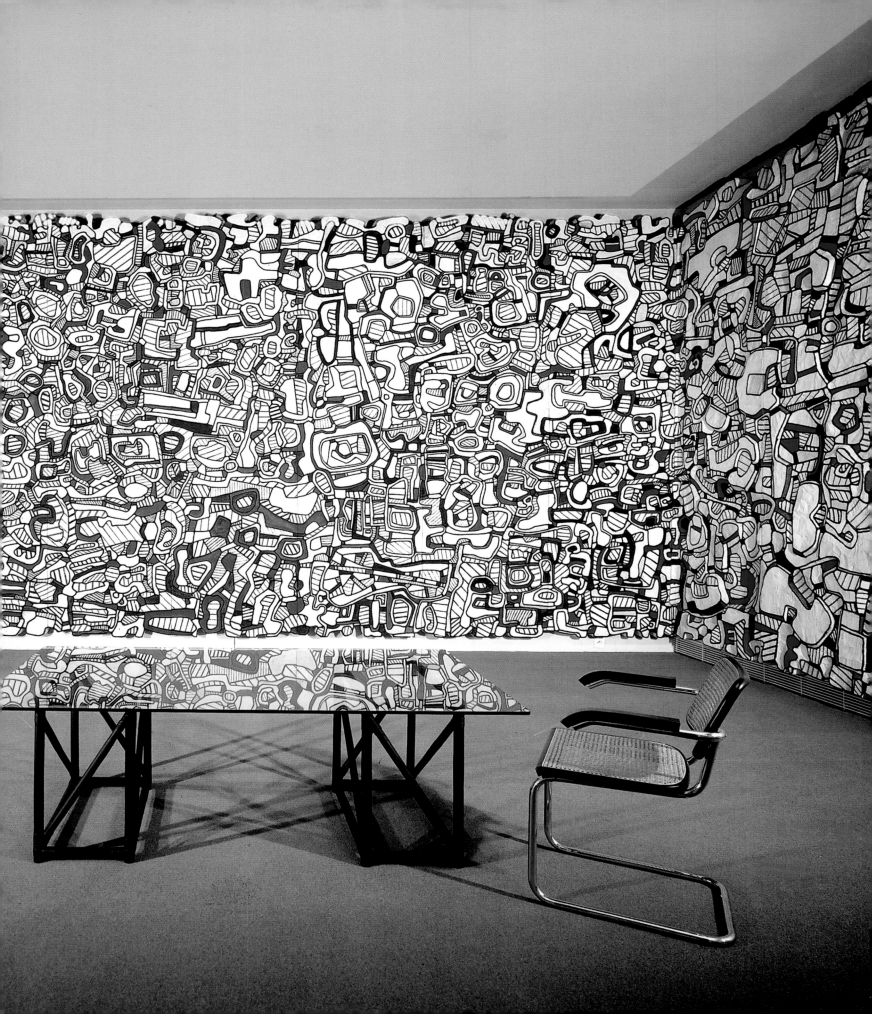

FACING PAGE
Building the *Closerie Falbala*:
black lines transferred onto
the white-painted ground
Périgny-sur-Yerres, June 1973

The distance between the metal framework and the inner skin varied from 5 centimetres to 100 centimetres. This detail was important, as it conditioned the amount of wadding needed between the inner and outer skins. The inner skin was made with sheets of polyester reinforced with fibreglass, using nearly 300 sheets measuring 100 × 200 centimetres. The sheets were cut to size and riveted on to the metal frame with thermal expansion joints. The wadding was fixed on to the inner skin formed by the sheets. The wadding (similar to what is used for shuttering) was initially planned to use expanded glass beads fixed together with polyester resin. A trial over 10 square metres was carried out. The material was very easy to handle and gave an impeccable finish. Unfortunately, it had to be abandoned for technical reasons and more especially its high cost. It was replaced by expanded clay beads. After many problems, mainly the non-polymerisation of the polyester caused by the water retention the material was prone to, it was stoved on site just before use. Two hundred cubic metres of clay were needed and 12 tonnes of polyester. The wadding was cut to size by hand.

From the outside, the form that took shape had a brownish aspect. Then the outer skin – fibreglass reinforced polyester 3 millimetres thick – was sprayed onto this by a machine. The process went well for the flat and horizontal surfaces, but there were many problems with the angular, vertical and, in places, the overhanging surfaces. All this was solved, but with great difficulty, and led to delays. A final top layer of white gelcoat was applied. All that remained was the white paint and the black lines. Sanding was advocated at this stage, but as it had not been planned, for one thing, and as the skin was too thin (3 millimetres), it all had to be redone. The skin was built up to a thickness of 10 millimetres, and the definitive coating of paint applied, giving the *Villa Falbala* its current aspect."

Plan for the *Jardin Falbala*
Marker on paper
46 × 56 cm
27 February 1971
Fondation Dubuffet, Paris

PAGES 126–129
Closerie Falbala
Painted epoxy resin
and sprayed concrete
1971–1973
Surface area: 1610 m²
Fondation Dubuffet, Périgny-sur-Yerres

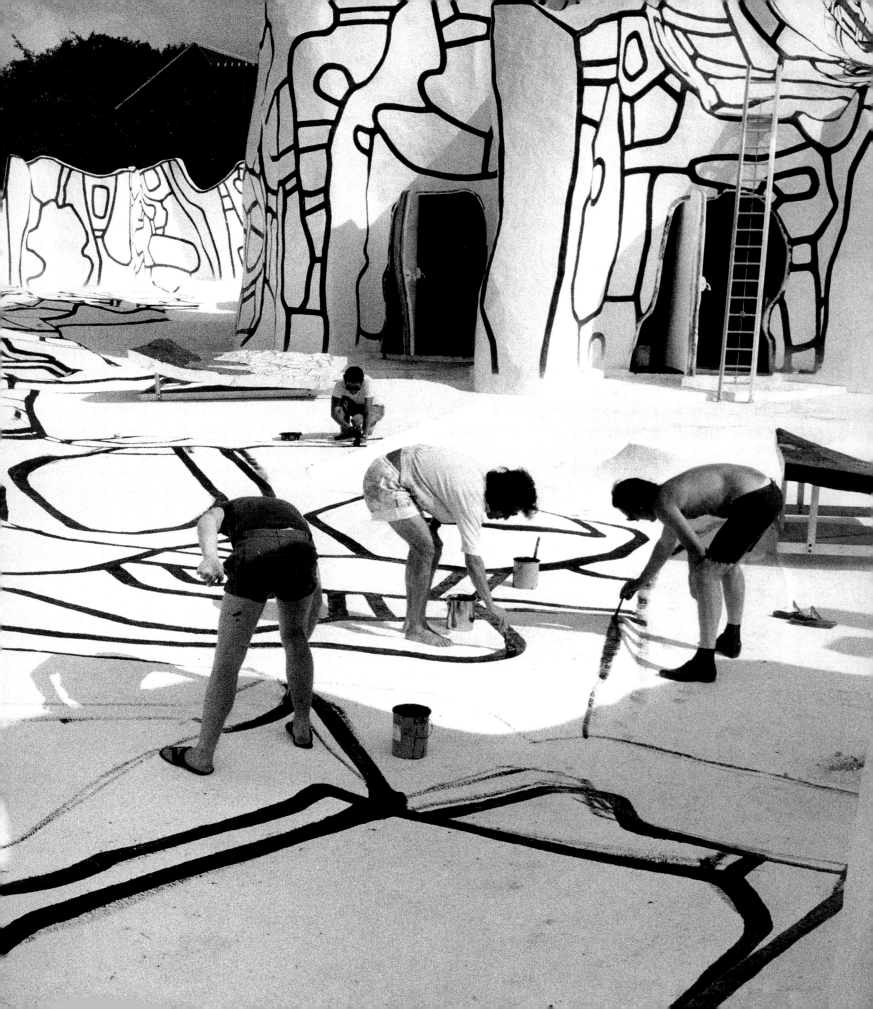

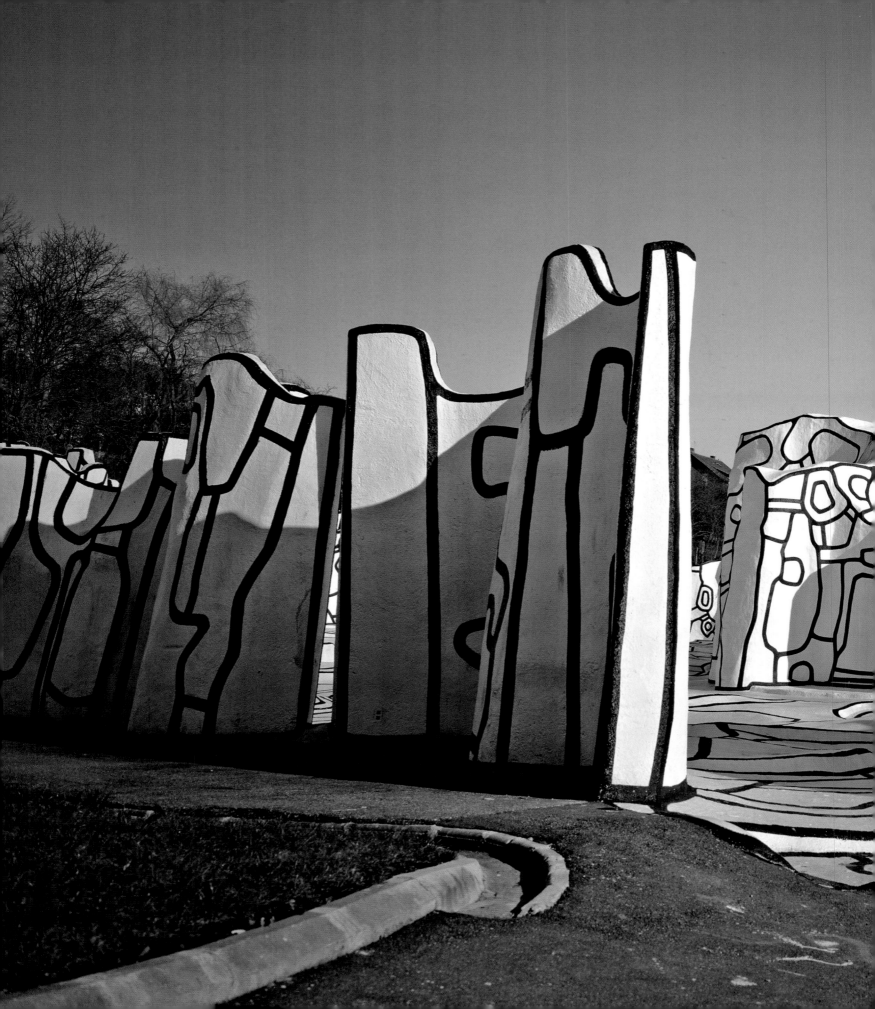

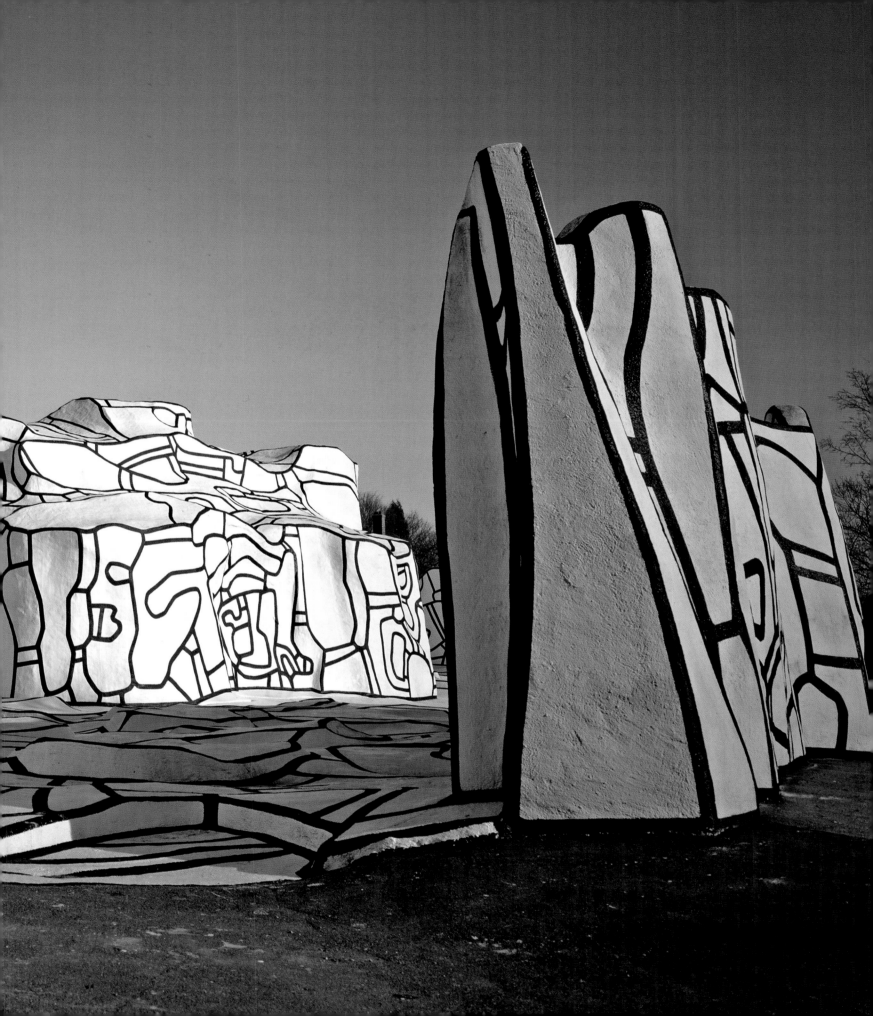

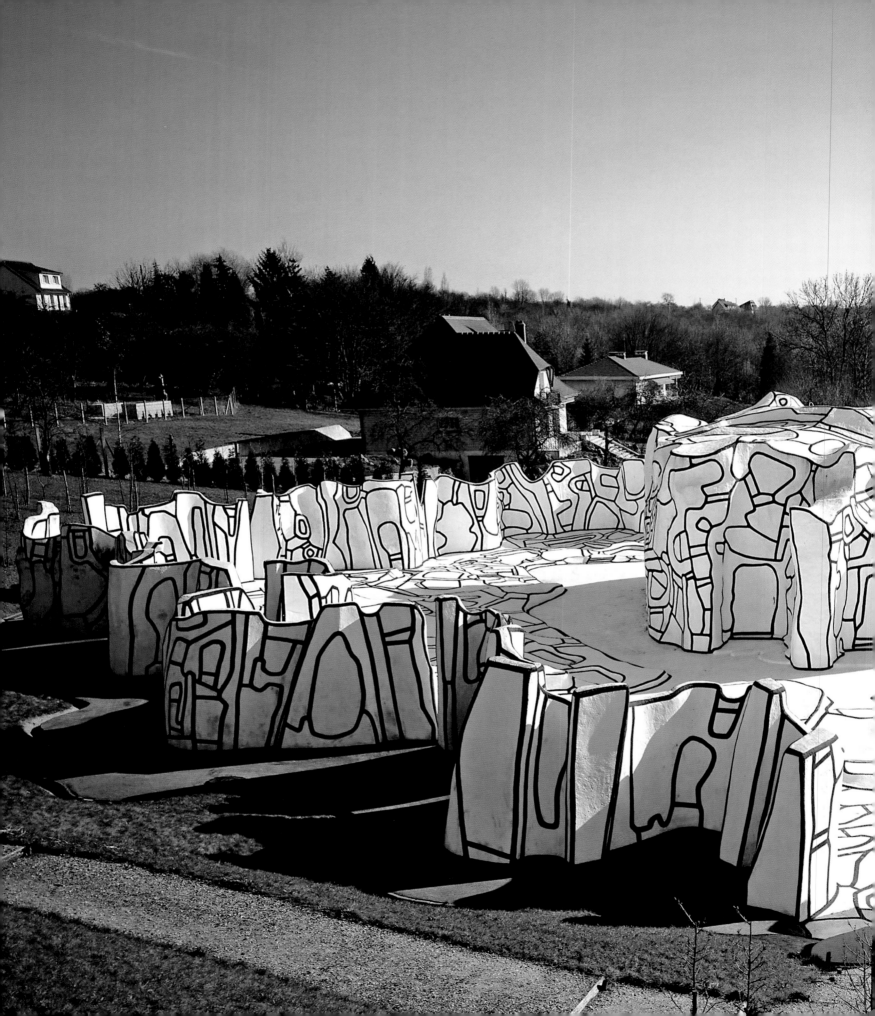

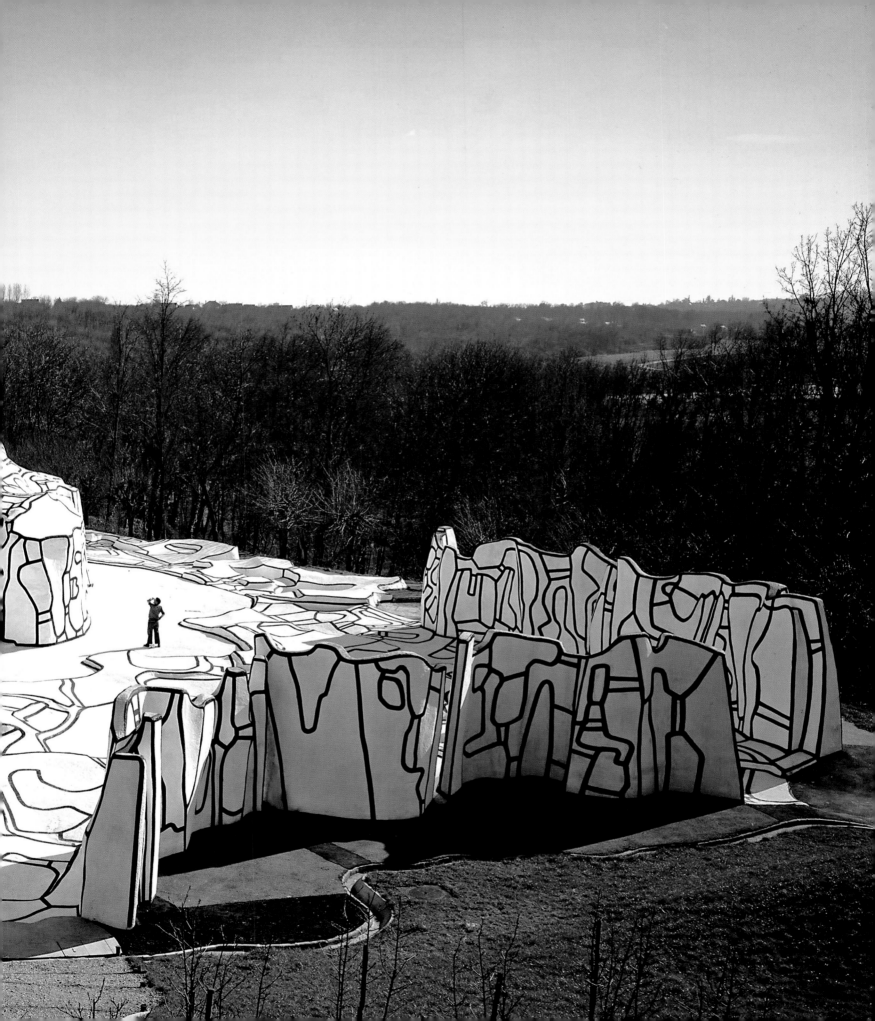

Lost Illusions

An artist's folly – this was the *Villa Falbala* in every sense. In 1690, Furetière wrote in his dictionary: "There are also several houses called follies by the general public, when someone has laid out a greater expense than he could, or when he has built it in an extravagant way." But however ruinous building the *Villa* was, it was still tangible proof that with the *Groupe de quatre arbres*, *L'Hourloupe* had moved beyond the realm of pure intellectual speculation and become reality. These extraordinary successes led to other commissions: one for the *Site scripturaire*, part of a monumental sculpture trail that the urban planning authorities for the Paris-La Défense area (ÉPAD: Établissement public pour l'aménagement de la région de La Défense) wished to create between the Seine and the esplanade at La Défense, and another from the Régie Renault for a monumental sculpture – the *Salon d'été* – in front of the new head offices in Boulogne-Billancourt. Yet what might have been Jean Dubuffet's ultimate achievements turned into disillusionment.

Just as work on the *Groupe de quatre arbres* for the Chase Manhattan Plaza in New York was finishing, Jean Millier, the chairman of ÉPAD, got in touch with Jean Dubuffet in spring 1972 to ask him to think about a monumental project that was to be installed halfway down the slope at La Défense. According to Germain Viatte, who initiated the project: "Because of a difference in level of about three metres, there was a clear space of about 60 × 60 metres, which in terms of the area of La Défense was equivalent to the distance from the Arc de Triomphe to halfway down the Champs-Élysées. When presenting this site to the artist, the urban planners emphasized its character as a crossroads, the special location it would provide as a permanent forum for different activities, an area for strolling and resting in, with various amenities below the residential buildings that at this point squeeze the architectural space, forming terraces in front of the taller tower blocks to the sides. Jean Dubuffet listened very courteously, set to work and very soon brought us his project."

For this undertaking, whose scope went far beyond the four New York sculptures, and whose ambition, urban location and use by the public involved difficulties in excess of any posed by the *Villa Falbala* when it was being built, Dubuffet requested and obtained permission to be assisted by an architect of his own choosing: Ieoh Ming Pei. This name was not a random selection: two years previously, in

1970, I. M. Pei, who was building a new wing for the National Gallery in Washington, had already asked Jean Dubuffet to make a group of monumental figures for the entrance hall to the East Wing. Although the project was still under study (and did not come to fruition), it had forged links between the two men, and Dubuffet, still rankling from the quick turnover in foremen employed on the *Villa Falbala*, thought he would be able to benefit from the architect's skills and his associates' know-how. On 13 November 1972, he wrote to I. M. Pei: "Contrary to Gordon Bunshaft's pessimistic opinion, I think this

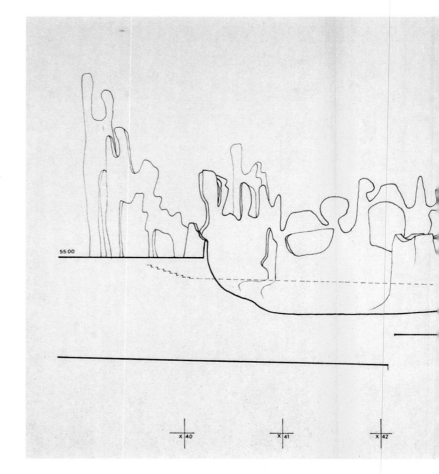

proposal should be accepted. . . . But I absolutely want you to assist me in the undertaking. Of course, I will insist that you are paid for this work, and generously paid. Will you accept? It's especially during the design stage that I will require your help. For the construction, if it reaches that stage, I will be assisted by a local architect called M. Poilpré, who has assisted me with all my building work at Périgny and elsewhere." The reply, dated 7 December, was enthusiastic: "Your trust in me for the La Défense project is very flattering. Nothing, I think, would please me more than to work with you on this project."

Longitudinal cross-section of the *Site scripturaire*

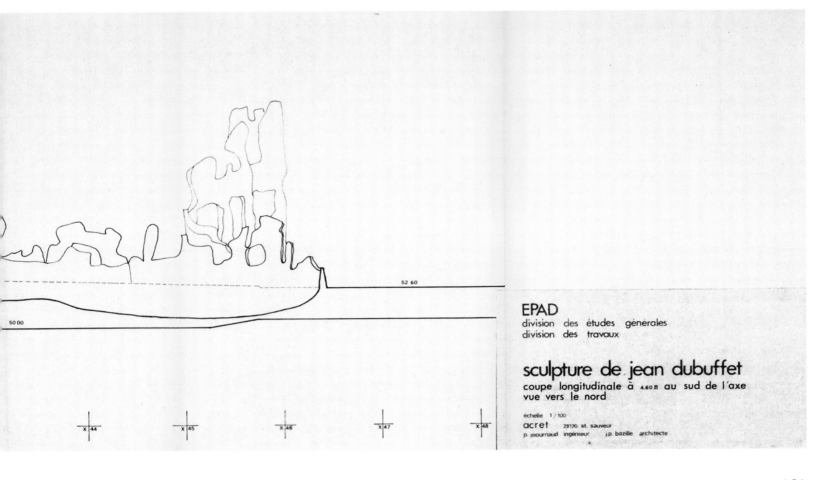

After ÉPAD agreed in principle to the project for the monument and the collaboration on 21 May 1973, Dubuffet started work on a first polyester 1:10 maquette between 11 and 29 May. It was presented to Jean Millier on 14 November. The principles behind its design and installation were defined subsequently: "The set of elements for the *Site scripturaire* is as follows. It cuts right across the straight, broad, tree-lined avenue from Paris that is reserved for pedestrians. Anyone wanting to continue walking will have to go round the *Site* either to the right or left. In either case, they will pass under some tall vertical elements with holes and archways through them. Other lower elements provide seating in many places. At the centre of the *Site*, there is a lower area that evokes a landscape: this is not accessible and must remain deserted, a spectacle just for looking at. A little castle rising in the centre, with an internal staircase, offers a view from the top. The little elevated train which goes right along the *Site* on the left is hidden from view by a series of tall elements whose wayward forms have openings for the travellers using the train to glimpse the *Site* as they ride past. The whole thing will be painted white and historiated with black lines, and will have an aberrant, ghostly character."

On receiving Dubuffet's photos of the maquette in progress, I. M. Pei replied on 16 August: "First of all, I am enchanted by the photos of the maquette. Even without the colours, I can see the many animated qualities it has. I look forward to seeing them in three dimensions." In his reply of 29 August, Dubuffet stated: "I have been actively working on the maquette for La Défense all through August and it is now finished and ready to be examined by you. In my mind, it is more a pre-maquette that will suggest ideas to both of us for a further one that may be made afterwards. However, this first maquette is sufficiently finished and exact for an engineer to evaluate it even now, for an estimation of the cost of the final construction. I think an estimation will be useful so it can be taken into account should I need to do another maquette."

In a letter dated 4 October 1973 to Jean Millier, I. M. Pei outlines his view of the collaboration: "I am responding to your invitation to work with Jean Dubuffet on his project for La Défense. I am sure you will agree that it is a very unusual task and I must admit that after much thought I still find it difficult to define the part I will play in this project. Nonetheless, I will attempt to describe what I consider to be my role:

1. Identifying the architectural and structural constraints that Dubuffet's sculpture might involve

2. Suggesting modifications, if need be, so that there is compatibility between the sculpture and the environment

3. Working with M. Dubuffet to prepare the maquette to be presented to ÉPAD.

I note that this phase of the work should be carried out over a period of about five months. In order to accomplish this within the time frame, I will be assisted by M. Yann Weymouth, a French-speaking architect whose main responsibility will be to work with M. Poilpré and the technical team from the ÉPAD."

In a long letter (21 November 1973), Dubuffet summarizes the situation for I. M. Pei:
"A meeting of the ÉPAD advisory committee took place last Wednesday, 14 November. M. Millier attended, as well as M. Boistière, M. Moritz and an engineer whose name I have forgotten and who is in charge of ÉPAD's building projects. We met first at Périgny, where M. Millier and the others seemed very interested in the *Closerie Falbala*. We then went on to my studio in the rue Rosenwald, where M. Millier seemed interested, even enthusiastic, about my maquette for La Défense. I spoke to him for a long while. The cost indicated by M. Weymouth and M. Mournaud did not put him off at all, in fact the issue of cost did not seem to have been uppermost in his mind. The question of the speed of delivery of the final maquette and also the subsequent construction was more important to him.

M. Millier and his associates would like the public to be admitted, at least on certain days and at certain times, inside the sculpted garden, wearing protective footwear which would be available for hire.

Now I must begin work on another maquette based on the various transformations we decided on when you were last in Paris. The task is one I find perplexing and worrying, as I think I will have to completely remake another maquette, which is a considerable task. To begin with, I will have the existing maquette moulded and made in epoxy, which operation is already underway. It will no doubt take three or four weeks. I therefore think that the new one will not be

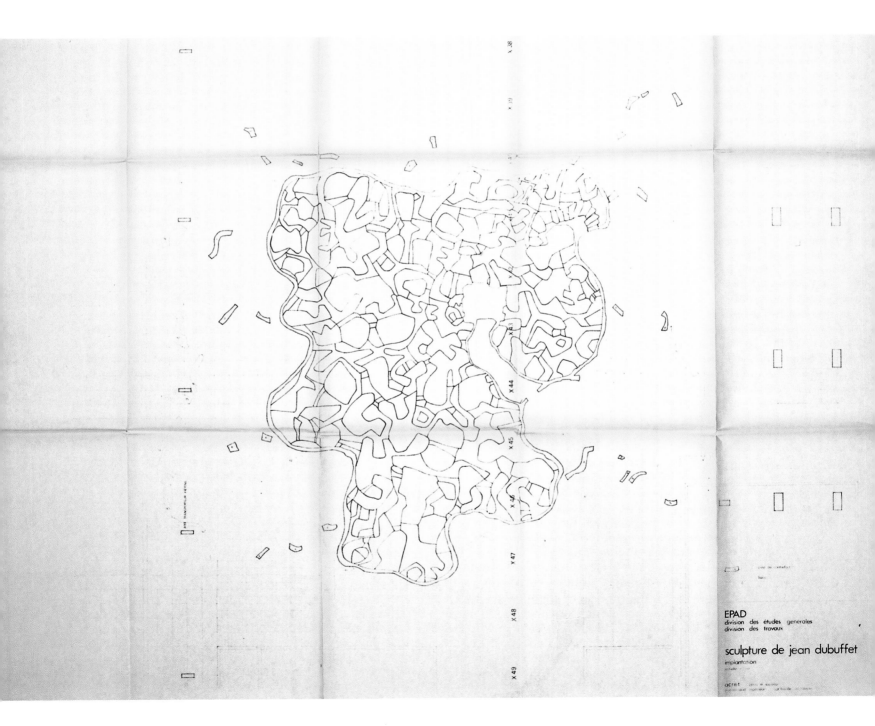

EPAD
division des études generales
division des travaux

sculpture de jean dubuffet
implantation

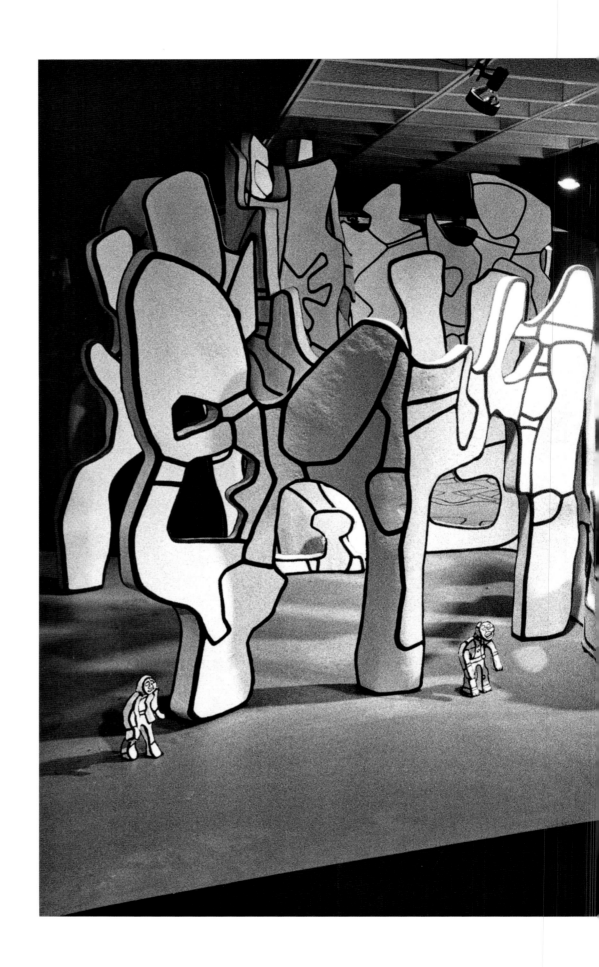

Site scripturaire II *
(1:10 maquette)
Epoxy with polyurethane paint
160 × 580 × 560 cm
12 January–17 February 1974
Fondation Dubuffet, Paris

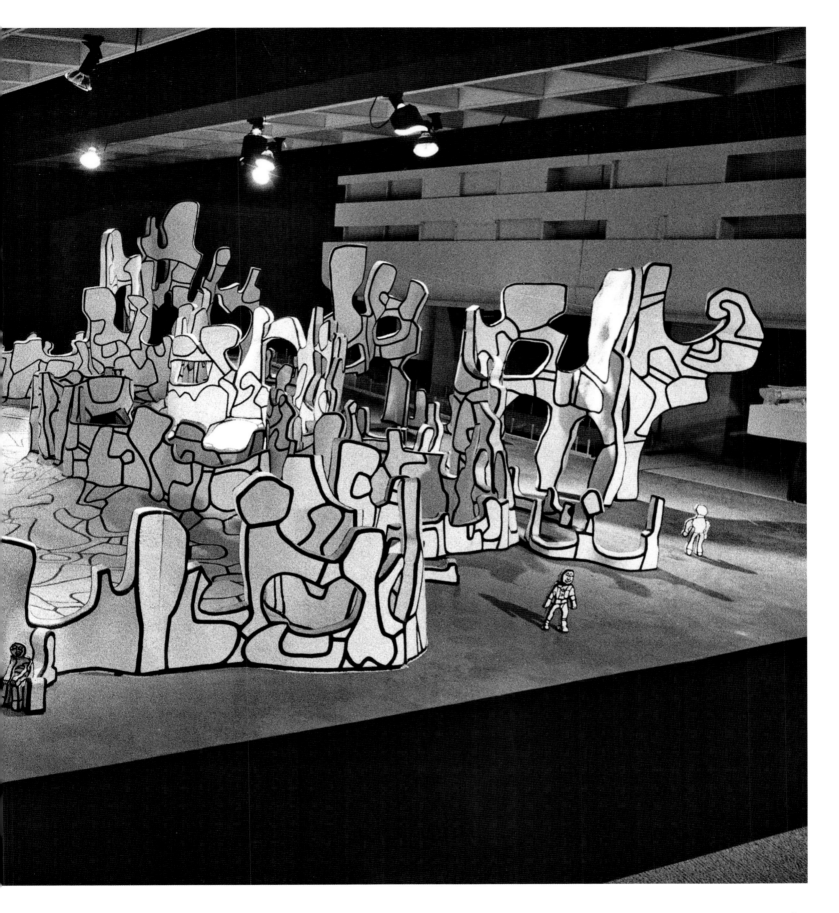

ready before late January at the earliest." (The first epoxy maquette was destroyed by the artist in 1977.)

Dubuffet was then delayed waiting for plans for a "tube" that was to run alongside the *Site* and in which there was to be either a moving walkway or, as ÉPAD had just decided, a little train, but by 12 January 1974 he was able to begin work on a second maquette that took into account the architectural constraints identified by I. M. Pei and ÉPAD, i.e. considerably raising the height of the walls of the sculpture that ran the length of the "tube" so that it and the escalator leading up to it were concealed from view. He finished the maquette just before 18 February, "on which date Monsieur I. M. Pei will come to Paris to examine it with me and present it to you," he wrote to Charles-Henri Boistière, chief architect and head of urban planning with ÉPAD, adding: "I have given it the title of *Scenic Patio.*"

When the second maquette had been approved by ÉPAD, the moulding process began. On 23 March, Dubuffet informed Charles-Henri Boistière:

"Operations for moulding all the elements that make up the maquette and the subsequent ones for the stratified castings are all underway. These operations are proving considerable. My entire team of assistants are now working on them in my studio in Vincennes [a large warehouse at the Cartoucherie de Vincennes, next to the one used by the Théâtre du Soleil, had been placed at Dubuffet's disposal in order to make *Coucou Bazar*], as well as two mould-making craftsmen. The sixty or so elements have been shared out between them. The moulding process alone will cost me 100,000 francs and the stratified casts another 50,000 francs apiece.

Initially, I had not envisaged a monument of such vast dimensions and consequently such great expense for moulding the maquette and the stratified casts. Apart from the stratified maquette that I must deliver to you, you need a further two casts, making three in all. I think I will give up on the idea of casting a fourth for my own purposes. Manipulating the moulds (which are very bulky and heavy) requires that the three casts for each of the elements be made in succession. I need assurance regarding your order for the two working maquettes. A decision on this matter must be taken urgently."

Far from giving the quick response Dubuffet expected, it was only on 21 August that the initial contract dated 13 February 1974 was amended for the Dubuffet studio to execute a single mould from the second maquette, in order to make "casts so as to establish dimensions and draw up plans . . . without endangering the original." As Germain Viatte related, Dubuffet's project "won M. Millier the chairman over immediately", but "the reluctance in his associates was soon to be bolstered by ÉPAD's financial difficulties": the oil crisis in October 1973 put and end to the *trente glorieuses*, the thirty years that France experienced after the war, and with office building programmes slowing down, ÉPAD entered a period of budget restrictions that no one could have foreseen when Dubuffet was first called upon.

What was only a delay led, however, to serious problems for Dubuffet. Writing to his usual contact with ÉPAD, Charles-Henri Boistière, on 6 January 1975, he says:
"Since last July, any decision regarding the building of the *Site scripturaire* has been on hold, meaning that I am now facing the problem of storing the moulds of the original maquette. They are taking up a large part of the space in my studio at the Cartoucherie de Vincennes.

First of all, there is the large mould for the main body of the maquette, which measures about 40 square metres. Its size means that it cannot be transported. The stratified cast to be made from this mould will therefore have to be done on site when the time comes. However, the moulds for all the separate elements (walls, etc.), of which there about forty and which take up about 90 square metres of floorspace, could be transported to other premises where the casts could also be made in due course.

This would require a properly lit and ventilated studio, at least 300 square metres in surface area. It crossed my mind that amongst the premises temporarily vacant at La Défense you might have something suitable. I would be most grateful if you could let me know whether you have such premises."

Despite the delays in making the final decision for the construction, ÉPAD carried on with its own study of the project. On 20 March 1975 – at a time when work on the *Salon d'été* for Renault's head offices had begun – Dubuffet wrote to I. M. Pei:

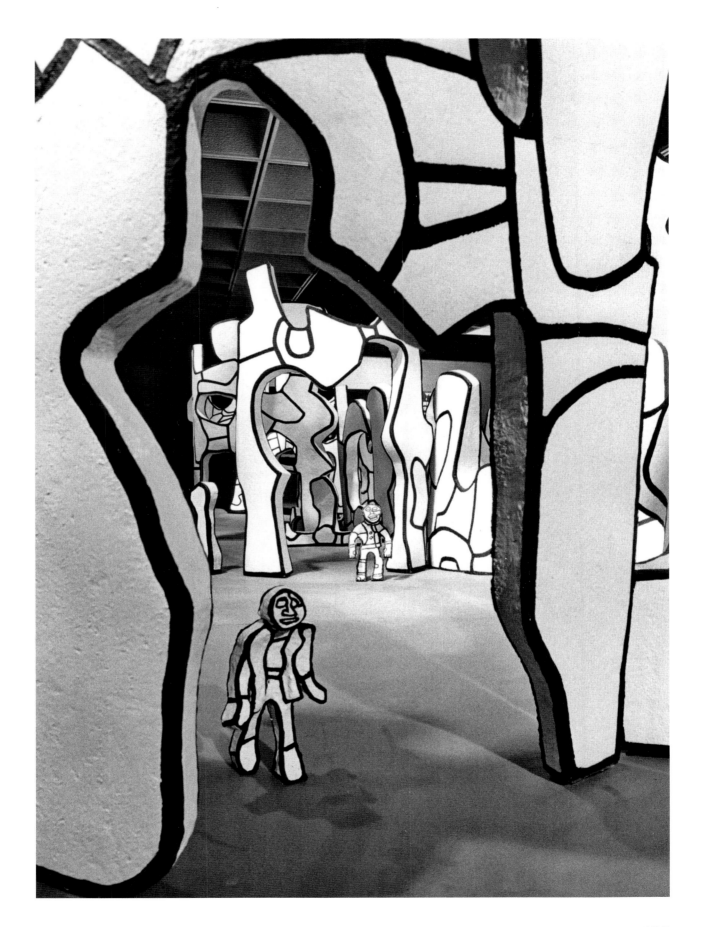

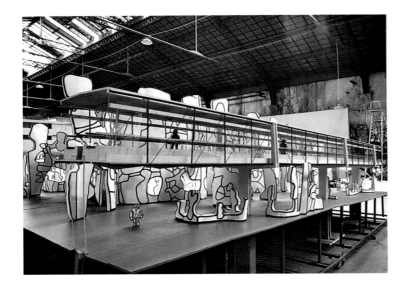

"ÉPAD (after much delay) has now brought to my studio in Vincennes the maquette elements for the buildings adjoining my *Site scripturaire* on the north side. These elements need to be located accurately and this means modifying the structure of my maquette. The structure will also have to be modified on account of changes in organizing the gradients. It has been agreed that my maquette's structure will be reworked accordingly by ÉPAD's maquette model-makers. They will also make a little construction to represent the maquette of the elevated tube with carriages inside it on the south side. The dimensions for the tube, which were given to me at the outset and on which my maquette was based, have been altered. The floor of the tube has been lowered by a metre. This worries me somewhat, as I fear that the elements I planned beneath will now be too high, and also the people riding in the carriages will be seated a metre lower than planned, below the level I had imagined for the viewpoints through the wall that give on to the inside of the monument. I will see in April, when the maquette of the tube has been installed, whether there are not too many drawbacks.

From what I have been told off the record by ÉPAD, the budget will not extend to finalizing their contractual commitments this year, 1975, either with you or me or the contractors, but they contemplate signing the contracts in early 1976 so that building can start straight away and be finished in early 1977."

Three weeks later, on 14 April 1975, a meeting took place with ÉPAD. The following day Dubuffet recounted the new developments to I. M. Pei:

"Yesterday there was a meeting in my studio in Vincennes with M. Moritz, the engineer (English) in charge of designing and planning the 'Tube' and myself. A maquette of the new version of the 'Tube' had been made by M. Moritz's department and placed on the maquette of my monument. His maquette is accurate, but was made rather crudely with elements in plywood and so it distorts the optical effect to some extent. Consequently, over the next few days M. Moritz will improve the presentation.

However, it now appears that the form and arrangement of the various elements on my first maquette, designed in accordance with the maquette of the previous tube, are no longer appropriate for the new version of the tube. . . . The result of such extensive and important changes to the tube is that the site, which on that side I had devised so that people could walk around between the tube and the monument, has become distorted, and I feel, cramped, not very congenial.

There seems to be no other solution than to re-make another maquette for the whole part of the monument concerned with new elements that match the tube's new form. For me, however, this will make a large amount of disheartening work. It's good for a work to be made in the heat of the moment, in one uninterrupted impulse, and it is not healthy if part of it has to be reworked subsequently, over a year later, when the initial impetus has gone cold. If the frame doesn't fit the painting, it would seem legitimate to change the frame and not the painting."

In a letter to Charles-Henri Boistière dated 10 November 1975, Dubuffet announced:

"The reworked maquette of the *Site scripturaire* is on the point of being finished. Only the photographs of the new arrangements need to be taken. The element that was too high in front of the windows of the residential block has been scrapped and replaced by another element, which has a very different movement but without any such drawback. A mould has been made for this element.

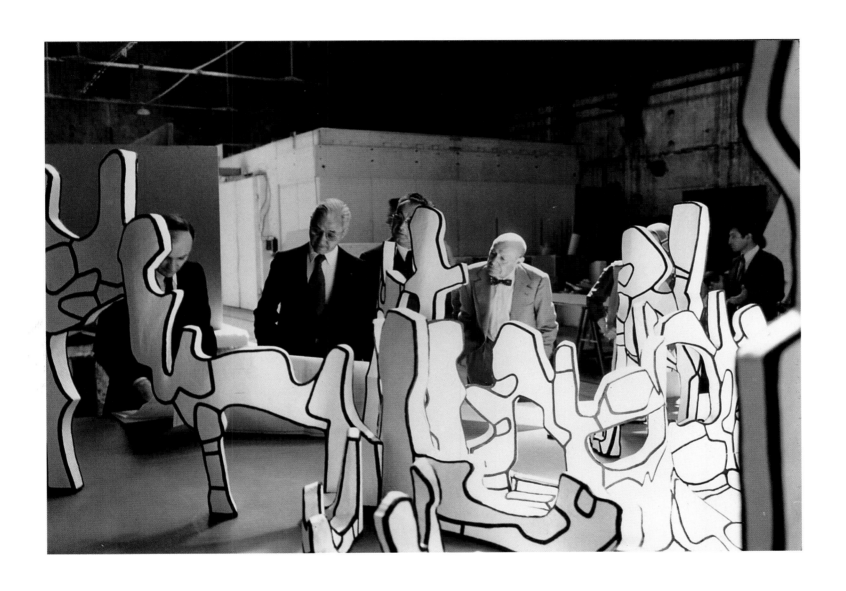

Members of ÉPAD viewing the
Site scripturaire project for La Défense.
From left to right: M. Moritz (ÉPAD
architect), M. Millier (chairman of ÉPAD),
M. Boistière (ÉPAD architect)
and Jean Dubuffet
Studio in Vincennes, 2 July 1974

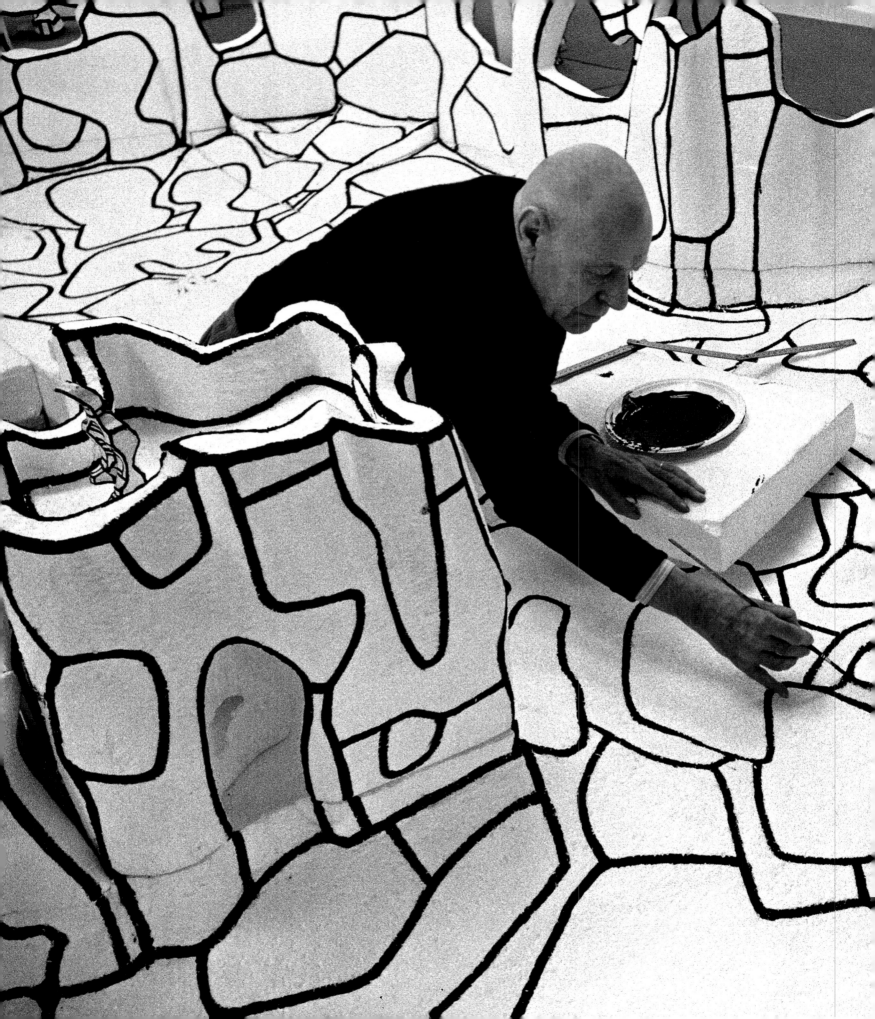

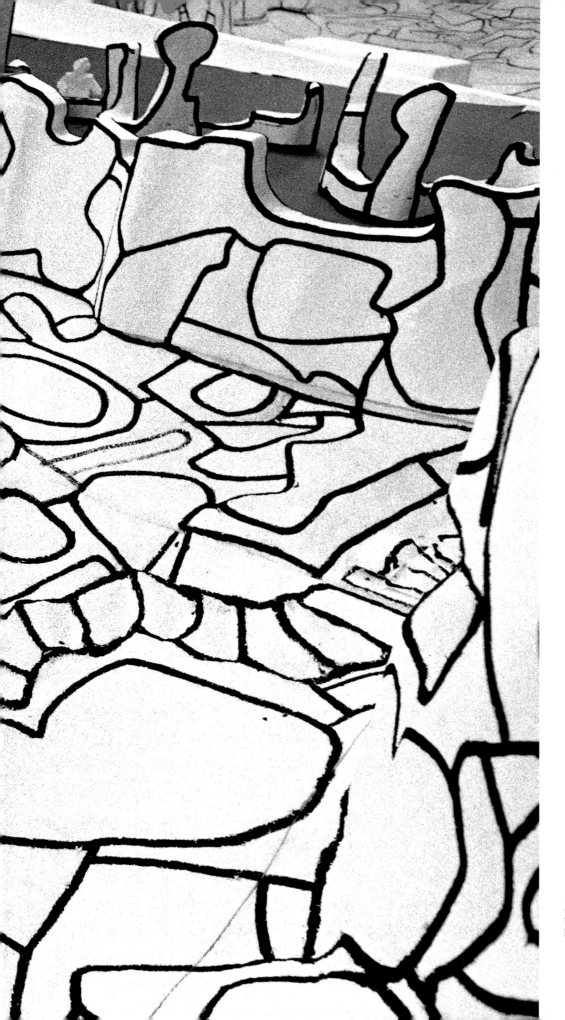

Jean Dubuffet painting the lines on
the maquette of the *Site scripturaire*
February 1974

Further, all the modifications required to match the final gradients and the differences in ground level all around the monument have been carried out. It was a considerable piece of work. Elastomere moulds of the new arrangements have been made so that they can be accurately reproduced when the time comes to make an identical copy of the maquette for the purposes of construction."

Although these latest modifications – of which I. M. Pei was appreciative – were transferred onto the maquette, four years after discussions started, no building work on the *Site scripturaire* had begun. In a letter dated 31 March 1976, in order to remedy the situation, Dubuffet suggests they adopt a process similar to the one he had used for building the *Villa Falbala*: "I would like the state of expectancy in which the building of my *Site scripturaire* has so long found itself to be clarified. My technical experiences over the last few years lead me to think that the best method for this construction is to make expanded polystyrene enlargements of the moulds of all the elements on the maquette using a pantograph; and stratified casts in the moulds. I also think that the best solution would be for the entire construction to be carried out by myself and my team of assistants directed by an engineer, perhaps M. Prouvé. He is ready to take matters in hand and even now is making a study of the project."

In his letter dated 10 November 1975 to Charles-Henri Boistière, Dubuffet was already explaining: "With my associate M. Richard Dhoedt, I have personally studied the possibility of building the whole monument using three enlarging machines similar to the ones I have and I think this would be the best solution. A good third of the work – the enlarging and the epoxy castings – would be done in my studios in Périgny by my team of assistants. Two other teams would have to work in tandem, one in my studio at La Cartoucherie, the second in other premises that will have to be found, and the three teams working simultaneously could be overseen by M. Richard Dhoedt. However, it would be desirable for the entire operation – beginning with the arrangements for the steel armatures and fixing the resin pieces to the armatures – to be headed by a highly qualified engineer. This could be either M. Weidlinger, for instance, or M. Jean Prouvé, if he were to agree. I feel that an engineer available in Paris and ready to intervene at any given time during the work would be advantageous."

On 29 May 1976, Dubuffet wrote to I. M. Pei: "M. Millier is now very determined to build the *Site scripturaire*, in the agreed conditions and with your participation. On my suggestion, he has appointed Jean Prouvé to go ahead with his study of the operation and to coordinate the technical aspects of the construction. It now seems that we are reaching the building stage." His enthusiastic reading of the situation stems from the fact that, as he wrote on 17 June to Charles-Henri Boistière, "The building of our *Site scripturaire* is now taking shape." ÉPAD had indeed contracted the Lanaverre company in Bordeaux to carry out trials on two elements for which Dubuffet had two casts: a large archway and a bench. Even though he felt that "with M. Lanaverre and M. Jean Prouvé" the project was "in the best possible hands", he soon began to feel concerned about the first results. On 3 July, he wrote to M. Lanaverre:

"I have examined the two different samples of the surface that you brought me, with two copies of each, one being in a raw state and the other painted in white polyurethane. The paint is not suitable because it is brilliant. Completely matt polyurethane paint with two components is what is required.

For your information, I must say that it is quite hard to find manufacturers of such paint. After various disappointing experiences, for my own work I have got the Dutch firm Sikkens to develop a paint combining polyurethane and acryl which is satisfactory. I think it should be used for our monument. It is important that the paint is very stable, very resistant, and its composition must therefore be closely attended to.

Regarding the surface texture, one sample will have to be eliminated, the one that was moulded using a piece of expanded polystyrene and on which the hexagonal cellular structure of the material is clearly visible. The resulting texture is rather mechanically uniform, I prefer the other sample where the polystyrene used for the mould was sanded. The texture is more varied and lively. Even so, I still find it a little uniform.

The tiny crevices in this texture are of some concern to me when I think of the dirt that I fear will get in, and which with the dust could make the whole monument look dirty."

However, it was not the technical issues that should have given "some concern" to Dubuffet. What sounded the death knell for the

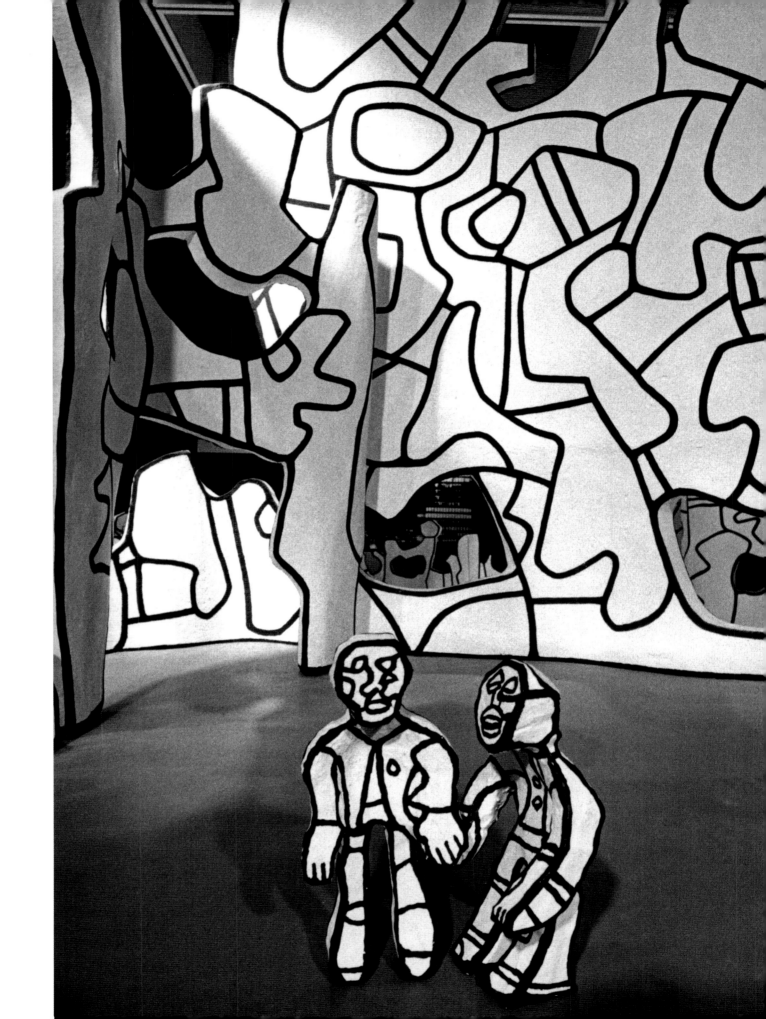

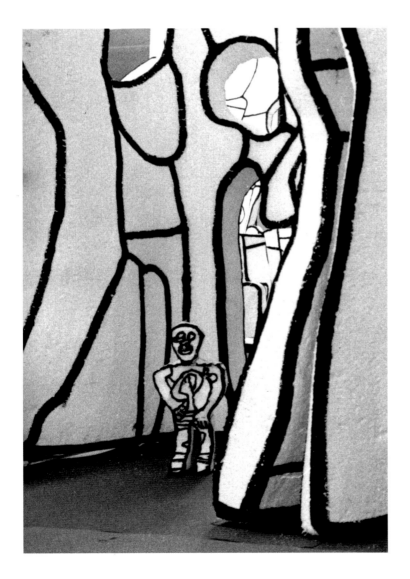

Site scripturaire II (detail)

project was the bankcruptcy of the Lanaverre company and Jean Millier's departure from ÉPAD (in 1977). With their usual disingenuousness, the public authorities failed to inform Dubuffet. Then, four years later, in July 1981, when ÉPAD's new director general informed him that, following Lanaverre's bankruptcy, they were finally going to take possession of the great archway that had been made in Bordeaux, adding: "Indeed, even though ÉPAD had to abandon the plan for the *Site scripturaire* as a whole, I would be glad if this sculpture were to bear witness to your talent and the interest you showed in La Défense," the reply was instant.

In a letter dated 28 July 1981, Dubuffet replied to Jean-Paul Lacaze: "As yet, I have not been notified that ÉPAD has abandoned its plans to construct, as was agreed (and even begun), the *Site scripturaire*. I have never had much luck with commissions in France. An artist should not be mobilized for a whole year during which he has constantly been cooperating with the departments concerned, only for them to change their mind. I have only ever been told that we were waiting for funding to become available in order to continue with the project. . . .

Nothing can be done with the element that was executed in the Lanaverre workshops. It turned out very well. But its only function is as one piece within a whole; it would be meaningless if shown in isolation. And I oppose this. Sadly, if the whole is not built, I see no other solution than for it to be destroyed."

There is, they say, a law of series. If true, it was after the *Villa Falbala* got underway and Dubuffet's interest for the other edifices he planned was increasing, that the law seems to have started to apply. Nine years were spent modifying maquettes for the *Site scripturaire*, consulting architects as prestigious as I. M. Pei and Jean Prouvé, researching new techniques, making moulds and prototypes, then seeing the whole thing get slowly bogged down, and never even receiving a letter notifying him that the project had been called off, during which period, as if tainted by this long, slow process of atrophy, new projects failed to get off the ground.

In 1973, Gordon Bunshaft, the instigator of the *Groupe de quatre arbres* in New York, once more invited Dubuffet to take part in a project for the head offices of the Banque Bruxelles Lambert, whose main building in Brussels he had designed and built between 1958 and 1964. Bunshaft

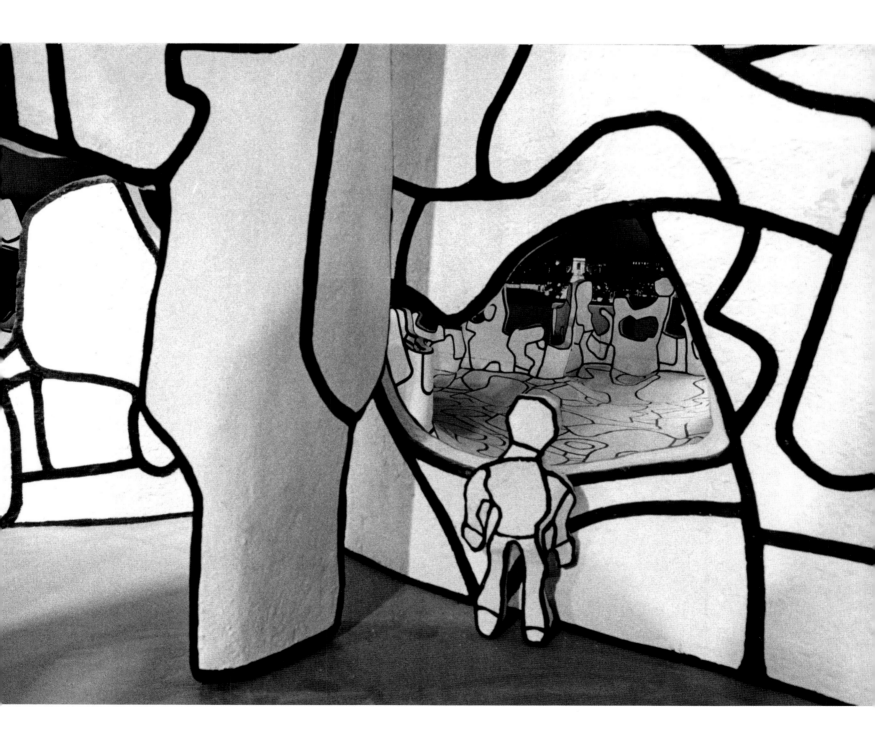

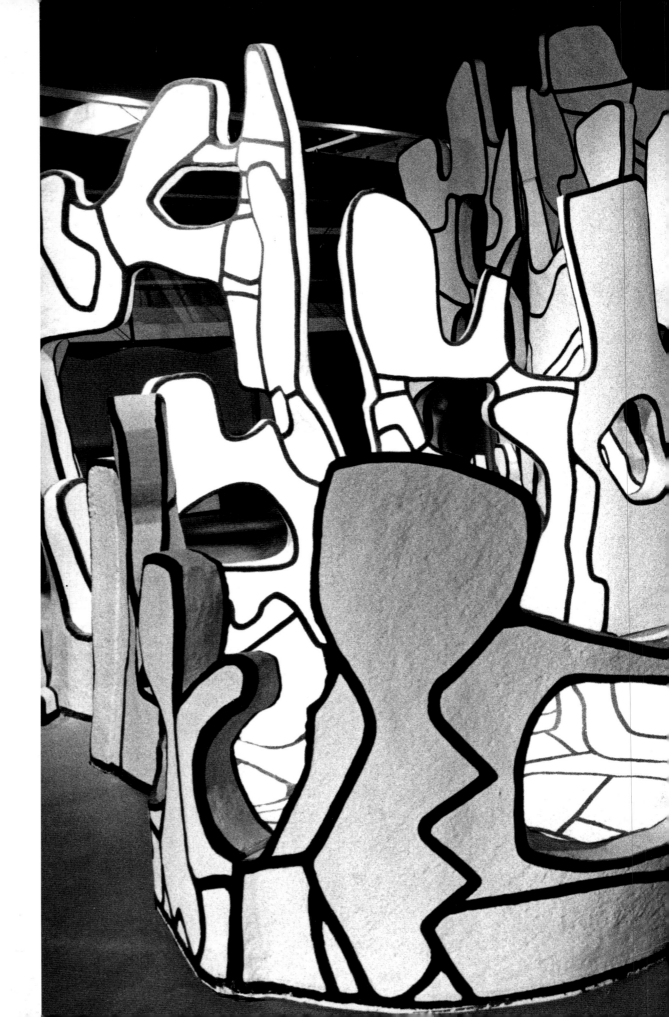

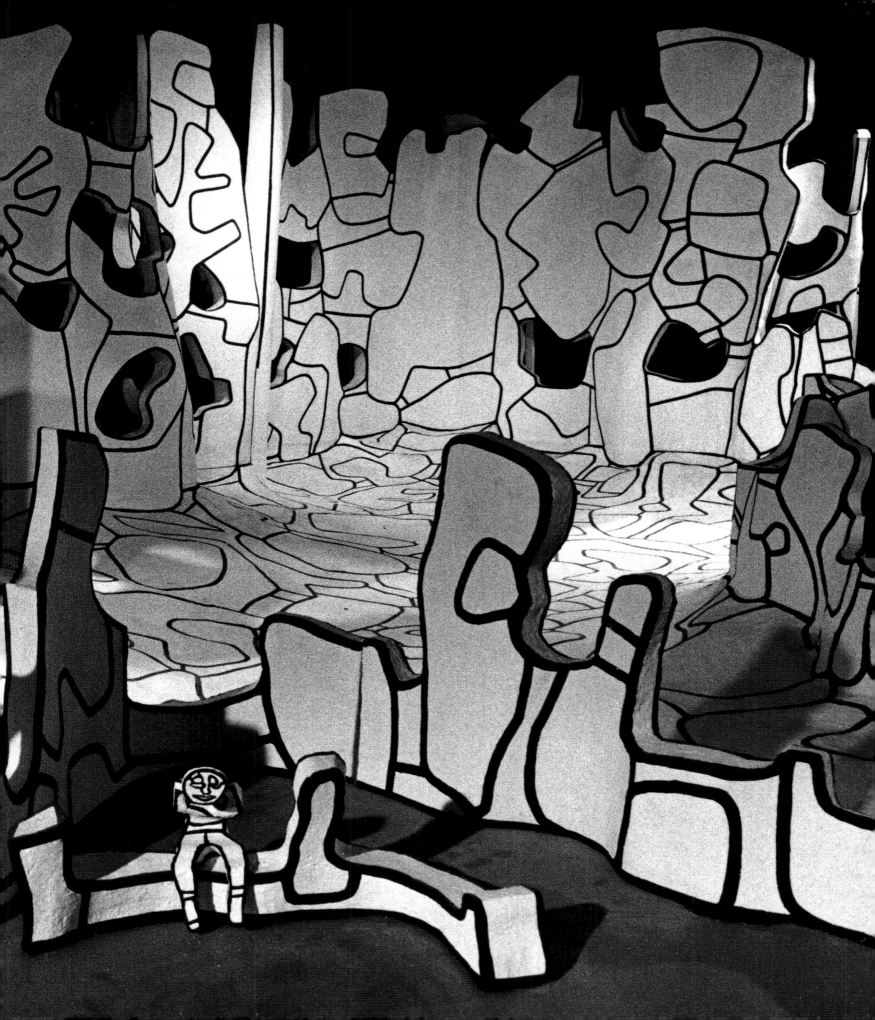

wanted to mark the second phase in the construction by installing a tower 15 metres high in the spirit of the *Tour aux figures*, alongside the Henry Moore bronze that had been set up in 1964, on the monumental esplanade in front of the main façade. The tower would require only a slight modification to its base for the evacuation of air from the underground rail system close to the building. The monument in *L'Hourloupe* colours was to provide a coloured counterpoint to the bank's sumptuous but austere façade, made of precast concrete with knuckle-joint elements in steel.

It was a kind of reversal of the previous collaboration between architect and artist for the Chase Manhattan Bank, where the rigorous black and white lines on Dubuffet's sculptures asserted their fixity, their immutability outlined against the shifting reflections of sky and cloud on the glass-clad building.

Dubuffet started work straight away on five projects in black or coloured felt pen of figures that are more or less immediately identifiable. All, however, have crenellated forms making them fundamentally different from the monolithic character of the previous edifices. Then, in the wake of these drawings, between June and October 1973, he made five sculpture maquettes, around a metre high, before deciding to visit the site in person. The *Tour crénelée* was the first in a new series of maquettes for which Dubuffet retained the volumetric form but modified the approach and thus the reading of it solely through the use of colour. Following this, the *Tours aux scriptions* and the *Tour dentellière* came into being.

The first project was the one he suggested to Gordon Bunshaft and Léon Lambert, which was approved by the commissioning body on 22 April 1974. Yet although Dubuffet was committed to delivering an enlargement of the tower stipulated in the contract he had signed with the Banque Lambert, it was a new project, the *Tour ballerine*, made in July, that he enlarged to an intermediate height of 3 metres prior to the final enlargement. Unlike any other monumental work he had made till then, this one was not to be made in resin but in cast aluminium covered in polyurethane paint. When the Banque Lambert merged with the Banque de Bruxelles in June 1975, with the accompanying huge increase in useable office space, the extension project was postponed, and with it, the installation of a new monumental sculpture. When

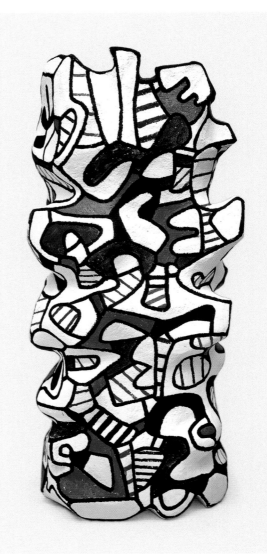

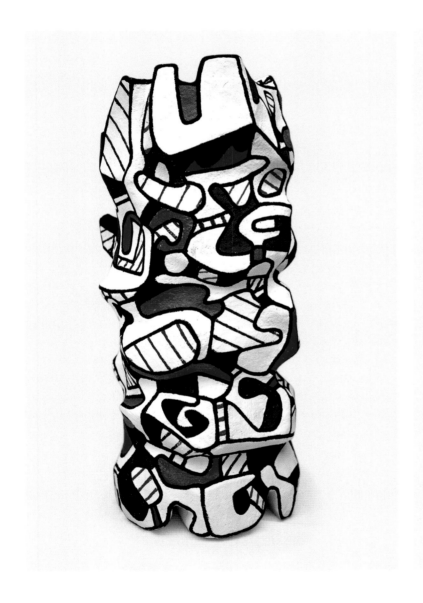

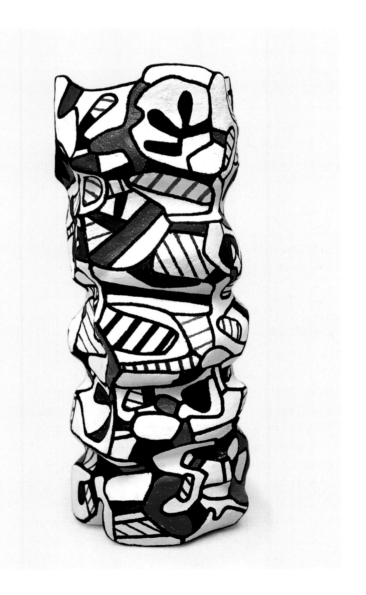

FACING PAGE AND ABOVE
Tour ballerine* (maquette)
Epoxy with vinyl paint
and acrylic (colours)
120 × 54 × 44 cm
July 1974
Fondation Dubuffet, Paris

the new building was finally built in 1993, Gordon Bunshaft, then retired, handed over his plans to be executed by Skidmore, Owings and Merrill, and Léon Lambert, a modern art enthusiast, had died. As for the sculpture – Dubuffet had died eight years previously – nothing more was ever heard of it.

Stranger still is the story of the *Salon d'été*, commissioned by the Renault automobile company, on which work was started, then buried, and which ended in a court battle lasting eight years (1975–1983). And yet everything had augured favourably at first. When Dubuffet encountered difficulties drawing up the three-dimensional plans for his *Villa Falbala*, Claude Renard had helped obtain permission to use Renault's Delta 3D machine, instrumental in enlarging the models of their vehicles. "I was very touched by the considerable help I have received from the Régie Renault, and wish to offer to those involved and to yourself my warmest thanks," he wrote on 31 January 1971 to Pierre Dreyfus, Renault's chief executive. From then on, various projects between artist and car manufacturer forged ahead: in 1973, Jean Dubuffet was commissioned by Renault to do a set of eighteen paintings designed specifically for the reception rooms at the head office. (The series of large-dimensioned cut-outs that Dubuffet entitled *Roman burlesque* was completed in 1974.) The following year, from early April to late August 1974, Dubuffet made a series of small collages which were handed to various of the car-maker's departments to be enlarged, transferred onto canvas and coloured, thus eliminating any intervention from the "hand of the artist". These were the *Paysages castillans* and the *Sites tricolores*: "47 canvases which are a swansong to my *L'Hourloupe* cycle," he wrote.

But of course the major episode in this collaboration was the commission for the *Salon d'été*. On 26 November 1973, just after Dubuffet had agreed to do the cut-outs for the *Roman burlesque*, Renault drew up a contract for him to "construct a monumental group including a wall approximately one hundred metres long with the possible addition of one or more complementary elements, to be installed at the company's future head offices in Boulogne-Billancourt within the area designated on the plan provided to M. Jean Dubuffet and acknowledged by him. . . . M. Jean Dubuffet will provide the Régie Renault with any useful, necessary documents for a feasibility study of the

building of this monument, as well as construction itself, namely maquettes, plans and descriptions.

The Régie Renault will pay the entire cost – excepting the author's maquette – of the feasibility studies, and the entire building costs for the monument, which will be carried out by contractors of the company's own choice, respecting the forms, the colours and the materials stipulated by M. Jean Dubuffet. . . . For the realization of the present contract, the total, all-inclusive and non-revisable payment to M. Jean Dubuffet has been agreed by all parties at 400,000 francs. These fees will be paid in instalments as follows:

–on signing the present contract: 200,000 francs

–on receipt of the maquette and the other related documents: 200,000 francs.

In the event that the construction should not be carried out or delayed due to the Régie Renault, then these two payments shall remain M. Jean Dubuffet's, or his heirs', in lieu of any other compensation."

On 5 March 1974, Dubuffet drew up a first draft of a sculpted area that was to include walls, benches and a pool, a place for the whole staff to relax in and walk around, that contrasted with the rigid environment of the new buildings. By 15 March, a first 1:50 polystyrene maquette had been completed. Two other drafts followed, as well as specific plans for the pool area. Then at the end of March there came a new 1:50 epoxy maquette made following the third draft. Finally, on 5 June 1974, Dubuffet completed a 1:10 polystyrene maquette measuring 6 metres by 5 metres which was submitted for Renault's approval. The decor consisted entirely of lines in black vinyl paint, and Pierre Dreyfus asked the painter to add a dimension in colour. Dubuffet usually refused to modify his proposals, but in this case he accepted the Renault managing director's request, and, as in the corridor leading to the *Cabinet logologique* in the *Villa Falbala*, added areas of solid blue colour and hatchings which underlined the complexity of the forms and reliefs. This modification was completed on 28 August 1974, approved by the managing director, and a definitive maquette in epoxy resin, similarly painted in black and blue was made, even as the construction works were beginning.

Certain technical problems arose during construction, especially leakages of water into the underground car park, part of which was

1040 maquette au 1/50
Troisième avant-projet Parc-salon Régie Renault
(Bassin et entourage)

28 mars

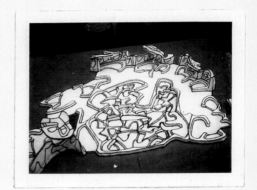

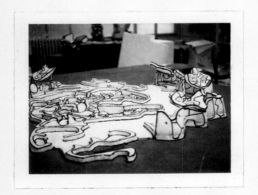
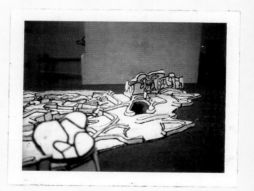

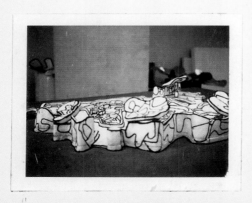
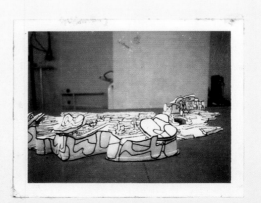

**"Parc-salon" for
the Régie Renault**
(1:10 maquette)*
Polystyrene with black vinyl
outlines
600 × 500 cm
5 June 1974

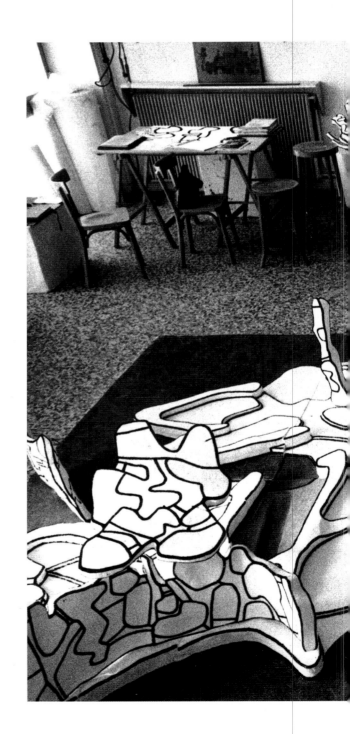

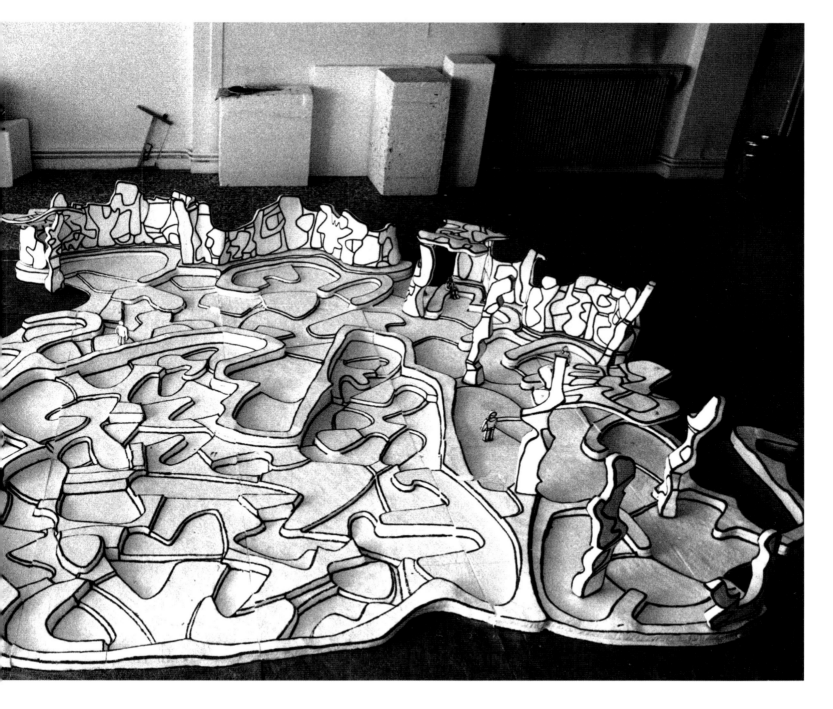

located beneath the monument. (It was never clearly established whether this was due to the building works themselves, or as an expert witness claimed, due to the defective nature of the waterproof coating.) This called a halt to any further work. However, the monument fell victim to other circumstances: Bernard Vernier-Palliez' appointment in June 1975 as managing director of the Régie Renault replacing Pierre Dreyfus; the uncertain costing of the final construction; and especially the aftershock on Renault's finances caused by the 1973 oil crisis.

Those who follow on are not usually known for their appreciation of their predecessor's plans. Pierre Dreyfus however, knowing he was about to leave, had diplomatically postponed the decision regarding the extra costs in constructing the monument – an artwork that was not unanimously appreciated by the staff, especially part of the executive. Work was halted on 20 September 1975 until this decision was taken.

The wait was not a long one: apart from the fact that the project was not his, M. Vernier-Palliez, the new managing director, unlike his predecessor, did not care for contemporary art and decided that, as part of his economic recovery programme, the superfluous expenditure on the activities of Renault "Art et Industrie" would be cut, the construction of the *Salon d'été* would be halted and what had already been built would be destroyed.

Before taking the Régie Renault to court, Jean Dubuffet wrote to managing director Vernier-Palliez on 21 December 1975 offering to bear any extra construction costs himself:
"The arguments put forward against the work continuing basically concern the techniques to be used and the exact amount of the subsequent expenditure – hence the word "risky" that was used. In order to put an end to such ill-founded fears (the consequence of which has been to delay work for three months during which period all the concrete for the ground and pool could have been laid), I have decided to involve myself personally in a different way from my previous offer to M. Dreyfus so that any concern over the amount of money to be spent can be completely dispensed with.

On condition, for your safeguard and mine, that I will be assisted by M. Prouvé, my engineer, I offer to take over in my own name any uncertainties that are being claimed regarding the technical issues and the expense.

Originally, the Régie Renault's budget, drawn up and put forward by your architect and your engineering advisor, amounted to 4,000,000 francs, over and above my artist's fees and the making of the maquettes. I believe that beyond this the Régie was willing to incur the extra sum of 1,000,000 francs as long as the company was sure that it would not go above this amount. It is equally clear that any new arrangements for replacing the monument would cost at least 1,000,000 francs.

I offer to relieve you of the risk that the construction represents in your eyes by assuming any costs that exceed the above-mentioned sums. My intention is to prevent you from finding yourself in an unpleasant position which would be very prejudicial to the image of Renault in the world.

However, were the Régie Renault to take a decision, given the new proposals I make above which answer all the arguments put forward, which would compromise the execution of my monument, without taking into account the considerable prejudice that this would cause me, and without further taking into account the outrageous contradiction that such a decision would make with regard to the creative arts policy your company has so remarkably developed over the past ten years, I would see this as an intolerable violation of my artist's rights, and it also would be viewed internationally as a scandal. I would then be forced, regrettably, to have recourse to all the measures available to me in order to oppose this.

I persist in believing however that these deplorable developments are implausible, and I think that my new proposals will enable you to recommence building work quickly. Three months are all that is required for all the concrete to be laid and painted (including the pool), and this will already make the esplanade into a pleasant area for the staff to walk and relax in. The remaining work for the completion of the monument will be carried out elsewhere, out of sight of the staff, within two years – unless you wish it to be spread over three." When this letter remained unanswered, Dubuffet took the Régie Renault to court, obtaining an order to prevent the unfinished work from being destroyed on 21 December 1976.

On 22 February 1977, the case brought by Jean Dubuffet against the Régie Renault opened in the upper Chamber at the Tribunal de

Salon d'été
(1:10 maquette)
Epoxy with polyurethane paint
(black and blue)
565 × 454 cm
28 August 1974–December 1974
Fondation Dubuffet, Paris

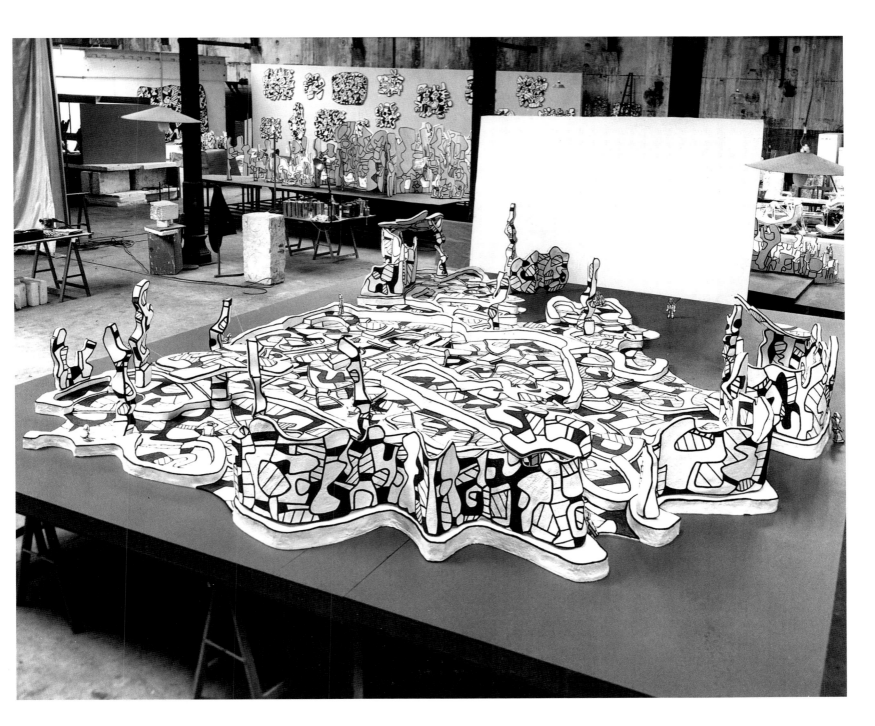

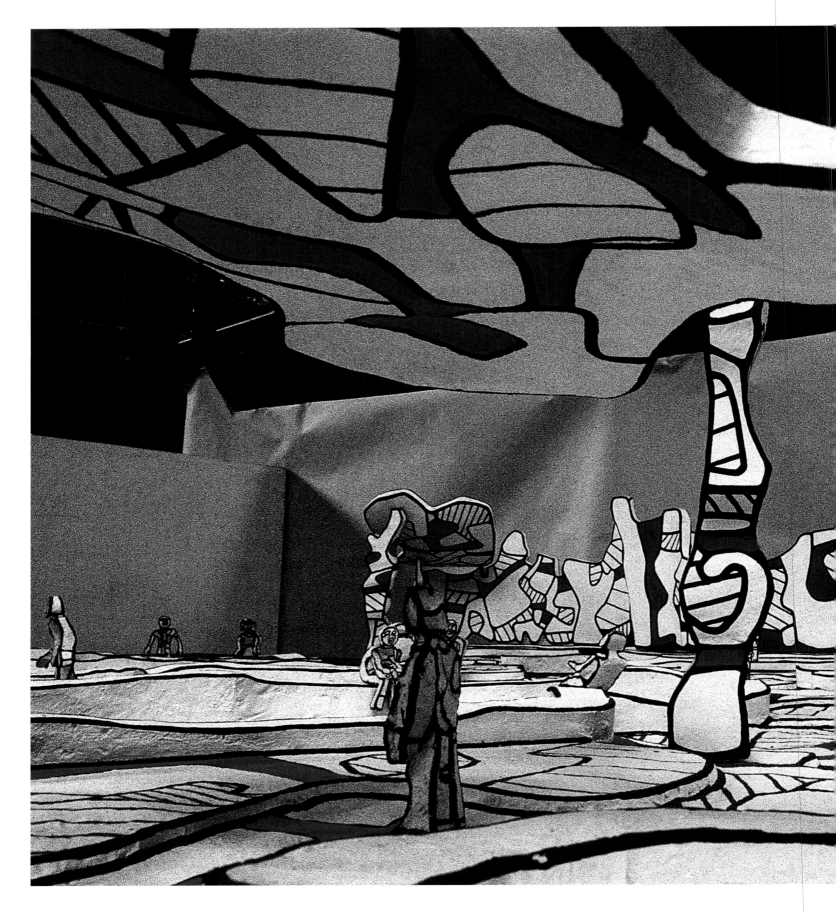

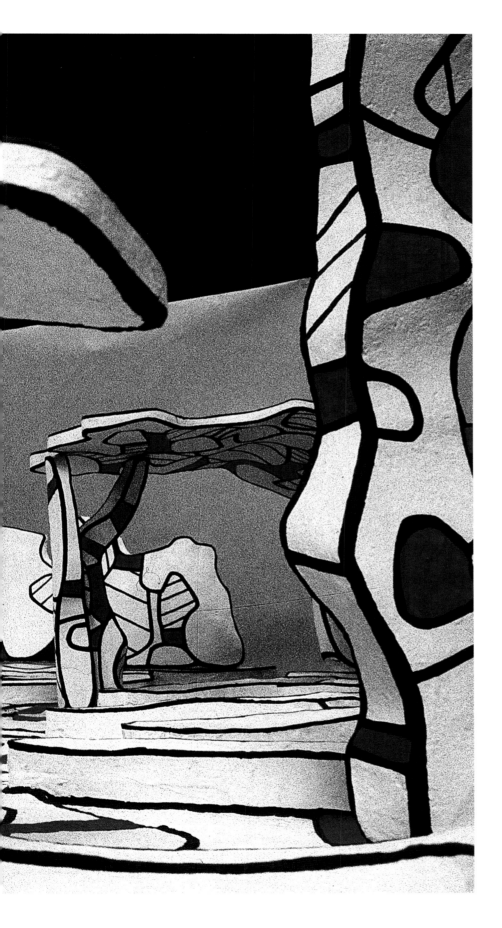

Salon d'été (detail)

158

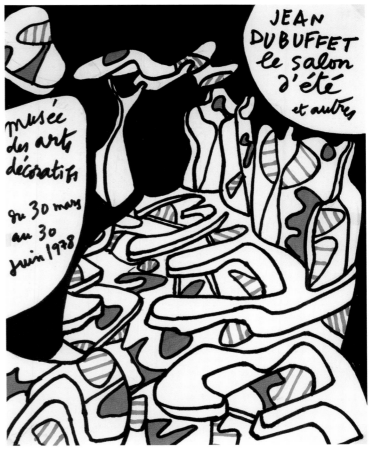

FACING PAGE AND ABOVE
Drafts for the exhibition posters for *Jean Dubuffet Le Salon d'été et autres**
Musée des Arts décoratifs,
30 March–30 April 1978
Felt pen on letter paper
27 × 21 cm (each)
12–14 February 1978
Fondation Dubuffet, Paris

Jean Dubuffet in front of the scale
maquette of the *Salon d'été*
Studio in Vincennes, April 1977

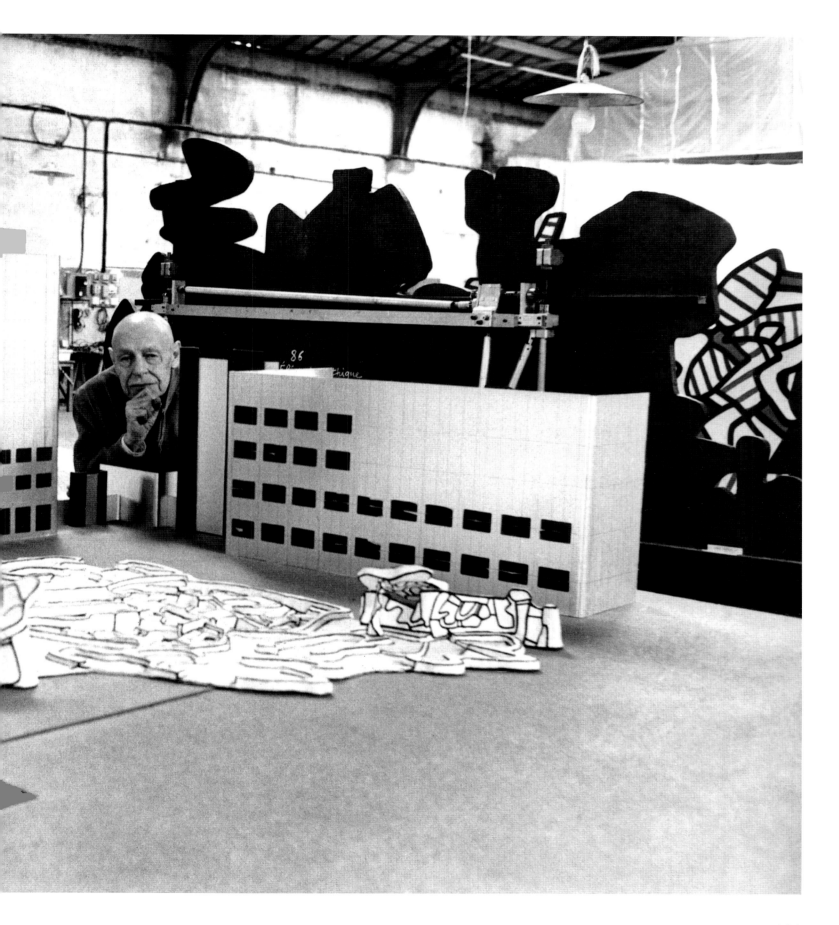

Grande Instance, with presiding judge Mme Rozès. The lawyer for the Régie Renault argued that the contract between the Régie and the artist stipulated that the latter could not receive any compensation if the Régie did not execute the work proposed, and concluded that his claim was unjustified. He even argued that in this case the maquette constituted the artwork, that the ongoing construction could not claim to be such, and therefore did not involve any artist's rights as claimed against the commissioning body. It was this line of argument that the tribunal adopted when giving its verdict on 23 March: "Given that in reality it must be considered that the right which has been recognized for the Régie Renault to not execute the work necessarily involves – in the absence of any clearly pronounced restriction – the construction that is underway being halted; . . . given that Jean Dubuffet invokes to no avail clauses in the law from 11 March 1957 and prerogatives relating to author's rights which permit him to see to his work's integrity and maintain the purpose for which it was made; given that, in this case the work does not consist of the construction work on the ground carried out and directed by the Régie Renault, but is the maquette itself which is under no threat of destruction and concerning which several offers have been made to return it to Jean Dubuffet; finally, given that the work conceived by Jean Dubuffet was not destined to be executed, as formally agreed by him on signing the contract dated 26 November 1973, and that the destination of the work was determined in accordance with the will of the parties concerned, and that on this point the contract is applicable; . . . then on account of these reasons, and after contradictory debate, the court rejects Jean Dubuffet's petition; it authorizes the Régie Nationale des Usines Renault to not pursue the construction of the work entitled *Le Salon d'été* and to proceed with the destruction of the existing elements." This judgment was upheld by the Paris courts on 2 June 1978 after Dubuffet lodged an appeal.

Meanwhile, on 1 August 1977, the first issue of a bulletin called *Le Petit messager du Salon d'été* came out. In it, Dubuffet made public all the documents and procedures used to prevent the monument being destroyed. On the opening page, there was a text written by Dubuffet entitled *Du mépris pour la création artistique* ("Artistic creation held in contempt"). The second issue published a petition against the destruction of the *Salon d'été*, signed

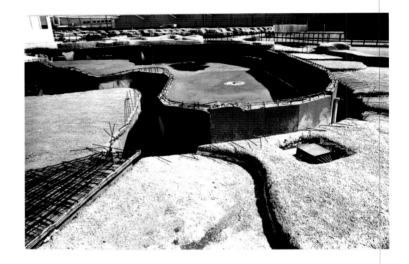

ABOVE AND FACING PAGE
Photograph of the *Salon d'été*
when "buried" in July 1977

162

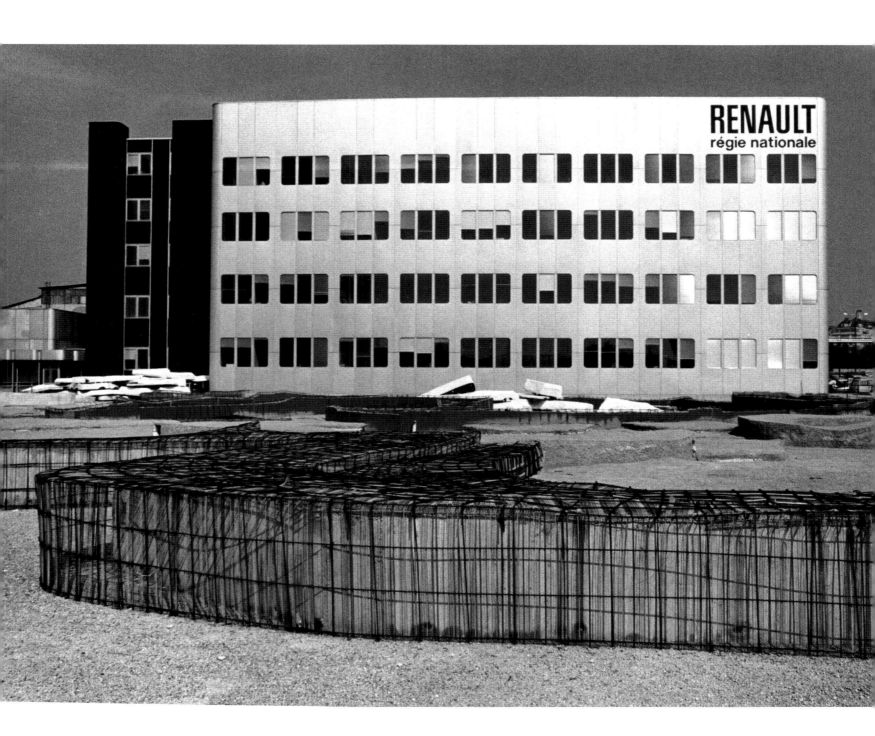

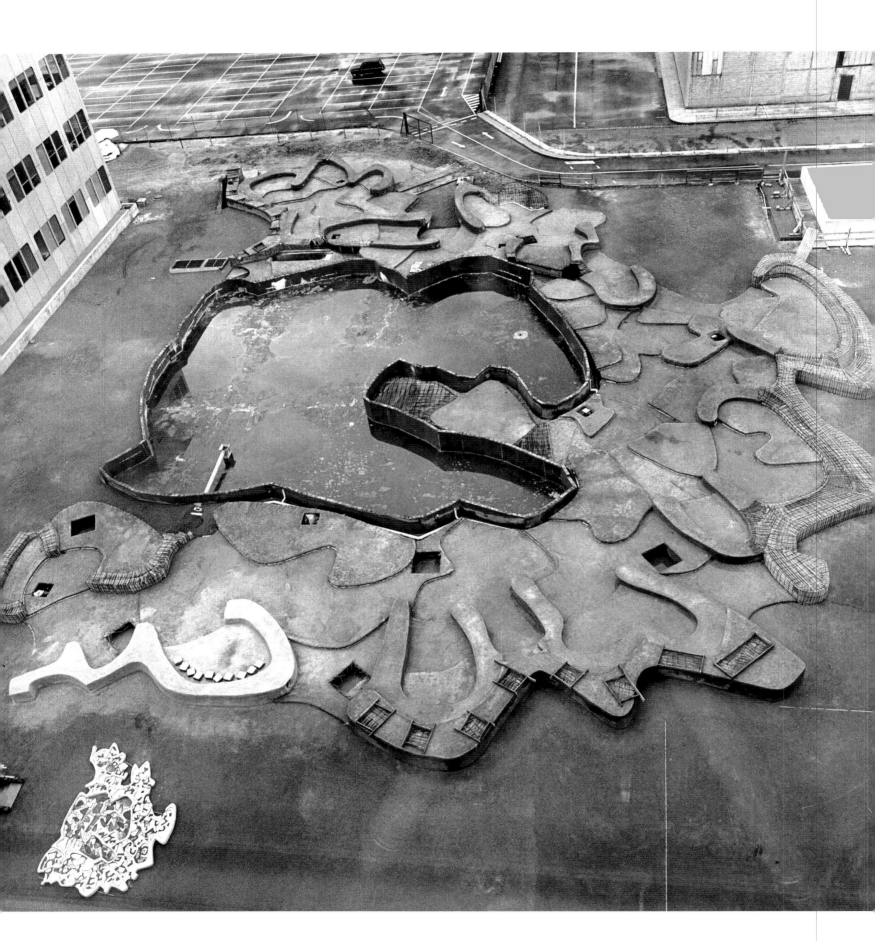

Première année – N° 1 / Prix 3 F 1er août 1977

le petit messager du Salon d'été

Publié par le Groupement de soutien pour l'achèvement du Salon d'été de Jean Dubuffet
Renseignements et correspondance :
Chantal Gaulin, 11, rue St-Médard, 75005 Paris

Juger sur pièces

Ce messager-là s'adresse à la fois à ceux de notre temps et ceux qui les suivront. Il n'est pas inutile qu'un mémorial demeure de faits dont l'avenir jugera. Nous voulons encore croire que l'opinion publique ne laissera pas détruire ce «Salon d'été». Encore faut-il que soit projetée sur l'affaire toute la pleine lumière et que soient bien dissipés tous les doutes que pourraient faire naître les efforts déployés pour dénaturer les vrais faits. C'est à quoi s'attachera notre publication. On verra par les documents que les raisons alléguées – elles sont essentiellement de l'ordre pécuniaire – sont spécieuses et dénuées de fondement.

Le coût de la construction du «Salon d'été» représente au total entre un et deux pour mille du budget d'investissement de la Régie pour l'année 1978. A qui veut-on faire croire qu'une dépense de cette proportion est intolérable pour que se voit terminer une construction qui est d'ores et déjà plus qu'à moitié payée?

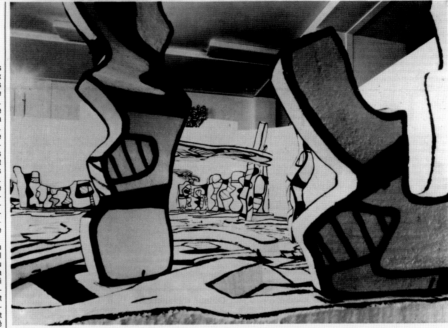

La Régie affirme que la maquette au 1/10ᵉ est la seule œuvre à considérer et que l'édifice construit n'en est rien de plus qu'une reproduction.

Du mépris pour la création artistique

La menace de destruction que les dirigeants de la Régie Renault font maintenant peser sur le «Salon d'été» révèle, en l'éclairant d'une subite lumière, la désaffection de la classe dirigeante pour l'art contemporain. Celle-ci va croissant depuis soixante ans mais elle s'accentue gravement dans les années présentes. Et cela justement dans le même temps que s'accroît au contraire à l'étranger l'intérêt porté aux inventions de l'art. Dans le même temps aussi que s'éveillent dans les masses populaires, chez nous comme ailleurs, une attention grandissante portée aux productions de l'esprit et une affection de plus en plus éclairée à leur endroit. Se raréfient maintenant dans la classe privilégiée ceux qui restent attachés aux productions de l'esprit. Elles y sont regardées comme dérisoires, illusoires; un scepticisme règne à leur égard, tandis que sont tenus pour seules vraies

PAR JEAN DUBUFFET

valeurs les profits immédiats et promotions sociales. Le goût des productions de l'esprit procède d'un intérêt pour la découverte et l'innovation, qu'exclut le conservatisme dont nos dirigeants sont imbus. Ils ne veulent que confirmer les données acquises et, bien loin d'aspirer à d'inédites positions d'esprit, ils ressentent aversion pour tout ce qui menace d'entraîner du changement. L'invention personnelle leur est suspecte. Tout un qui tient dans son bec un fromage vit, on peut bien le comprendre, dans la crainte du moindre mouvement du vent.

Ce qui est frappant, ce qu'il faudrait produire une bonne fois au clair c'est le gouffre entre la prétention de la classe dirigeante à régenter la création d'art et le mépris qu'elle lui porte dans la réalité. Les mécènes se posent en bienfaiteurs. Ils sont dans l'erreur en croyant que leurs acquisitions entrent dans le cadre de la bienfaisance. Ce qu'ils reçoivent a plus de valeur que ce qu'ils donnent et les gratifiés de l'opération ne sont pas ceux qu'ils croient. Très singulier est, parmi les mythes, celui de ce qu'on veut appeler la «culture». On a fait de ce terme un mot magique au prononcé duquel tout se prosterne tandis qu'il n'a plus le moindre contenu. De véritable considération pour la création d'art il n'y a depuis longtemps plus l'ombre. Il est bien établi qu'il ne saurait y avoir, aux yeux de gens sensés, d'autres utilités, ni d'autres raisons de vivre, que les investissements et les promotions. Et le gazon. J'oubliais le gazon. L'intérêt des classes dirigeantes pour le gazon est de nos jours en brillant essor.

Cependant ils n'avaient pas eu encore la pensée de lancer les bulldozers à démolir un monument. Nous allons assister à une première. Ce ne s'est encore produit nulle part. Il est vrai qu'il n'y avait pas de monument à démolir. A ce que j'en connais pas un seul monument – je veux dire d'ample dimension, portant en lieu public témoignage frappant de l'époque – n'a été de tout ce siècle édifié à Paris. Que ce premier grand monument construit de nos jours en France soit spectaculairement immolé comme le fils d'Abraham – voire anéanti de façon plus radicale encore avant même qu'il ait vu le jour – on ne pouvait trouver mieux pour faire apparaître avec plein éclat le mépris dans lequel est maintenant tenue chez nous la création d'art. Et, qui sait? pour provoquer peut-être dans l'opinion, à la faveur de cette révélation, un sursaut de ressaisissement, voire de revirement.

J'entends tout mettre en œuvre pour faire obstacle au geste abominable dont mon ouvrage est menacé. Il est l'aboutissement de mon cycle de travaux groupés sous le nom de «L'Hourloupe» et qui m'a occupé pendant douze années; il en est la pièce maîtresse, la somme. Je tiens capitalement, on peut bien le comprendre, à ce que cet ouvrage reçoive existence. Je n'accepte pas que mon travail soit insulté par ces patrons prospères. Ils sont les moulins à sous du pays; toute l'économie française repose actuellement sur la vente des autos; le président d'une Régie Renault est le prince de l'heure. Un signe de lui et tout plie et s'incline, y compris les pouvoirs publics. A ce que je sais de lui – bien qu'il n'ait jamais condescendu à ce que je puisse l'apercevoir – il n'est pas homme dont on puisse attendre qu'il prenne l'idée qu'une création comme celle qu'il prétend démolir est une affaire plus importante – et socialement un fruit de plus haut prix – que la courbe de vente des autos Renault. Patrons prospères ou autres je ne me permets à quiconque d'insulter mon travail. Et pas seulement le mien. Une quarantaine de gens ont participé à cette construction avec ferveur, et je ressens comme intolérable qu'eux aussi se voient avec moi pareillement insultés.

by artists (Bazaine, Brassai, Paul Delvaux, Estève, Hartung, Hélion, Miró, etc.), writers (Simone de Beauvoir, Roger Caillois, René Char, Jean Genet, Ionesco, Francis Ponge, Claude Simon, etc.), art historians (G. C. Argan, Giuseppe Marchiori, Michel Ragon, etc.), public figures (Robert Badinter, Pierre Boulez, Christian Bourgois, John Cage, René Clair, Jean-Jacques Pauvert, etc.) and museum directors (the Carnegie Institute, Albright-Knox Museum, Boymans Museum, Solomon R. Guggenheim Museum, Kunstmuseum in Basel, Henie Onstad Art Centre, Tate Gallery, etc.).

At the same time, the Régie Renault, claiming to protect the parts of the *Salon d'été* that were already built until a decision was made by the appeal courts, had them concreted and grassed over, masking the litigious building site from view of the Renault managing director's offices.

Despite the two previous verdicts, Jean Dubuffet took his case further to the supreme tribunal, the court of appeal. The appeal court's decision was quashed on 8 January 1980, and sent back to the appeal court in Versailles in 1981, entailing a complete review of the case. At the end of this trial, the precision and flamboyance of the defence speeches from the two lawyers assisting Dubuffet, Jean-Robert Bouyeure and Georges Kiejman, led to a decision obliging the Régie Renault to complete the monument as planned. They in their turn went to the court of appeal. This court, on 16 March 1981, and four years of legal wranglings later, found in favour of Dubuffet. He had just turned eighty, and was pleased to see his case finally upheld, but he had surprises in store for managing director Vernier-Palliez. In 1977, he had already thumbed his nose at him by depicting him in a series of nine satirical paintings which related the episodes leading up to the *Salon d'été* being "buried". But now that the final verdict had gone his way, it was time for the sting in the tail: Dubuffet let him know that he would not undertake the construction of his work in a place "where it was so little wanted".

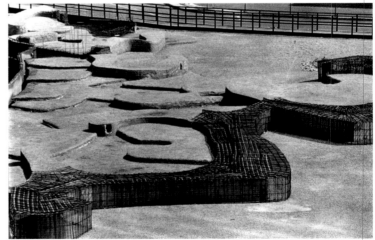

Was it perhaps the failure of these two monumental projects – the *Site scripturaire* and the *Salon d'été* – that encouraged Dubuffet to accept a medal of honour from the American Institute of Architects in 1982, the only one in his life that he did not refuse? The award was proof that, despite his failure to make his dreams come completely true in France, Dubuffet the painter was also, in the eyes of nations abroad, *Dubuffet the architect*.

FACING PAGE, TOP
Polyester elements from
the *Salon d'été* abandoned,
Nouan-sur-Loire, July 1977

FACING PAGE, BOTTOM
Photograph of the *Salon d'été*
when "buried" in July 1977

RIGHT
Le petit messager du Salon d'été,
no 2, 1 September 1977
published by the support group
in favour of Jean Dubuffet's
Salon d'été being completed
Archives Fondation Dubuffet, Paris

Première année - N° 2 / Prix 3 F

Jeudi 1er septembre 1977

le petit messager
du Salon d'été

Publié par le Groupement de soutien pour l'achèvement du Salon d'été de Jean Dubuffet
Renseignements et correspondance :
Chantal Gaulin, 11, rue St-Médard, 75005 Paris

Enterré vivant

■ Voici dans les péripéties du «Salon d'été» un coup de théâtre. Une géniale trouvaille, qui consiste, dès lors que la Régie n'a pas le droit de le détruire, alors à l'enterrer. Provisoirement affirme-t-on, en attendant le jugement de la cour d'appel, et dans le seul but de bien le préserver des intempéries et d'empêcher qu'il pleuve dans les parkings du sous-sol. Il y pleut en effet depuis deux ans car la dalle qui les recouvre, et qui est, au-dessus d'eux, porteuse du monument, n'est pas étanche. Un système de gouttières et de tuyaux est en place depuis plus de deux ans, au plafond des garages, pour écouler les eaux qui passent au travers. On s'avise tout à coup d'un urgent besoin d'enlever ces tuyaux et de refaire l'étanchéité de la dalle sans qu'il soit tolérable d'attendre pour cela un jour de plus. Il faut mentionner qu'il existe bien divers moyens d'assurer l'étanchéité sans avoir du tout pour cela à raser le monument pour le reconstruire ensuite, ni encore moins à l'enterrer comme on s'y apprête. Mais la notion d'enterrement, les symboles qui s'y lient, enchantent l'architecte de la Régie, résonnent dans son esprit comme un chant de triomphe. On enterre tout à la fois : l'œuvre indésirable et aussi la malfaçon off fait la porte. D'une pierre deux coups. On pourra même aussi prétendre que l'œuvre était la cause de la malfaçon.

Le programme est d'envelopper le monument de granulats d'argile expansée et de recouvrir tout d'une chape de béton qui recevra de la terre plantée de gazon. Il est intéressant (pour l'histoire de l'époque) que, dans le même temps qu'on fait ailleurs de très coûteuses fouilles pour mettre au jour des monuments du passé, s'opèrent actuellement à Boulogne-Billancourt des travaux non moins dispendieux aux fins d'ensevelir un monument contemporain.

1° Une couche de gravier destinée à permettre la circulation et l'évacuation de l'eau sous le gazon,
2° Un feutre jardin,
3° 30 cm de terre végétale pour supporter le gazon.

Ainsi le monument se trouvera enterré avec un ouvrage qui, s'il est bien réalisé, doit pouvoir assurer une garantie décennale.

■ *2e point : Rechercher si lesdits travaux présentent des risques et des inconvénients quant à la conservation du monument et rechercher notamment s'il serait possible, après les avoir exécutés, de revenir à la situation actuelle (c'est-à-dire à la situation au moment de l'arrêt des travaux d'édification du Salon d'été) sans que le monument en souffre;»*

Nous estimons, en l'état actuel de nos investigations et des éléments qui nous ont été fournis, que les travaux conçus par la R.N.U.R. ne sont pas de nature à provoquer des désordres irréparables aux parties du monument actuellement existantes.

En effet, ces parties ne correspondent qu'à des noyaux de béton projeté sur des armatures.

Le relèvement en ciment blanc, constituant le parachèvement des éléments, n'est réalisé que sur une infime partie.

L'œuvre d'art ne sera réalisée qu'après application sur l'ensemble des bétons projetés de ce revêtement en ciment blanc.

En conséquence, il sera possible de revenir à la situation des ouvrages telle qu'elle était au moment de l'arrêt des travaux d'édification du Salon d'été, sauf éventuellement à procéder à quelques réparations qui pourraient être dues soit à des oxydations d'armatures, soit à des effondrements éventuels et ponctuels de ce qui n'est, rappelons-le, que le noyau de la future œuvre d'art.

■ *3e point : «Dire s'il est possible techniquement d'assurer l'étanchéité de la dalle recouvrant les parkings sans porter atteinte au monument conçu par Jean Dubuffet; dans l'affirmative, de décrire les moyens techniques pouvant être mis en œuvre en ce sens;»*

STUDIO MULLER

Une opération prétendue provisoire

On n'a jamais fini de s'émerveiller des sinueux détours de la procédure et de l'esprit d'invention qu'on peut y apporter. La Régie Renault ne tient pas l'invention dans l'art en grande estime mais elle en porte par contre très haute à l'invention dans les recours de procédure. La grande idée étant, dès lors qu'elle n'a pas le droit de détruire le «Salon d'été», de l'enterrer, elle s'est adressée au tribunal non pas pour lui demander, comme on s'y attendrait, de l'y autoriser, mais pour exposer que, s'apprêtant à le faire (pour le motif de troubles d'étanchéité), elle demandait qu'un expert soit nommé pour surveiller l'opération. Le tribunal n'a pas accédé à la demande, mais il n'a pas non plus interdit que l'opération ait lieu, se bornant à stipuler que la Régie ne pourrait la faire qu'«à ses risques et périls». On ne peut mieux exprimer qu'on s'en lave les mains.

L'artiste à son tour demande au tribunal que soient interrompus les travaux destinés à cet enterrement au moins jusqu'à ce qu'un expert ait pu vérifier qu'ils ne portent pas atteinte à l'intégrité de l'œuvre et qu'ils permettent de la remettre ultérieurement en son état actuel pour terminer la construction. Pour constater aussi qu'ils ne sont nullement nécessaires à assurer l'étanchéité. Le tribunal acquiesce à commettre un expert (il en nomme même deux) mais pas à ordonner que les travaux soient suspendus.

On trouvera ci-dessous le pré-rapport déposé d'urgence par les experts dans l'impossibilité pour eux, en présence de la hâte avec laquelle les travaux sont pressés, d'étudier bien l'affaire avant que l'ensevelissement soit devenu fait accompli.

Pré-rapport d'expertise établi par : Jacques Robine, architecte, expert près de la Cour d'Appel de Paris et Michel Verrier, ingénieur des Travaux publics E.T.P., expert près de la Cour d'Appel de Paris.

■ *1er point : Décrire les travaux actuellement entrepris par la R.N.U.R. sur le chantier abandonné du monument dit «Salon d'été» correspondant à la maquette livrée par Jean Dubuffet;*

La R.N.U.R. a entrepris actuellement un certain nombre de travaux qui sont décrits ci-dessous :
— Mise en place en périmétrie de certaines parties d'ouvrages de parpaings destinés à supporter un ensemble de prédalles.
— Fourniture et mise en place de prédalles reposant sur lesdits parpaings dans les zones où les ouvrages en béton projeté n'ont pas été réalisés.

Le programme conçu et en cours de réalisation pour la R.N.U.R. consiste d'abord à protéger ce qui existe du Salon d'été au moyen de parpaings, de dalles, dans le but d'enterrer l'ensemble du Salon d'été sous une couche d'argile expansé (autrement dit de billes de la grosseur d'une noix) légère, recouvrant l'ensemble du monument un peu à l'image du recouvrement par les cendres volcaniques du Vésuve de Pompéi.

Au-dessus de ce recouvrement qui enterrera le monument, elle prévoit de créer une dalle en béton armé, dans le but de recevoir par la suite une couche d'étanchéité, ainsi le monument Salon d'été sera protégé de la pluie.

Au-dessus de cette couche d'étanchéité il est prévu de créer un espace gazonné dont la réalisation nécessite :

La solution, actuellement en cours d'exécution, permettra à la R.N.U.R. d'assurer l'étanchéité de ses parkings sans porter atteinte au monument conçu par Jean Dubuffet, mais elle présente néanmoins des difficultés d'exécution qui sont loin d'être négligeables mais tout à fait surmontables (notamment pour ce qui concerne la tenue générale du support de l'étanchéité).

Par contre, si l'on entend mettre à titre provisoire seulement le parking à l'abri des infiltrations, autrement dit attendre que la Cour se soit prononcée sur le sort du monument, il suffirait d'établir au-dessus de ce monument un «parapluie».

Dans ce dernier cas, de nombreuses solutions peuvent être envisagées.

le petit messager du Salon d'été

Deuxième année · N° 3 / Prix 3 F
15 mars 1978

Publié par le Groupement de soutien
pour l'achèvement du Salon d'été de Jean Dubuffet
Renseignements et correspondance :
Chantal Gaulin, 11, rue St-Médard, 75005 Paris

Audience de la Cour d'appel (1re Chambre) 28 avril prochain à 14 heures

Notre pays sera-t-il celui où pour la première fois dans les temps modernes une grande production de l'art contemporain sera livrée aux démolisseurs? La 1re chambre de la Cour d'appel de Paris en sera saisie en son audience du 3 février prochain.

Les nazis ont brûlé des livres ; les inquisiteurs de Tolède l'avaient fait naguère, et les Chinois plus récemment. Mais c'était symbolique ; il en restait d'autres exemplaires. Ils n'ont pas que l'on sache brûlé (ni cassé, ni enterré) des œuvres d'art monumentales. La France inaugure.

On trouvera ci-après les arguments qui seront présentés par les avocats de l'artiste et par ceux de la Régie. Aussi par ceux de l'A.D.A.G.P., organisme institué pour la défense des droits d'auteur. La loi qui les protège serait rendue inopérante si se voyait confirmé le jugement rendu en première instance et selon lequel la seule maquette de l'œuvre, et non l'œuvre elle-même, bénéficierait de la protection qu'a voulu donner le législateur aux créations d'art.

Mais est-il besoin d'une loi et de tribunaux pour que soit empêché dans notre société l'acte abominable d'anéantir délibérément, pour une simple démonstration d'autorité et de puissance d'un capitaine d'industrie, une œuvre de l'ampleur du «Salon d'été»? On voudrait qu'y suffise l'indignation ressentie devant un tel geste par l'opinion publique.

Le monument est à cette heure construit à plus de moitié de son achèvement. Plus de 2 millions et demi ont été déjà déboursés par la Régie pour cette construction et vient de s'y ajouter récemment encore un million pour enterrer sous une énorme chape de béton recouverte de gazon — la tombe, prétendue provisoire — les éléments de béton dont il est pour partie constitué. Ceux de polyester, qui en forment la plus grande part, reposent depuis deux ans dans un champ au bord de la Loire. Ils occupent de ce champ 800 mètres carrés, déposés sur l'herbe sans protection. En voie d'y pourrir si la Cour d'appel n'y met promptement ordre. Il serait étrange que le seul monument de grande envergure offert au public en notre siècle dans la ville de Paris ou en ses abords immédiats reçoive ce statut de mort-né. S'inscrirait là devant l'histoire la désaffection portée par notre temps à la création d'art, parallèlement aux belles proclamations sur l'animation culturelle.

Les allégations de la Régie touchant au coût de l'achèvement du monument (qu'elle affirme incertain

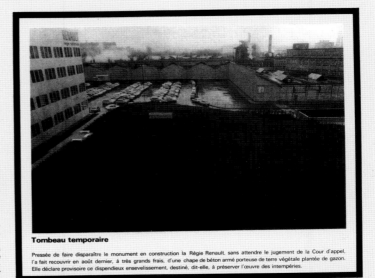

Tombeau temporaire

Pressée de faire disparaître le monument en construction la Régie Renault, sans attendre le jugement de la Cour d'appel, l'a fait recouvrir en août dernier, à très grands frais, d'une chape de béton armé porteuse de terre végétale plantée de gazon. Elle déclare provisoire ce dispendieux ensevelissement, destiné, dit-elle, à préserver l'œuvre des intempéries.

tout en s'opposant à ce qu'on le détermine) sont fallacieuses. Il lui en coûtera 3 ou 4 millions, ce qui, rapproché de ses investissements pour la seule année 1978 qui sont de 3.500 millions, est en proportion d'un pour mille. Ses bénéfices de l'an dernier étaient de plus de 600 millions et son exploitation est pleinement prospère. Ses dires sur de prétendues difficultés techniques qu'offre pour elle cette construction n'ont guère de fondement. Ni non plus ceux sur les dépenses qu'impliquera l'entretien du monument une fois celui-ci construit. Il n'est guère crédible que la technologie de la

Régie Renault ne soit pas en mesure de construire ce que Dubuffet lui-même a réalisé par ses propres moyens à Périgny-sur-Yerres avec sa Closerie Falbala, qui est à peu près de même importance (1 600 mètres carrés contre 1 800). On trouvera plus loin de celle-ci une photographie. Peu crédible aussi que les ultérieurs frais d'entretien soient une charge appréciable dès lors qu'ils sont nuls pour le «Groupe de 4 arbres», en place à New York depuis plus de cinq ans, ou pour le «Jardin d'émail» d'Otterlo, dans lequel circulent plus de 100 000 visiteurs par an.

Pétition/Seconde liste

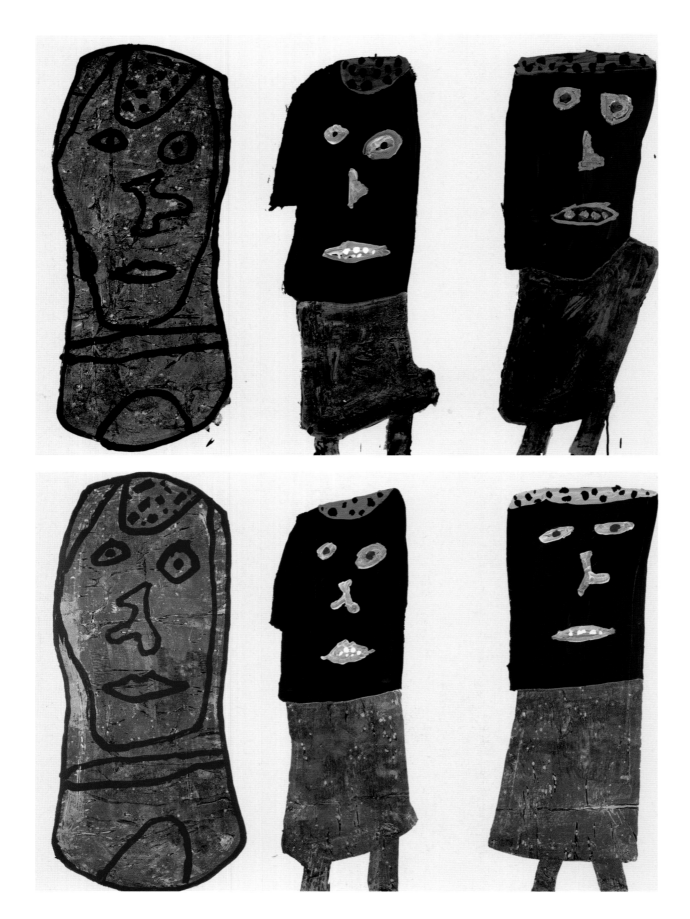

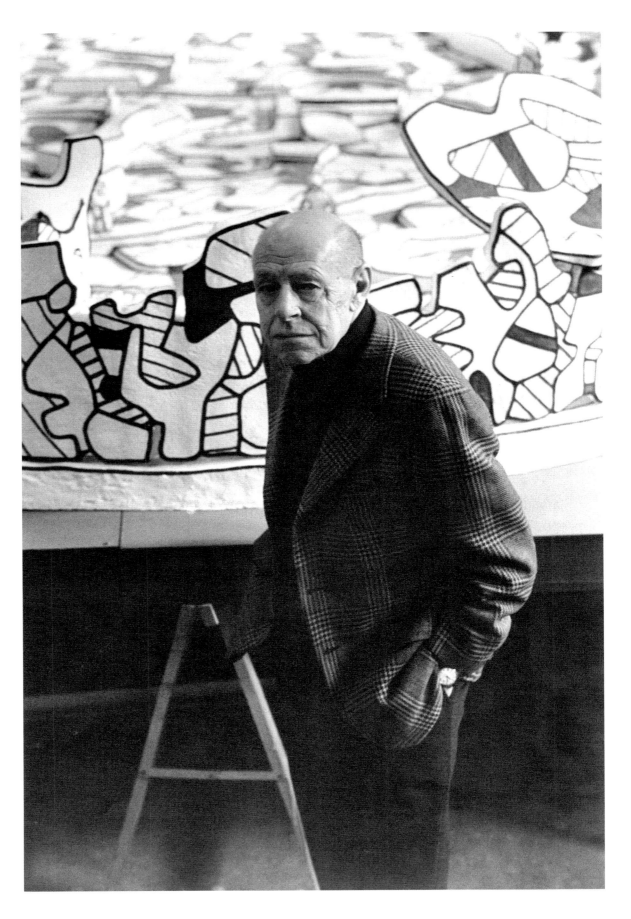

Les avocats de la Régie, maîtres Herbaut et Mathély exposant à la magistrate madame Rozès les difficultés techniques qui s'opposent à la construction du "Salon d'été"
Acrylic on paper
mounted on canvas
70 × 102 cm
4 December 1977
Fondation Dubuffet, Paris

Les avocats de la Régie, maîtres Herbaut et Mathély exposant à la magistrate les charges financières exorbitantes qu'implique l'achèvement du "Salon d'été"
Acrylic on paper
mounted on canvas
70 × 102 cm
4 December 1977
Fondation Dubuffet, Paris

Jean Dubuffet in front of the maquette of the *Salon d'été* at the time of the Renault affair
Studio in Vincennes, 1977

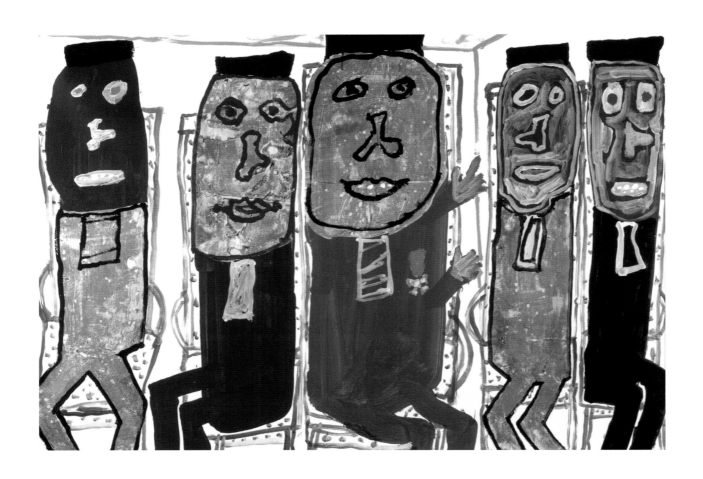

FACING PAGE

Tribunal prononçant
qu'il est loisible de détruire
les monuments si l'on
sauvegarde leurs maquettes,
estimées légitimement
moins encombrantes
Acrylic on paper
mounted on canvas
70 × 102 cm
4 December 1977

RIGHT

Le petit messager du Salon d'été,
no 4, 1 July 1978
published by the support group
in favour of Jean Dubuffet's
Salon d'été being completed
Archives Fondation Dubuffet, Paris

le petit messager
du Salon d'été

Deuxième année · N° 4 / Prix 3 F
1er juillet 1978

Publié par le Groupement de soutien
pour l'achèvement du Salon d'été de Jean Dubuffet
Renseignements et correspondance :
Chantal Gaulin, 11, rue St-Médard, 75005 Paris

Tiroir-caisse roi
LA COUR APPROUVE LA CASSE

Il paraît faire maintenant peu de doute que le Salon d'été ne verra jamais le jour. Meurtre avant naissance. Le tribunal se moque du monde quand il nie que la réalisation finale du monument, la réalisation visée, ait au regard de la loi, qualité d'œuvre d'art et quand il attribue à la seule maquette de l'ouvrage cette qualité. La loi philistine, je pense. La loi de ceux qui ne veulent pas appliquer la loi. La loi du profit prévalant dans tous les cas sur tout argument. Il fallait être bien à court pour recourir à telle fiction que l'œuvre considérée n'a pas qualité d'œuvre d'art, sous prétexte qu'elle n'est pas faite de la propre main de l'auteur. Voici donc maintenant *hors la loi* toutes les œuvres d'architectures et tous les monuments.

En vain fut-il clamé que j'ai participé constamment à la construction. Que je suis allé assidûment tant à Billancourt pour y contrôler les sculptures de béton qu'à Nouan-sur-Loire pour diriger les formes des éléments de résine. Que mes propres assistants, rémunérés par moi depuis nombre d'années, collaborateurs de mes monuments antérieurs, y ont, sous ma conduite, amplement mis la main. La cour est résolue à n'en rien savoir. Ce qu'elle veut seulement c'est faire bon plaisir au procureur que le ministère a dépêché à l'audience pour demander que, vaille que vaille, dernier mot soit donné à la régie Renault. Nul (ni surtout une loi) n'étant admis à se mettre en travers des lubies de son capitaine. Voici celui-ci maintenant servi. Du moins pour l'heure.

Il y a même surenchère car il faut observer que le procureur, sentant sans doute le pied peu sûr à dénier au monument qualité d'œuvre d'art, avait, dans son réquisitoire, glissé sur cette argutie scabreuse et mis plutôt l'accent sur la clause du contrat par lequel la Régie, avant qu'aucun projet soit fait, avait pris soin de préciser qu'elle serait libre de construire ou non ce que j'allais proposer. C'est le second pilier du jugement. Le premier pilier est que le monument, n'étant pas construit intégralement de ma propre main, n'a pas la qualité d'une œuvre dont la loi prescrit la sauvegarde. Le second est qu'en me commandant de soumettre un projet la Régie s'était réservé le droit de refuser ce que je proposerais. Dans la logique du procureur j'avais là par avance renoncé à me prévaloir de la sauvegarde ultérieure du monument quand celui-ci serait construit. Ce qui est très remarquable c'est que la loi stipule bien que le droit de l'auteur à la sauvegarde de son œuvre est imprescriptible et *inaliénable*. Je n'étais donc pas en droit, même si je l'avais voulu, d'y renoncer. L'eussé-je fait que ma renonciation eût été sans valeur.

Il va de soi que la commande d'un projet faite à un artiste — ou à un architecte — n'entraîne pas l'obligation de construire ce qu'il proposera, et c'est dans ce sens que la clause en question figurait dans le contrat qu'avait établi la régie Renault et dont j'ai accepté les termes. Lorsque, un an plus tard, je présentais les plans et la maquette du «Salon d'été» rien, bien sûr, ne pouvait s'opposer à ce que la Régie prenne (avec ou sans clause au contrat) la décision de construire ou celle de ne pas la faire. Mais une fois prise la décision, une fois la construction entreprise et conduite à plus de moitié son achèvement, la liberté de construire ou non, et encore moins celle de détruire, ne sauraient plus être mises en cause. Sauf pour le procureur, à qui devrait pourtant apparaître, en bon juriste, que la Régie, si elle avait donné à la clause visée l'extension alléguée, m'aurait alors imposé *léoninement* (comme ils disent) une renonciation que la loi interdit. Ce qu'elle n'aurait, semble-t-il, osé. Mais sait-on?

Oui, on sait. On sait qu'il se trouvera toujours des arguties à quoi faire semblant de croire si on veut affirmer que le chien est enragé. On sait que tous ces débats sur l'interprétation d'un mot ou d'un autre sont ici seulement pour noyer le poisson. On sait que la France d'aujourd'hui ne porte plus consideration à rien d'autre qu'au profit et que, nonobstant les rodomontades et proclamations, personne n'y porte plus de véritable intérêt aux créations d'artistes. Bâteleurs, saltimbanques! Joueurs de bonneteau! A nous les comptables et la bonne soupe! Il est bien entendu — parfaite entente là-dessus — qu'on fait en France seulement *semblant*. Le faire semblant, dans notre société, est devenu dans tous les domaines le recours majeur, *ars magna*. Tout l'appareil des ministres du faire semblant est en place.

C'est dommage. Il faudrait plutôt s'employer à revaloriser la bonne franchise. Si en France maintenant les productions de l'esprit n'apparaissent plus d'aucune usage, si rien d'autre n'y est plus révéré que les comptes et le porte-monnaie, s'il est attribué à ceux-ci en tous points et dans tous les cas la priorité, alors déclarons-le bien ouvertement, proclamons-le sans plus rien feindre. Pleins feux sur le cas du Salon d'été! Il est important que s'inscrive dans l'histoire, pour bien éclairer ce qu'aura été notre société actuelle, le sac du Salon d'été par la régie Renault avec l'approbation des pouvoirs publics en fonction dans le moment.

Jean Dubuffet

Devant la Cour d'appel, les avocats et le prétendant auteur tout lui denie ce titre

Audience du 28 avril

La vaste et pompeuse salle de la première Chambre, toute pleine d'assistance, ne vit arriver les juges qu'avec un retard d'une heure, de sorte que la séance, coupée seulement vers 17 heures d'un court entracte, se prolongea jusqu'à plus de 19 heures.

Me Jean-Robert Bouyeure prit le premier la parole et fit l'exposé, dans une forme frappante et admirablement articulée, de tout le développement du litige et toutes les circonstances s'y rapportant. Il éclaira l'un après l'autre tous les points de droit soulevés et réfuta de manière totalement convaincante les allégations des adversaires et les indéfendables arguments sur lesquels s'était fondé le jugement de première instance. Sa plaidoirie, à laquelle toute l'assistance portait grande attention, s'étendit sur plus d'une heure. Celle de Me Georges Kiejman lui fit suite et dura le même temps. Elle fut d'une impressionnante éloquence. S'y virent évoquées plus particulièrement les implications sociales — et nationales — de l'acte de destruction du Salon d'été. Y fut aussi fortement souligné le caractère inaliénable qu'attribue la loi au caractère du droit d'auteur et dont il découle que l'artiste ne pouvait pas, quand même il l'aurait voulu, renoncer à ce droit sur son œuvre.

Me Blaustein plaida ensuite au nom de l'A.D.A.G.P., association pour la défense des droits d'auteurs, qui avait introduit auprès de la Cour une action incidente, s'estimant lésée par l'interprétation que faisait de la loi le jugement de première instance selon lequel la maquette seule et non l'œuvre édifiée, bénéficierait de la protection légale.

Puis Me Mathely, avocat de la Régie, réitéra les arguments de celle-ci qui parurent faibles. Il ne manqua pas d'appuyer sur les prétendues craintes des dirigeants de l'entreprise à propos d'éventuels surcroîts de dépenses que l'achèvement de la construction pouvait entraîner par rapport au budget prévu à l'origine. Sans chiffres précis ni preuves d'ailleurs. Il insista sur l'appartenance au contribuable de l'argent dont dispose Renault et sur la prudence de bon gestionnaire qui s'impose dès lors à son président. Le contribuable n'est pas supposé donner sans aucun doute la priorité aux bénéfices de l'entreprise sur des dépenses jugées somptuaires; ce resterait à vérifier. Il se complut enfin à mettre en relief l'énormité de la somme de 400.000 francs attribuée à l'artiste. En omettant de mentionner qu'elle correspondait à un forfait convenu, non pas seulement pour la création et l'exécution des plans et de la maquette, mais pour tout l'ensemble des prestations ultérieures impliquées par l'achèvement de la construction : nombreux déplacements et voyages à Billancourt et à Nouan-sur-Loire; interventions constantes au long de plusieurs mois de l'artiste lui-même et de ses assistants rémunérés par lui;

longue participation effective de ceux-ci aux travaux.

Sa plaidoirie fut un peu terne. Il provoqua de la gaieté quand il énonça que le destin de l'œuvre était, par la clause du contrat, qu'elle ne fût pas construite. Il ne partagea pas lui-même cette gaieté qu'il réprouva vertement bien que les juges s'y fussent associés. Sans doute n'estimait-il pas utile de se donner trop de peine, l'appui donné à la Régie par les pouvoirs publics lui paraissant peut-être pour l'édification de la Cour d'un poids plus décisif que son exposé.

Toute l'assistance, quand il se rassit, était convaincue qu'il n'était pas pensable que le tribunal puisse rien faire d'autre qu'obliger la Régie à achever la construction. C'est alors que se manifesta pour finir un avocat du ministère public qui, à la stupéfaction générale, et comme s'il n'avait rien perçu des débats, donna pleine approbation aux arguments de la Régie, insistant notamment sur la clause du contrat qui lui donnait le droit de construire ou non le monument quand celui-ci serait proposé, et conseillant aux juges de confirmer le jugement antérieur.

Il ne restait alors qu'à préparer le recours devant la cour de cassation.

L'arrêt, ajourné au 2 juin, fut prononcé à cette date. On en trouvera le texte plus loin. Aussitôt rendue la sentence fut déposé le jour même un pourvoi auprès de la Cour de Cassation.

Danse du président
Vernier-Palliez et de l'architecte
Pierre Vigneron sur le gazon
recouvrant les décombres
du "Salon d'été"
Acrylic on paper
mounted on canvas
102 × 70 cm
26 December 1977
Fondation Dubuffet, Paris

L'architecte Pierre Vigneron
dessinant le plan
de l'ensevelissement
du "Salon d'été"
Acrylic on paper
mounted on canvas
102 × 70 cm
27 December 1977
Fondation Dubuffet, Paris

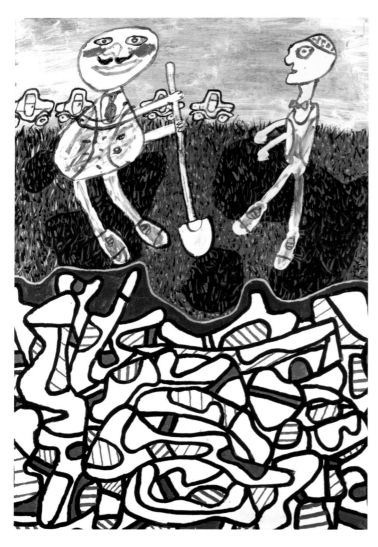

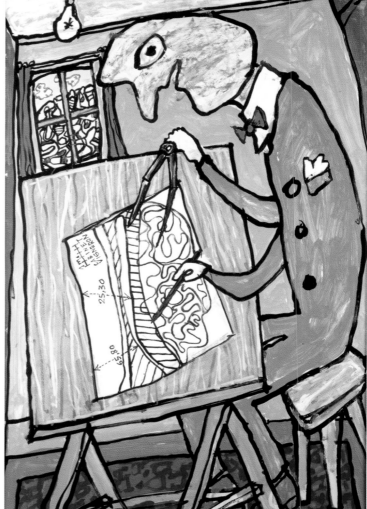

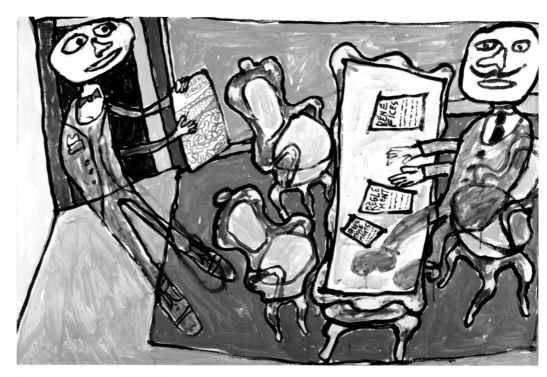

L'architecte Pierre Vigneron
présentant au président
Vernier-Palliez le plan
de l'enterrement du "Salon d'été"
Acrylic on paper
mounted on canvas
70 × 102 cm
28 December 1977
Fondation Dubuffet, Paris

Le président Vernier-Palliez
signant devant le corps directorial
l'ordre d'ôter le "Salon d'été"
du champ de son regard
Acrylic on paper
mounted on canvas
70 × 102 cm
29 December 1977
Fondation Dubuffet, Paris

Salon d'été
(1:10 maquette)
Epoxy with polyurethane
paint (black and blue)
565 × 454 cm
28 August 1974–December 1974
Fondation Dubuffet, Paris

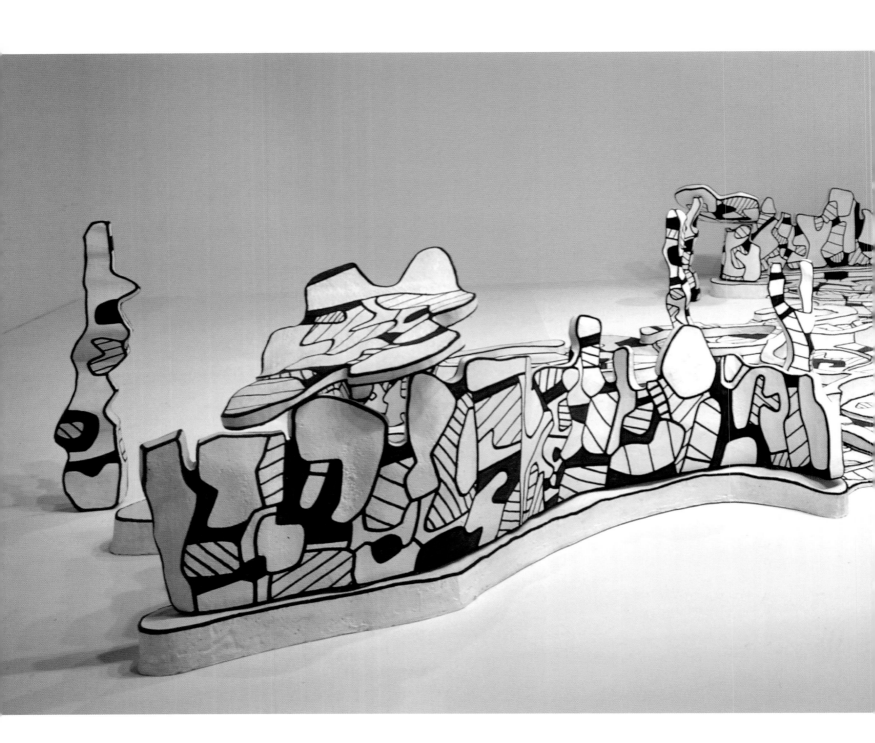

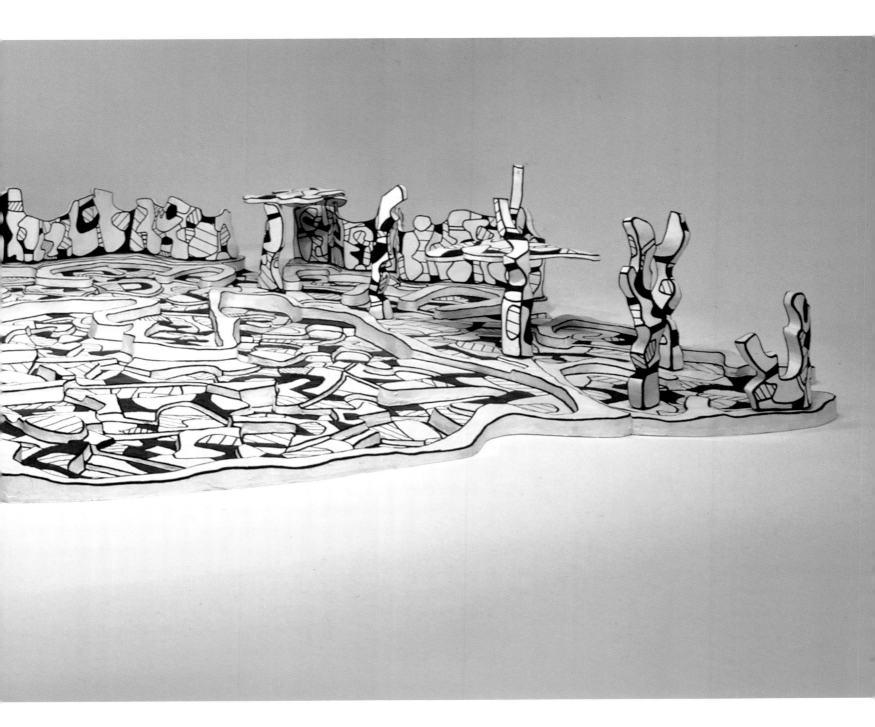

The Temptation of Jean Dubuffet

After the event, it seems obvious to state that Jean Dubuffet's sculptural then his architectural work came into being as he worked on the *L'Hourloupe* cycle. Even the first *L'Hourloupe* figures had a slight undifferentiated area surrounding them, presciently identified by Hubert Damisch as the margin Dubuffet was careful to include when cutting out these figures, even though at the time this was thought to be the painter's new style, leaving "some distance from the outline as if he intended to endow it with a kind of halo". The *L'Hourloupe* figures carried their habitat with them, like hermit crabs.

Dubuffet seemed to pay particular attention to this feature: if the image was not cut out, he took care when drawing it onto the canvas to leave a kind of pouch between the background that was painted uniformly black or that bore the traces of hasty markings, and the outline of the figure. The pouch was arbitrary, sometimes flattened, sometimes looser, both isolating and insulating the figure, a sort of placental source of nourishment, a reserve of living space. *L'Hourloupe* figures seem to come from another world, like deep-sea divers ready to face the sculpture's continually fast-flowing current.

As if to respond to this function – creating fixed points within the flux – the pouches quickly filled out and took shape. They became entrances to impenetrable caves (*Rue au fumeur de pipe*, 3 August 1962), beehive stirrings in alveoli (*Cité des nuées*, 5 August 1962), Chinese stelae (*La vie en ville*, 24 August 1962) . . . before the realization that they were first and foremost urban spaces – shopfronts, road crossings, unlikely stairs and possible crossings between buildings. "Tout le monde aux fenêtres" (Everyone at the windows) Jean Dubuffet already announced back in 1944.

Away with the cows, butterflies and tree-lined paths, *L'Hourloupe* straightaway viewed itself as a city-dweller, a child of *Paris Circus* and the *Restaurant Rougeot*, the buses, the *Rue Pifre* or *Rue Turlupet*, just as it would be the child of the *Rue de l'Entourloupe* (Dirty Tricks Street), although *entourloupe* was not among the words that through analogy or sound association sprang to Dubuffet's lips when he gave the name *L'Hourloupe* to the series that was to occupy him for twelve years. "Through assonance," he wrote in his *Biographie au pas de course*, "I associated the name with *hurler* [yelling], *hululer* [an owl hooting], *loup* [wolf], 'Riquet à la houppe' ['Riquet with the Tuft', a fairy-tale by Charles Perrault], and 'Le Horla', the Maupassant story inspired by mental derangement."

Façade d'immeuble à trois étages
Marker and vinyl on paper
(cut out and glued on to kraft paper)
41 × 46 cm
26 August 1970
Fondation Dubuffet, Paris

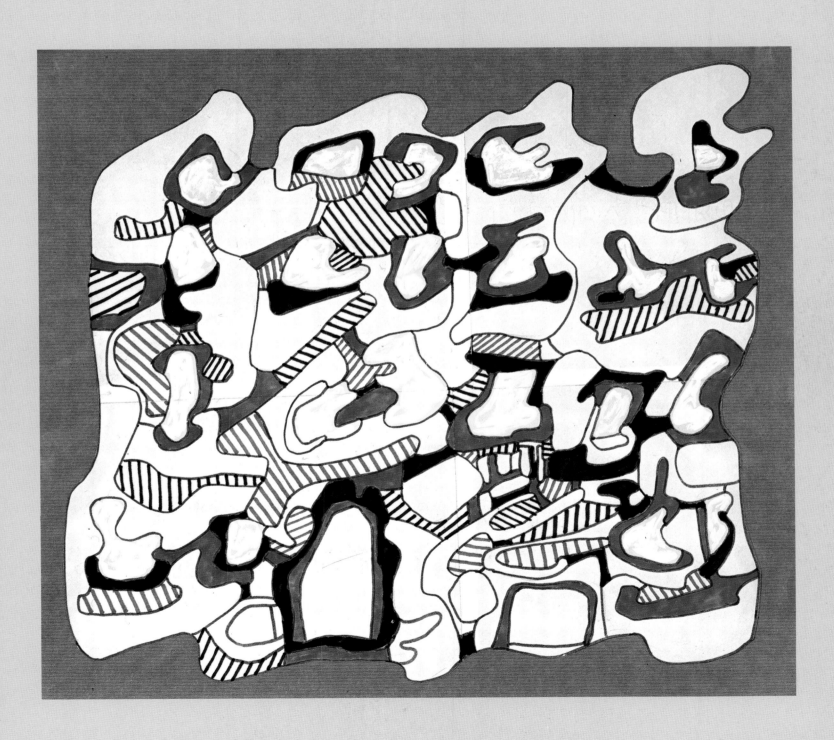

In the first gouache paintings of *L'Hourloupe* – *Pignons sur rue*, *Urbi et orbi*, *La vie en ville*, *Site urbain*, etc. – the outlines of a city emerge, still hazy but obviously present, like a ghostly desert mirage, its façades suggested, the doors and windows latent, the pavements and streets illusory. There is nothing yet in these images of the maniacal cynicism Dubuffet used in *Paris Circus* to baptise the shops and list the business premises: *Banque La Ténébreuse*, *Agence La Tocarde*, *Aux bouchées doubles*, *Veille au grain*. While for his own business sign – *L'Entourloupe* – he stated, as if wanting to clear his name, *Commerce honnête* (Honest Business), translating perhaps his dismay at the new world that was coming into being, as yet a fugitive evocation that might just as easily disappear as become concrete reality.

In the hubbub of *L'Hourloupe*'s early stages, Dubuffet was just as much an onlooker as the ordainer of the coloured cells that poured out, forming, deforming and reforming images – a real maelstrom inside which, as in Edgar Allan Poe's vortex, one is surprised "to watch, with a strange interest, the numerous things that floated in our company", and, once the filter of habit lifts, to see their mystery and incongruity. *L'Hourloupe* is primarily a systematic questioning of all knowledge and certainty; doubt is its fundamental thrust, but unlike Descartes's immediate reassurances, Dubuffet sets out, initially, to explore an opaque world with no landmarks. *Les riches fruits de l'erreur*, *J'opterai pour l'erreur*, *Compagnie fallacieuse*, *Banque des équivoques*, *Erre et aberre* – many such titles from the early paintings in 1963 emphasize the feeling of being on a drunken boat on a sea that is entirely subjected to the force of *L'Hourloupe*'s tidal current.

Yet no unknown land resists exploration for ever; in the end, it offers up its landmarks. All cartography starts out in this manner. Sucked into the vortex of *L'Hourloupe* at first, Dubuffet, like Poe's mariner, was finally able to see how it worked, to analyse what it carried in its wake, to prevent any further harm to himself and so to play his own game. Carrying out an inventory of *L'Hourloupe*, from the *Cathedral* to the *Cannon*, from the *Tree* to the *Piano*, from the *Hammer* to the *Wheelbarrow* and the *Typewriter*, noting the many variations on what might well be the same thing, how what is single is in fact multiple because there is no exhaustive definition of it, making sure that the tree no longer hides the forest but that the forest is all the trees – all this was important to his work and his thinking before receiving the commission from Paris University's Faculty in Nanterre for the mural works, an opportunity that was very different from his usual studio work. *Nunc Stans* (the now that stands still of Thomas Aquinas in reference to Boethius), and *Épokhê* (the suspension of judgment) are both in a way the key to a state of mind that culminated in the complete nihilism of the *Non-lieux*. At this point, Dubuffet could have written the same as he wrote of his final works painted a month before he died: "The notion of being is no longer irrefutable but relative; it is nothing more than a projection of our thought, a whim of thought. It behoves our thought to establish being wherever and for however long seems right. There is no difference in nature between being and fantasy, being is an attribute given to fantasy by thought." But in asserting this, Dubuffet had to test the justness of the world of *L'Hourloupe* against the real world.

Painting, and sometimes even painters (from Fautrier to Tàpies, from Burri to . . . Dubuffet, of course), has always maintained a link with the immaterial. The story of Butades' daughter, as related by Pliny, seems from the beginning to have given painted work the fragility of the shadow it needs to exist. It was perhaps in order to contradict this myth, to prove the validity of a language in the process of construction – and in which for twelve years he sought signs of autonomy, the ability to exist by itself independently from its inventor – that Dubuffet gradually moved *L'Hourloupe* from the virtual world into concrete reality.

He had already been tempted to do this at least twice before: in 1954, with the *Petites statues de la vie précaire* and their implausible components – fragments of a burnt out car, scouring pads, sponges, coal slag – and especially in 1957, just as he was beginning the *Texturologies* series. Dubuffet said that for a while he had wondered whether he would not simply exhibit off-cuts of asphalt from a road rather than the paintings from the series. Proof through reality was what Dubuffet first envisaged when he projected the flat figures from *L'Hourloupe* into the third dimension. But he was a painter, not a sculptor. The *Petites statues de la vie précaire* were akin to collages, at best assemblages; his asphalt fragments did not go any further than the world of dreams.

Although the commission for the frescoes in Nanterre was never executed, it did in a way provide the catalyst for Dubuffet to make the move from a purely speculative philosophical position of distance to one of producing objects that may have seemed utopian but which very quickly began competing with reality: he soon imagined setting them in an everyday universe. For his *Édifices* exhibition in the Musée des Arts Décoratifs in 1968, Dubuffet did indeed imagine little castles, towers and pavilions, no longer as items of pure intellectual speculation, but as projects that could fit into an urban context. This was visible in the exhibition in which photomontages showed buildings from *L'Hourloupe* in various places in Paris, such as the place Victor Hugo and the place des Victoires. In the decades to come, this came true: the *Jardin d'émail* was built in the gardens of the Kröller-Müller Museum in Otterlo, the *Villa Falbala* in what became the Fondation Dubuffet, and finally the *Tour aux figures* in the Ile Saint-Germain, an island in the Seine not far from the centre of Paris, to quote only those buildings shown in maquette form at the time.

Such projects in urban settings – ambitious but modestly dimensioned – then quickly expanded, first in space, with the *Groupe de quatre arbres* in New York (1972), the *Jardin d'émail* in the Netherlands (1974), the *Monument au fantôme* in Houston, the *Monument à la bête debout* in Chicago, and *Le Boqueteau* in Flaine and in Paris and its suburbs: *L'Accueillant* and *La Tour aux figures* (to mention only those projects that were commenced during Dubuffet's lifetime). They also expanded in terms of surface area: the *Villa Falbala* was enlarged by the *Closerie*, the *Salon d'été* in front of the head offices of the Régie Renault covered 1,800 square metres, and the *Site scripturaire* at La Défense occupied 3,000 square metres.

L'Hourloupe, as if in obedience to its cellular structure, moved out of the studio dream world and into the physical world, a rapidly multiplying organism. It was at this point that the finality became apparent, an end that was quite different in

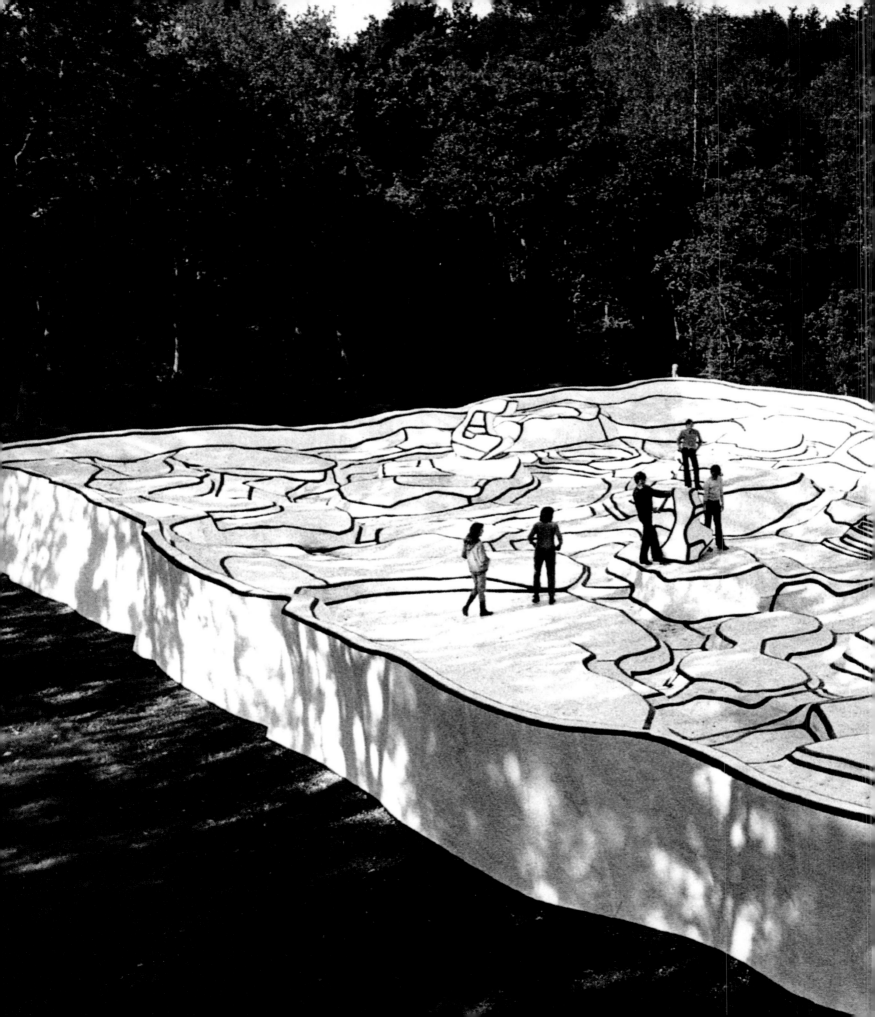

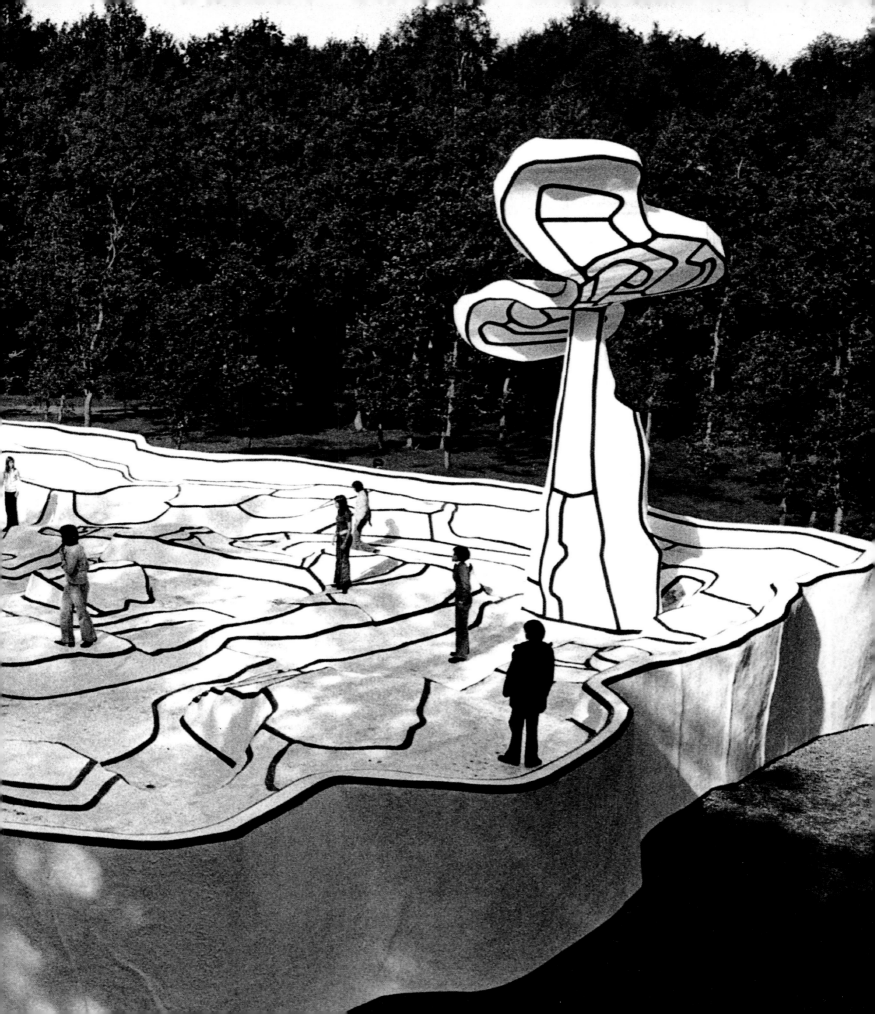

scope from Dubuffet's inventorying of the world. The creator's initial point of view of understanding through drawing, painting and volume was insidiously replaced by another logic: replica at first, then duplication, and finally substitution. A totalitarian parallel world seemed to be coming into being. In the eyes of its own inventor, and as if out of his control (but possibly not without some degree of satisfaction on his part), *L'Hourloupe* had become an automatic mechanism with its own autonomy, which in accordance with its own logic pursued new developments.

The myth of a created work becoming independent from its creator (in whom both frustration and fascination intermingle) in order to exist in its own right has been a recurrent image since Pygmalion, one that at various periods, down to Villiers de l'Isle-Adam and George Bernard Shaw, has found new forms. Perhaps it is an effect such as this that should be sought in Dubuffet's attitude to *L'Hourloupe* when it settled into the real world? In his *Matériologies* series, he gave one of the paintings the premonitory title of *La vie sans l'homme* (Life without Man). Erected, freestanding in the world, Dubuffet's sculptures and constructions were no longer, as his previous body of work was, a sort of additional commentary on the world, but suddenly became an integral part of it. How far could the process go? To what extent could the artist still be directly involved?

Coucou Bazar, subtitled *Le Bal de L'Hourloupe*, took a step in this direction. Distinct from the tableau vivant in which real characters are frozen in a set pose, *Coucou Bazar* presented a "tableau animé", with elements on wheels that were moved around by invisible performers, and sculptures inhabited by equally invisible dancers moving so slowly that they first appeared motionless. "The idea", said Dubuffet, "was to inspire the spectator with the feeling that all the elements on show are living, or to be more precise, potentially so." Giving life to what is inert, this is the demiurgic temptation of Pygmalion, as if ultimately things had to come full circle.

In summer 1962, *L'Hourloupe* came into the world with a language, a jargon that went with the first cut-outs published in *Le Petit Jésus*, and which, like the cut-outs, revitalized the relationship with their more orthodox homophones such as "bautine" (*bottine*, boot), "jénice" (*génisse*, heifer) and "cerviteure" (*serviteur*, servant). Twelve years later, when this lengthy cycle of Jean Dubuffet's work, the only one of such duration, was about to close, it seemed that he would proceed with clinical scrupulousness as far as the experiment took him. From the *Petit Jésus* cut-outs to the monumental projects and *Coucou Bazar*, *L'Hourloupe* had gradually taken its stand as an autonomous world, a form of language both verbal and plastic, whereby everything could be structured. It only needed testing to see whether it was indeed a language common to all, one that could be used by others, and not just an idiolectal outpouring.

It was not words but images that Dubuffet turned to for this final stage. He decided to entrust the entire execution of pieces to assistants not as many painters did in the privacy of their studios, but in order to create a distance between himself and the painted objects. Dubuffet provided them with two series of small collages about 50 centimetres high, partially painted in gouache, to be enlarged without any intervention whatever on his part on to canvases measuring for the

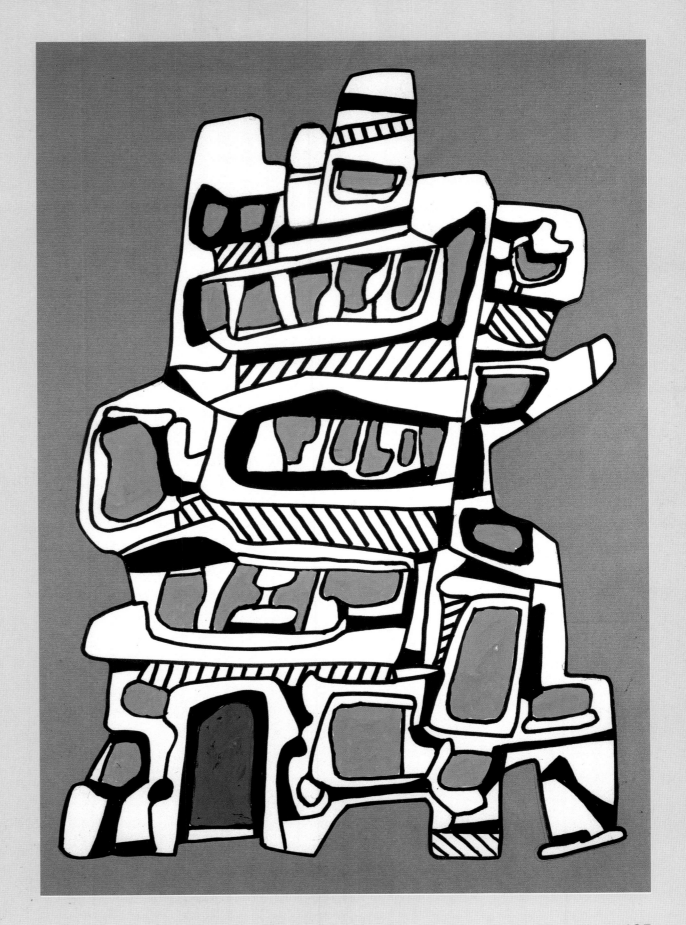

most part 200 × 130 centimetres. Like a composer who discovers unsuspected riches in his score when played by musicians, Dubuffet no doubt expected another life for his work. When his paintings of the *Paysages castillans* and the *Sites tricolores* were released from the hands of the enlargers, they were cold and mechanical. Technically perfect, they were no better than a photographic reproduction. The music box had not managed to improve on the bird's trills.

With *L'Hourloupe* at an end, Dubuffet could not have failed to note that although works of art are essential to the world, they do not replace it; executors and creators will always remain distinct; and that a child's ordinary pencil has as many visions, thoughts and dreams in it as any complex technology. At the age of seventy-four, Dubuffet began his series of *Crayonnages*, the final chapter in his work, as if nothing else had ever existed. ■

FACING PAGE
Jean Dubuffet behind the
maquette of the *Site scripturaire*
February 1974

Jean Dubuffet biography

1901

Jean Dubuffet was born on 31 July in Le Havre (Normandy), the son of a wine merchant.

1908–1917

School in Le Havre. Close friendship with Georges Limbour and Armand Salacrou. Attends night classes at the Ecole des beaux-arts.

1918–1919

Moves to Paris to study at the Académie Julian, which he leaves six months later to work alone. Meets Suzanne Valadon, Elie Lascaux, Max Jacob and Charles-Albert Cingria. Visits Raoul Dufy.

1920–1922

Studies linguistics, philosophy, literature, music.

1923

Trip to Italy and Switzerland. Military service at the meteorological station of the Eiffel Tower. Becomes acquainted with Fernand Léger and André Masson.

1924

Breaking off of all artistic endeavours. Stops painting (for eight years). Residence in Buenos Aires for six months.

1925

Returns to Le Havre; enters the family wine business.

1927

Marriage to Paulette Bret. Death of his father. His daughter Isalmina is born two years later.

1930

Founds his own wholesale wine business in Paris (Bercy).

1933–1935

Dubuffet's artistic interest is rekindled.

He rents a little studio in the rue Val-de-Grâce. Separates from his wife Paulette (divorce in 1936). Leases his business. Meets Émilie Carlu, Lili (wedding in 1937). Dubuffet models masks and puppets.

1937

Abandons art once again and returns to save his wine business from bankruptcy.

1939–1940

Soldier. When demobilized, returns to Paris to run his business.

1942

For the third and final time, Dubuffet decides to devote himself to art.

1943

Meets Jean Paulhan, who introduces him to the Parisian intelligentsia, painters and writers.

1944

First exhibition at the Galerie René Drouin: lively controversy.

1945

Starts collecting Art Brut in France and Switzerland.

1946

Publishes *Prospectus aux amateurs de tout genre* (Gallimard). *Mirobolus, Macadam & Cie* exhibition at the Galerie René Drouin.

1947

First American exhibition at the Pierre Matisse Gallery in New York. First of three successive journeys in the Algerian Sahara. Exhibition of *Portraits* at the Galerie René Drouin. Sells his wine business.

1948

Foundation of the Compagnie de l'Art Brut.

1949

Publication of *L'Art brut préféré aux arts culturels*.

1950

Beginning of *Corps de Dames* series.

1951

First journey to New York (six months).
Programmatic speech on *Anticultural positions* at the Arts Club of Chicago. Begins *Sols et Terrains* series.

1954

Retrospective at Cercle Volney, Paris.

1955

Moves to Vence (Alpes-Maritimes). Construction of a house and studios. Within the following years, he alternately lives in Paris and Vence.

1957

First Museum retrospective at Schloss Morsbroich, Leverkusen (Germany).

1958-1959

Dubuffet begins the series of lithographs *Les Phénomènes* (completed in 1962).

1960-1961

An office, which documents his work, is installed in Paris. Major retrospective at the Musée des Arts décoratifs, Paris. Musical experiments together with Asger Jorn, which result in a series of LP recordings. *Paris Circus* series.

1962

Return to Paris of the Art Brut collection, which had been stationed in United States since 1951. Major retrospective at The Museum of Modern Art, New York.

Important change in Dubuffet's work: in July, beginning of the *L'Hourloupe* cycle, which he works on until 1974.

1964

Exhibition of *L'Hourloupe* at Palazzo Grassi, Venice. Publication of the first volume of his *Catalogue intégral des travaux* (38 volumes).

1966

Retrospectives in Dallas, London, Amsterdam and New York. Shows *L'Hourloupe* at the Solomon R. Guggenheim Museum in New York. The artistic language of *L'Hourloupe* is being expanded to the third dimension: sculpts polystyrene.

1967

Important donation of his own works to the Musée des Arts décoratifs, Paris. Publication of a collection of Dubuffet's writings, 2 volumes: *Prospectus et tous écrits suivants* (2 additional volumes to be published in 1995).

1968

Publishes *Asphyxiante culture*.

1969-1970

Commission for a monumental sculpture for the Chase Manhattan Bank, New York. Construction of large studios in Périgny-sur-Yerres near Paris. Breaks ground there for the project *Closerie Falbala* (constructed 1971–1973, completed in 1976).

1971-1972

Beginning of series of *praticables* and costumes for *Coucou Bazar*: installs a studio at the Cartoucherie de Vincennes, near Paris. Inauguration of the monumental sculpture *Groupe de quatre arbres* in New York.

1973

Retrospective at the Solomon R. Guggenheim Museum, New York, and world premiere of the performance *Coucou Bazar*, which will be shown in Paris at the Grand Palais in the autumn.

1974

End of the *L'Hourloupe* cycle. Inauguration of the *Jardin d'émail*
(30 × 20 m) at the Kröller-Müller-Museum, Otterlo.
Beginning of the construction of the *Salon d'été* commissioned
by Renault. Creation of the Fondation Dubuffet.

1975–1976

The *Salon d'été* construction is stopped. Legal action.
Donation of the Art Brut collection to the city of Lausanne.

1977–1978

Retrospective in Le Havre. In the context of the exhibition organized
by Fiat in Turin, a third version of *Coucou Bazar* is performed.

1981

On the occasion of his 80th birthday, large exhibitions at both
the Solomon R. Guggenheim Museum in New York and the Centre
Georges Pompidou in Paris take place.

1983

Wins case against Renault, but declines to force the company
to reconstruct the *Salon d'été*. Public commission by the French State
for the 24 m high *Tour aux figures*, which is unveiled in 1988.

1984

Exhibition of the *Mires* series at the French pavilion
of the Venice Biennale. Stops painting.

1985

Writes his *Biographie au pas de course* in three months.
Jean Dubuffet dies in Paris on 12 May.

This catalogue is published in conjunction
with the exhibition *Dubuffet architecte*

Henie Onstad Kunstsenter, Høvikodden, Norway
10 March–29 May 2011
Skissernas Museum/Museum of Public Art, Lund, Sweden
19 June–2 October 2011
Musée d'Ixelles (Brussels), Belgium
20 October 2011–22 January 2012

EXHIBITION CURATOR Daniel Abadie
With the participation of the **Fondation Dubuffet, Paris**

The organisers wish to express their gratitude to the institutions
that have contributed to the success of this event:
La Collection Renault, Boulogne-Billancourt and Curator Ann Hindry
The Solomon R. Guggenheim Museum, New York
and Director Richard Armstrong
Nasjonalmuseet for kunst, arkitektur og design, Oslo and Director, Nils Ohlsen

HENIE ONSTAD
ART CENTRE

Henie Onstad Kunstsenter/Henie Onstad Art Centre
Sonja Henie Vei 31
1311 Høvikodden, Norway
www.hok.no
Karin Hellandsjø, Director

SKISSERNAS MUSEUM
MUSEUM OF PUBLIC ART

Skissernas Museum/Museum of Public Art
Finngatan 2
223 62 Lund, Sweden
www.skissernasmuseum.se
Elisabet Haglund, Director

MUSÉE
D'IXELLES

MUSEUM
VAN ELSENE

Musée d'Ixelles
rue Jean Van Volsem, 71
1050 Brussels, Belgium
www.museedixelles.be
Claire Leblanc, Director

Fondation Dubuffet
137, rue de Sèvres
75006 Paris
www.dubuffetfondation.com
Sophie Webel, Director

The exhibition was organised with support from the French Embassies
in Norway, Sweden and Belgium, and from Renault S.AS.

photographic credits

© Archives Fondation Dubuffet, Paris: cover, p. 18, 19, 20, 22, 24, 25, 27–35, 38, 42, 46–47, 48, 50–55, 57, 58, 59, 62–63, 65, 73, 81, 82, 84, 85, 99, 106, 108, 109, 110 (bottom), 124, 148, 149, 155, 165, 166 (top), 167, 169, 173, 176–177, 179, 185; photo Azoulay: p. 171; photo Luc Boegly: p. 107; photos Belzeaux: p. 126–127, 128–129; photos Dumage: p. 80, 120–121, 122–123; photo Jacqueline Hyde: p. 12; photos Luc Joubert: p. 60, 61; photo Jurado: p. 79; photos Maya Klasen: p. 162, 163, 164, 166 (bottom); photos Arthur Lavine: p. 90, 91, 92–93, 94, 95 and back cover; photo Max Loreau: p. 125; photos Studio Muller: p. 100, 138, 156–157; photo Richard Payne Aia: p. 71; photo Ieoh Ming Pei: p. 139; photos Rousseau: p. 26, 36, 37 (bottom), 40, 41, 44, 45, 48 (left), 50 (to left), 51 (right), 56, 66–70, 75, 76, 82–83 (plan), 96, 98, 101, 105, 110 (top), 112–113 (plan), 130–131, 133, 151, 158, 159, 168, 170, 172, 174, 175; photo Maximilien Schell: p. 113 (top); photos Borge Venge: p. 37, 38 (2 at the bottom); photo Christian Vioujard: p. 160–161; photos Sabine Weiss: p. 103, 116–117, 118–119; photo Willi: p. 49; photos Kurt Wyss: p. 2, 86–89, 97, 104, 111, 114, 115, 134–135, 137, 140–141, 143, 144, 145, 146–147, 152–153, 182–183, 187.
© Skissernas Museum, Museum of Public Art, Lund/photo Christina Knutsson, p. 16.
© Henie Onstad Kunstsenter, Høvikodden/photo Øystein Thorvaldsen, p. 17.
© Museum Jorn, Silkeborg/photo Lars Bay, p. 39.
© Nasjonalmuseet for kunst, arkitektur og design/The National Museum of Art, Architecture and Design, Oslo (Norway)/photo Børre Høstland, p. 43.

© Daniel Abadie, 2011 for his texts
© ADAGP, Paris, 2011 for all works by Jean Dubuffet
© 2011, Éditions Hazan, Paris
www.editions-hazan.com

DOCUMENT RESEARCH FONDATION DUBUFFET
Claire Baulon, Florence Quénu

EDITORIAL ASSISTANCE AND COORDINATION
Chloé de Lustrac

GRAPHIC DESIGN
Bernard Lagacé

TRANSLATION
Elaine Briggs

EDITING
Bernard Wooding

PRODUCTION
Claire Hostalier

ISBN 978-0-300-17661-2

Printed in Mame, Tour, France
Library of Congress Cataloging-in-Publication Data Number: 2011006749
A catalogue record for this book is available from
The British Library